KT-228-628

Representations of Working-Class Life 1957–1964

STUART LAING

POLYTECHNIC LIBRARY
WOLVERHAMPTON

ACC No. 478609 CLASS

CONTROL

305.
562
LAI

DATE 25. MAY 1990 DY

MACMILLAN

© Stuart Laing 1986

All rights reserved. No reproduction, copy or transmission
of this publication may be made without written permission.

No paragraph of this publication may be reproduced, copied
or transmitted save with written permission or in accordance
with the provisions of the Copyright Act 1956 (as amended).

Any person who does any unauthorised act in relation to
this publication may be liable to criminal prosecution and
civil claims for damages.

First published 1986

Published by
Higher and Further Education Division
MACMILLAN PUBLISHERS LTD
Houndmills, Basingstoke, Hampshire RG21 2XS
and London
Companies and representatives
throughout the world

Typeset by Wessex Typesetters
(Division of The Eastern Press Ltd)
Frome, Somerset

Printed in Hong Kong

Laing, Stuart
 Representations of working-class life 1957–64.
 1. Labor and laboring classes in art 2. Labor
 and laboring classes in literature 3. Great
 Britain—Social life and customs—1945–
 I. Title
 790.2′0941 NX652.L3

 ISBN 0–333–37998–5
 ISBN 0–333–37999–3 Pbk

Contents

Introduction

On 29 February 1960 an editorial in the *Times Literary Supplement* commented – 'it is rather ironical that, at a time when the British working-classes seem to be growing conservative in their political views and growing middle-class in their tastes and habits, we should be enjoying for the first time in many years something like a renaissance of working-class literature'. This apparent paradox has since been noted with regard to a wide range of forms of representation, from sociological writing to commercial cinema and this book's starting-point lies in the attempt to recognise and interrelate the variety of cultural practices and products which were concerned to provide representations of contemporary working-class life in the period 1957–64.

For the most part the analysis is presented through a series of chapters each devoted to a specific medium or genre of writing. There is here a deliberate intention to avoid that kind of generalising 'cultural history' in which the institutional determinations and formal characteristics of different cultural practices are dissolved as a consequence of the pressure to seek thematic similarities. Instead, emphasis is placed on the significant variations between forms of representation in the handling of common issues placed on their agenda by general political and social developments. There are, of course, many points of connection and interrelation between the chapters; here I have tried to avoid excessive explicit cross-referencing and have assumed that readers will be making many such connections for themselves.

This book is not then a full cultural history of the period. Even as regards the representation of working-class life some important cultural forms are not discussed – for example, radio (apart from some brief comments on the Radio Ballads in Chapter 6) and the visual arts (both painting and photogra-

phy). There is also no account of two crucial political movements of the period, whose personnel and concerns frequently overlapped with those discussed here. A consideration of the politics and aesthetics of CND would put this book's assessments into a wider perspective, as would study of the New Left. In the latter case I particularly registered the absence of other work on which to draw. Almost all extant accounts come from those directly involved and to date the authoritative, yet necessarily partial, perspectives of Raymond Williams, Stuart Hall, E. P. Thompson and Perry Anderson appear to have discouraged rather than enabled more disinterested analysis. This perhaps reflects the extent to which the issues and problems which forced the New Left into existence after 1956 remain current and live; there can be no settling of accounts in this respect which does not also involve immediate questions of policy and practice (intellectual and political).

Finally it should be noted that the work undertaken here is primarily within the sphere of cultural studies, rather than literary criticism. The origins of the book lie in work done at the Centre for Contemporary Cultural Studies at the University of Birmingham in the early 1970s (although virtually none of the original material has been retained). The impetus and desire to go back to the issues which this book addresses have derived from more recent work at the University of Sussex, in the School of Cultural and Community Studies. The result is intended to contribute to the collective work of both interdisciplinary enterprises.

1. This New England

In October 1959 Labour suffered its third successive general election defeat. In the inevitable inquest which followed, a central issue was the party's working-class image. Douglas Jay saw Labour's two fatal handicaps as 'the class image and the myth of nationalization'.[1] Patrick Gordon Walker said simply: 'The Tories identified with the new working class rather better than we did.' Richard Crossman observed that 'each year which takes us further, not only from the hungry Thirties but from the austere Forties weakens class consciousness',[2] while the Party Leader Hugh Gaitskell warned of 'the changing character of labour, full employment, new housing, the new way of life based on the telly, the frig., the car and the glossy magazine – all have their effect on our political strength'.[3]

In the wake of these plausible but unverified observations the pro-Gaitskell journal *Socialist Commentary* commissioned Mark Abrams to discover what image of Labour was held by different groups of voters. Abrams's findings (published in the summer of 1960) suggested significant discrepancies between the class identification of Labour and non-Labour voters. Half of all non-Labour working-class voters described themselves as middle class, while all groups tended to see Labour as 'identified with the working class – especially the poor and the labouring working class'. The image of the Labour Party, concluded Abrams, was 'one which is increasingly obsolete in terms of contemporary Britain'.[4]

In a commentary on the survey Rita Hinden, the journal's editor, followed Abrams's lead: 'Labour may "stand for the working class" but not for the increasing number who feel rightly or wrongly they have outgrown that label'.[5] In arguing for a change in the party's image she went on to conjure up, in a classic form, the image of an affluent working class, in

the throes of embourgeoisement, shedding the social and political characteristics of pre-1939 Britain:

> One has only to cast the imagination back to those days to appreciate the extent to which things have changed. ... Large groups of manual workers have higher earnings than white-collar workers or than sections of the middle class. They are cushioned by the provisions of the welfare state; their children have educational opportunities beyond the dreams of their parents. They now have opportunities for leisure, for the enjoyment of most of the good things of life. ... But this is not all. The manual workers have not only vastly improved their position as manual workers, they have also *changed* their position; some are no longer manual workers at all. As a result of technological changes some blue-collar workers have become white-collar workers ... more cross over the line each day. There is an increasing fluidity in our society. ... The day is gone when workers must regard their station in life as fixed – for themselves and for their children.[6]

Labour's persistent and accelerating electoral decline was then attributable to the emergence of a new social group, secure, prosperous and satisfied: a group who, increasingly, saw themselves neither as working class nor in need of traditional Labour politics.

Electoral Politics 1945–59

In 1960 the plausibility of this thesis depended substantially on comparisons with Labour's extremely successful electoral performance in the immediate post-war period. The 1945 election had provided Labour with its biggest ever Parliamentary majority (either before or since). Labour received nearly 12 million votes, 47.8 per cent of the poll and 393 seats, against the Conservative totals of just under 10 million votes and 213 seats. Even in the context of this overwhelming success the election results of 1950 and 1951 seemed to show not so much a decline in Labour support as an effective regrouping of Conservatism. In 1945 only 72.7 per cent of the

electorate had voted; in contrast the 1950 and 1951 elections remain the only occasions in post-war politics when the turn-out has been above 80 per cent. In 1950, on an 84 per cent poll, Labour increased their total vote to 13.3 million; this represented however a drop to 46.1 per cent of the popular vote and secured a total of 315 seats. The overall Labour majority was then only five and the lead over the Conservatives 17 seats. The Conservatives increased their number of votes by 25 per cent to 12.5 million and their share of the vote to 43.5 per cent.

In both 1945 and 1950 the Liberal Party had maintained a 9 per cent share of the vote. This collapsed in 1951 to 2.5 per cent predominantly because whereas in 1950 they fielded 475 candidates, in 1951 there were only 109. Of the 1.9 million Liberal votes lost between 1950 and 1951 direct statistical inference suggests that the Conservatives gained 1.2 million and Labour only 600,000. Despite this Labour retained its lead in the popular vote with just under 14 million votes – the highest number of votes ever recorded for a single party in British electoral politics. The 48.8 per cent of the poll also constituted the highest proportion of the popular vote which Labour has ever achieved. The Conservative total of 13.7 million votes, however, allowed them to secure 321 seats against Labour's 295. This discrepancy between votes and seats was due partly to the four unopposed Unionist seats in Ulster but mainly to the disproportionately huge Labour majorities in the older industrial areas. Given these figures it is not surprising that the Labour Party did not regard the 1951 defeat as, in any sense, reflecting a loss of contact with their traditional areas of support.

The contrast of this defeat with that of 1955 is striking. Apathy was the keynote of the 1955 election. The total number of votes was 26.8 million (76.8 per cent of the electorate) as against 28.6 million (82.5 per cent) in 1951. This drop took place in spite of a number of factors suggesting the vote should have increased. The registered electorate had increased by 200,000, there were 33 more candidates, 5 more constituencies and no unopposed seats. It has also been estimated that the differing dates of the electoral register may have led to a 2 per cent underestimation of the decline in

turnout. Altogether the true percentage drop may have been nearly 10 per cent. The Conservatives were thus able to increase their share of the vote to 49.7 per cent despite losing over 400,000 votes. Labour, however, lost 1.5 million votes. Detailed analysis of the voting in one constituency (Bristol NE) suggested that 'Labour apathy among older electors, sometimes carried to the point of abstention, may well have been the crucial factor in the national Conservative victory'.[7]

This combination of general political apathy with specific Labour losses provided a much more serious set of problems for Labour than the 1951 defeat had done. The party set about refurbishing itself to cope with this new political situation and approached the 1959 election with some confidence. However, the results seemed merely to confirm further the evidence of 1955. The election in 1959 saw the fourth successive rise in the number of Conservative seats (to 365, a lead over Labour of 107), while Labour's overall vote dropped by a further 200,000 and its proportion of the poll to 43.8 per cent. It is hardly surprising that the defeat was seen by many (both inside and outside the party) as indicating the demise of Labour as a party of potential government and as requiring a major examination of its bases of support.

Political Rhetoric and Party Image 1950–59

Labour, in the mid and late 1950s, was not only losing elections, it had also lost the initiative in the political construction of social imagery – particularly with respect to the key image of the general character of contemporary British society. The nature and significance of this loss become apparent if a comparison is made between the first two elections of the 1950s and those of 1955 and 1959.

In 1950 the central plank of the Labour campaign was the comparison between their domestic record of 1945–50 and the 'bad old days' of the 1930s. In 1945, and even more in 1950, Labour was able to enlist history effectively on its side. Such enlistment is typically a two-stage manoeuvre. First it is necessary to be able to point to (or create) an accepted historical view of a specific period. The view of the 1930s as the time of the depression, dole and Jarrow constituted such

a view through the first two post-war decades. It was never seriously contested by the Conservatives (and indeed in the late 1950s they were able to use it themselves to present Labour as outdated).

The second stage involves linking anecdotal history to a particular pattern of causation – in this case a presentation of the 1930s experience as the inevitable consequence of Conservative rule. In the *New Statesman* Harold Laski commented ironically on 'the Tory pledge of a basic wage for everyone; most workers, remembering the thirties pretty vividly, suggest that Mr Butler and his committee probably have 16/– in mind'.[8] Laski's comment was unusually detailed, but indicated, in the attributed memory (of the basic 'dole' money), the importance of tying the political message to an already known social experience.

The contrast between 'then' and 'now' was overwhelmingly the keynote of the Labour campaign. Four out of their five radio election broadcasts made explicit comparisons with the 1930s. On the day before the poll the *Daily Herald* published a front-page picture of cloth-capped Stepney unemployed with the caption 'Life in the Tory Thirties'. The Jarrow marchers, who in photographic form 'must have tramped through several hundred thousand copies of Labour addresses' were also a key symbol for Labour. One national Labour election poster showed marchers with a banner reading 'Jarrow Crusade' and had a caption 'Unemployment – don't give the Tories another chance'.[9]

The Conservative reaction to this 'myth' was twofold. They either denied responsibility or stressed that the party had changed since the 1930s. They did not, and could not, contest the myth directly. The *Spectator* recommended that they should 'make it abundantly clear that as a party they have learned much from the years of travail, and that the Tories of 1950 are not the Tories of 1935'.[10] Both main parties in 1950 shared a view of history which focused on the move from mass unemployment and poverty in the 1930s to full employment and social security in the late 1940s. The key domestic political question then underlying both the 1950 and 1951 elections was how to move from a position of security to one of prosperity.

The 1951 election campaign was dominated by questions of peace, war and rearmament: issues raised particularly by British involvement in the Korean War. In the area of domestic issues, however, the rhetoric and historical view were the same as in 1950. It was, then, Labour's continuing emphasis on the inevitable (disastrous) results of any Conservative administration, together with their majority in the popular vote, which led to their extraordinarily passive attitude to the Conservative victory. This was typified by a post-election article in the *New Statesman* in November 1951 which noted that 'for years the Tory party have been trying to persuade the people of Britain that they can both keep their cake and eat it – that greater benefits, more houses, lower prices, full employment and rearmament are all possible simultaneously.' The logic of this metaphor implied inevitable failure. There was, therefore, no need for Labour action since 'the obvious tactic for the Labour party is to wait upon events and to let them show the gap between Tory policy and practice. ... The Opposition should give the Government time to condemn itself out of its own mouth.' Labour supporters, would be able 'to have a quiet bit of fun' at the expense of those Tories who 'expect the butchers' shops to be filled with succulent steaks at prices they can afford'.[11] Labour's major problem in the construction of a plausible rhetoric for the 1955 election was, however, to be precisely an inability to deny that the 'steaks' had in fact arrived in the 'shops'.

Between 1951 and 1955 a decisive change occurred in the terms of British political rhetoric. By 1955 the Depression had lost its viability as an electoral weapon partly because the Conservatives had disproved one central element of the 'myth' (they did not *inevitably* cause mass unemployment) and, more positively, because of the apparent arrival of a new era of British history, which was already being defined and named. David Butler,[12] noting the sense of national well-being which helped the Conservatives in 1955, refers to a number of non-political events which restored British confidence: the four-minute mile, the regaining of the Ashes, the ascent of Everest and, above all, the Coronation.

All these events took place in 1953. During 1952 it seemed as if Labour's predictions of disaster were proving correct.

Unemployment rose, the Korean War continued and the Budget included cuts in food subsidies and increased health charges. However, by the end of 1953 unemployment was back to its level under Labour, income tax was cut and the 1950s consumer boom began to gather momentum (with notable increases in the sales of cars and televisions). The government achieved its housing target and in May the Conservatives won the first by-election seat to be gained by a government since 1924.

The Coronation then took place at a moment (June 1953) of economic and political self-confidence. Further, both the general philosophy of constitutional monarchy and its particular elaboration in 1953 were fully consistent with the Conservative philosophy of national unity on the basis of continuity, tradition and renewal. Contemporary public expositions of the Coronation presented the new reign as simultaneously a renewal of British tradition and stability and, also, the beginning of a new era. The phrase 'the new Elizabethan age' clearly embodied this unity of old and new. The *Economist* typically commented:

> For forty years, the British people, more than almost any other in the world, have lived in constant crisis and under constant strain. ... But nothing vital has been lost and if for a generation they could be granted a surcease of alarm, there could be a great resurgence of spirit from a people still basically at one, still rich, still proud and still free.[13]

The 1950s were now not merely the post-war rewards of peace and prosperity, but potentially the epochal moment of British revival and return to her true course (a course apparently lost since 1914). In the *Observer*'s Coronation supplement William Clark argued that success in the Second World War had been based on our spirit of national unity, which the welfare state further strengthened:

> Though the legislation was carried through by a Socialist Government, credit for its social acceptance belongs to the Conservatives. The process has strengthened our institutions, and the country is today a more united and stabler

society than it has been since the 'Industrial Revolution' began.[14]

The account concluded with the obligatory reference to the value of 'old Elizabethan qualities' in the 'new world'. Clark's comments on the Conservative acceptance of the welfare state prefigure their election profile of 1955 and also suggest how the Coronation was taken to represent a sense of 'We have come through' – the final emergence from conflicts, depression, war and deprivation to a new world in which *traditional* British virtues can operate. Both the particular moment of the Coronation (the first stirrings of 'affluence') and its implicit message (unity through hierarchy) were supportive of the Conservative 1955 election theme – a prosperous, conflict-free Britain.

David Butler has described the 1955 election campaign as 'unprecedently quiet'.[15] In the *Daily Express* 'William Hickey' asserted 'this is an essentially satisfied country. The basic problems of sharing wealth in an industrial community have been solved.'[16] The Conservatives had avoided war, maintained full employment and the welfare state, raised pensions and reduced income tax. Their manifesto, which contained (according to *The Times*) 'a maximum of rhetoric and a minimum of programme', invited the voters to ask: 'Which were better for themselves, for their families and for their country? The years of Socialism or the years of Conservatism that have followed?'[17] The comparison was now not between 1930s deprivation and 1940s sufficiency; it was rather 1940s austerity against 1950s affluence. Employment and welfare were still dominant national goals, but the Conservative record had successfully countered Labour's reliance on them as party issues. The historical perspective – the agenda of domestic issues in effect – was now being determined by the Conservatives. Where in 1950 and 1951 the Conservatives could be presented as the party of unemployment, now Labour became the party of rationing. The Conservatives took full credit for ending rationing of tea, sugar, sweets, butter, meat, bacon and cheese between 1952–4. By contrast Labour was presented as a party which could not govern without rationing; a Conservative poster had the caption:

'queues, controls, rationing' – 'Don't risk it again'.[18] With Labour identified as an outdated party of restriction, the Conservatives were the party of prosperity. Summing up the state of Britain in 1955 the *Daily Express* prefigured the expansive confidence of the Macmillan era of 1957–9: 'The British people never had it so good. Shops are fuller than ever ... higher pay packets, lower taxes, full shops and nice new homes.'[19] while in Bristol NE the Conservative candidate's address boasted that 'You do not queue for food and sweets. You can see more television aerials and cars – signs of prosperity.'[20]

Labour had no alternative social description to offer. They were forced to deny a reintroduction of rationing, to attribute the rising standard of living to 'world prices' and to rely on claiming credit for having initiated the post-war full employment policy. With the loss of the 'return to the Thirties' as a credible argument, Labour was forced to offer itself simply as an alternative economic management team. Labour seemed to accept that defeat was due directly to the widespread prosperity. Gaitskell (about to succeed as party leader) summed up the causes, 'the lack of fear of the Tories, derived from the maintenance of full employment, the end of rationing and the general feeling that "things were better" '.[21]

Conservative preparations for the 1959 election began early. After the fiasco of Suez and Eden's resignation in January 1957 the party sought to rebuild its image almost solely in terms of rising domestic prosperity. Between June 1957 and September 1959 they spent an estimated £468,000 on press and poster advertising – the general themes of which were announced by Macmillan in two speeches in July 1957. At Bedford on 20 July he stated that 'most of our people have never had it so good. Go round the country, go to the industrial towns, go to the farms and you will see a state of prosperity such as we have never had in my lifetime.'[22] The same points were made in a Parliamentary debate on 25 July when he referred to a *Daily Herald* advertisement (placed in *The Times*) which sought to attract potential advertisers by showing a family with a car, implying that their readers were becoming more prosperous, with surplus money (or credit) at their disposal. Conservative Party advertisements used similar

images. One poster showed a cloth-capped worker with a plump, prosperous-looking face. The text read:

Six Conservative years have brought big improvements all round. Life's better in every way than it was. He and his wife are both clear about that. So many more things to buy in the shops. More money to buy them with too. The kids are coming along well at school. In fact in his view a pretty encouraging outlook for all of them. Well what's so special about that? Aren't there millions these days who are just as well fixed. You bet there are.[23]

The political message could now be incorporated fully within the description of contemporary social experience; there was no need for explicit comparison with Labour's record, the simple 'more' and 'better' were sufficient. This centring of the message on the individual family was as much at the heart of the new Conservative ideology as the photographs of a collective march of the working class (Jarrow) or of an underprivileged group (pensioners) were of Labour imagery.

The extent of the 1957–9 advertising campaign was such that Butler has noted[24] that it was the first election in which the opening of the official campaign period (during which expenditure was restricted) brought a sharp reduction in political advertising. In the summer of 1959 a series of posters proclaimed 'Life's Better with the Conservatives. Don't Let Labour Ruin It'. Two of these showed 'typical' families: one washing a car, the other eating an abundant meal with a television set strategically placed in full view. Not surprisingly the Conservative manifesto repeated the message, referring to 'the good things of life' which families were now enjoying and noting the significant growth in the ownership of televisions and cars.

As in 1955 Labour hardly contested the central message of prosperity (they concentrated on the poverty of peripheral groups, pensioners especially). Angus Wilson, writing in the *Spectator* indicated the problem which Labour faced in constructing a response to the consumer boom:

The difficulty is that to attack such complacent 'room at

the top'-ism suggests that the critic is for some reason against a materially prosperous society. The Labour Party has only just thrown off its nostalgic attachment to the depression years and I have certainly no wish to see it return to such living in the past. In any case, to everyone a car seems to me excellent ... and as one who has for twenty years done his own cooking and housework, to everyone, indeed all washing machines and refrigerators.[25]

Labour's task in 1959 was to find a way of distinguishing between these highly tangible signs of material prosperity and the general Conservative record. Neither electorally nor rhetorically did they succeed.

This New England

The plausibility and success of Conservative social imagery in the late 1950s necessarily depended on its ability to connect with both the individual experiences of sufficient numbers of voters and with generally circulating forms of social description (as at the time of the Coronation, for example). In particular behind and supporting the dominant Conservative image of the satisfied affluent worker and his family lay a considerable weight of detailed social description suggesting the progressive disappearance of the working class.

As Raymond Williams pointed out in *The Long Revolution* in 1961 the thesis that workers were simultaneously becoming more prosperous and less class-conscious was hardly new. However, the immediate forms that the proposition took in the mid 1950s can be traced to the end of the 1930s and the early years of the Second World War, as the worst effects of the Depression began to be alleviated and the social patterns developing in the more prosperous areas of Britain came to be taken as portents of the future. In his essay 'England Your England' (February 1941) George Orwell sketched the likely direction for future social change. It hinged on the recent and continuing 'upward and downward extension of the middle class'. This took two forms: the relative increase in the numbers of middle-class jobs in industry and the professions, and also ('much more important') 'the spread of middle-class ideas

and habits among the working class'. Orwell related this both to advances in collective social provision (including transport, health and education) and the emergence of common forms of consumption in clothing, housing and, particularly, cultural products: 'the rich and the poor read the same books, and they also see the same films and listen to the same radio programmes'. The contrast was then between the 'old style "proletarian", collarless, unshaven and with muscles warped by heavy labour', decreasing in number although still predominating in 'the heavy-industry areas of the north of England' and a new group of 'people of indeterminate social class'. According to Orwell 'the place to look for the germs of the future England is in light-industry areas and along the arterial roads. In Slough, Dagenham, Barnet, Letchworth, Hayes.' The sense of new physical environments (whether 'labour-saving flats or council houses') was central to this image of a new 'rather restless, cultureless life, centring round tinned food, *Picture Post*, the radio and the internal combustion engine'.[26] Here in embryo lay already all the elements of Conservative social imagery of the late 1950s.

In the late 1940s, such imagery lay dormant. The scale of the Labour victory in 1945 had rendered speculation about the disappearance of working-class consciousness politically irrelevant, while the economics and culture of austerity (centring, above all, on rationing of essentials) seemed to threaten the proletarianisation of the middle class rather than the reverse. Certainly within Labour social analysis, it was not until after the 1955 defeat that the party began to wonder about the possible loss of its grass-roots support. In the early 1950s the problem seemed rather how to cope with too much success. In *New Fabian Essays* (published in 1952, but written before the 1951 defeat) a group of young Labour MPs, reviewing their post-war achievement, were both self-congratu-latory and perplexed. They were quite clear that major social changes had taken place. Antony Crosland argued that the post-1945 period demonstrated that 'capitalism is undergoing a metamorphosis into a quite different system, and ... this is rendering academic most of the traditional socialist analysis'.[27] Richard Crossman felt that 'after scarcely four years in office, the Government had fulfilled its historic mission'.[28] The

achievement of its programmes regarding nationalisation, social security, the health service and economic planning 'seemed to have exhausted the content of British socialism'. The subsequent acceptance by the Conservatives of the great majority of these changes then deprived Labour of a clear line of opposition and an electoral programme.

Generally *New Fabian Essays* perceived structural social change occurring not at the level of embourgeoisement so much as that of the benevolent managerial revolution. In the mixed economy and with larger scale capitalist organisations, control, argued Crosland, was moving from property owners to the 'new class of (largely) non-owning managers'.[29] Austen Albu suggested that 'the habits, experiences and behaviour of these salaried officials are in a different world from those of the small masters of true private enterprise and much nearer those of some branches of the Civil Service and of public industry.'[30] This behaviour was defined in terms of team-work, and co-operation as against 'the crude self-interest of classic entrepreneurs'.[31]

It was not until after 1955 that the implications of the necessary other dimension of these supposed structural changes came to be fully realised within Labour debates, particularly through Crosland's major 'revisionist' book, *The Future of Socialism* (1956). Crosland's work, while presenting itself as a detailed and empirical study of post-war British society, took many of its arguments from Evan Durbin's *The Politics of Democratic Socialism* (1940), an attempt to construct a social democratic way forward for Labour from the experience of the late 1930s. Durbin had argued that the period of *laissez faire* capitalism was drawing to a close to be replaced by a society in which public expenditure, social planning, progressive taxation and new class formations were the determining features. Much of this was restated in *New Fabian Essays*, but not Durbin's potentially pessimistic observations on class composition. He argued that the increase in 'shopkeepers, government officials, clerks, the employed professional class, school-teachers and typists ... the black-coated workers and the suburban householder' meant that 'we are living in a society whose class composition is shifting steadily against Marx's proletariat'. Durbin suggested that these 'intermediate

classes' should be considered as 'predominantly "conservative" in the political sense'.[32]

Additionally Durbin, like Orwell, felt that there was an *embourgeoisement* (to coin a horrible word) of the proletariat':

> The proletariat has acquired many of the characteristics that were regarded, fifty years ago, as typical of the petty bourgeoisie. It has acquired elementary education, and it – or a considerable fraction of it – has acquired a small reserve of property. A statistical study of the circulation of newspapers, of the attendance at cinemas, and of the numbers taking regular holidays, would all reveal, I suspect, the acquisition of other and not unimportant habits that were once regarded as typically and exclusively middle-class.[33]

By 1956 Crosland was arguing that the social democratic programme outlined in Durbin's book had been achieved: full employment, the disappearance of poverty and 'classical capitalism' and the taming of the Tories. The two major problems for Labour which remained were what further goals to pursue and, in the wake of 1955, how to respond to the loss of electoral support. Crosland here followed Durbin closely, arguing that Labour 'would be ill-advised to continue making a largely proletarian class appeal when a majority of the population is gradually attaining a middle-class standard of life, and distinct symptoms of a middle-class psychology.'[34] Like Durbin, Crosland saw patterns of consumption as decisive indicators, although detailed comparison between the two accounts indicates some of the problems inherent in this kind of analysis. Crosland identified the key items as television sets, cars and annual holidays, defining these as 'middle-class luxuries, i.e. genuine prestige-symbols of high consumption'. He also noted rises in expenditure on drink, tobacco, gambling, cinema-going and newspapers but stated that these were not significant since 'they are either not accepted as significant symbols of high consumption, or else they are traditional *working-class* luxuries'.[35] For Durbin, however, it had precisely been cinema attendance and purchase of newspapers which provided evidence of 'embourgeoisement'. It was not until the

late 1940s that both became seen as characteristic 'proletarian' habits (as exemplified particularly by massive expansion of sales of the *Daily Mirror*). This then ruled them out of court for Crosland's purposes. By contrast the television and the car (as the Conservative advertising of 1957–9 was to show) were at precisely the right stage of dispersal through the society for an 'embourgeoisement' thesis to be made plausible by their use as reference points.

1956 was the key year for the consolidation of this image of an affluent Britain undergoing embourgeoisement. In June 1956 *Encounter* published three articles which, under the collective heading of 'This New England', offered themselves as a comprehensive description of the social and political changes which had overtaken England since the 1930s. T. R. Fyvel's 'The Stones of Harlow: Reflections on Subtopia' was immediately recognisable as sketching an up-dated version of Orwell's 'future England' of 1941. The centre of attention was the post-war suburban council estate, often situated in new towns (such as Harlow) or near new industries. According to Fyvel it was in the 2 million new Local Authority dwellings, mostly on housing estates ('standardised and endless small, semi-detached houses with gardens') that the new social trends of 'mass participation' (in car and television ownership and the reading of the mass circulation press) could best be seen. In summary Fyvel moved to notions of class-identification:

A generation ago, the English suburban house – and garden – still belonged to a middle-class way of life beyond the reach of the mass of the workers. Today the whole nation feels entitled to this privilege: hence you have the sprawling suburban housing estates.[36]

A second article, 'The Passing of the Tribunes' by Charles Curran (a Conservative candidate in the 1955 election) assessed the political implications of these changes. There were now no political grievances left. Only one question existed in British domestic politics, 'How can we have full employment without inflation?' The 'fall in the political temperature of the 1950s' was also due to the boom in television ('the most significant social event of the decade')

which was affecting cinema attendance and consumption in pubs and was intrinsically a-political since it offered 'a private universe of fantasy ... a Welfare State equivalent of the medieval monastery'.[37] Curran had in fact already presented a more detailed version of this thesis in two articles in the *Spectator* in January and February of 1956. Here the defining phrase had been 'The New Estate' – a phrase which completely identified the new housing estates with a new social and political 'estate' or class. Since 1931, Curran argued, there had arisen:

> a new class composed of the manual workers who are the principal beneficiaries of the resettlement. They have been lifted out of poverty and also out of their old surroundings. Now they form the bulk of the inhabitants on the municipal housing estates that encircle London and every other urban centre. They are the New Estate of the realm.[38]

The article went on to provide a familiar picture of this new way of life based around hire-purchase, mass-produced household items, football pools, popular journalism and, increasingly, television. Curran argued further that the New Estate electorate was the key to the Tory success of 1955. This would, however, now need further consolidation since 'the New Estate is a classless zone, neither proletarian nor bourgeois. It has turned its back on the first but does not wish to assimilate to the second.'[39] The consolidation should be achieved in two ways: an expansion of the property-owning impulse to houseownership (rather than council housing) and a campaign to supply the New Estate with a (Tory) 'ideal image of itself'. Subsequently (as already indicated) emphases on both homeownership and the 'affluent worker' life-style became key elements within Conservative social imagery.

There were only two discordant notes in the whole 'New Estate' picture. Firstly, there was the problem of cultural quality. The general editorial in *Encounter* which prefaced the 'This New England' section complained that 'the price paid for diffused facilities is sacrifice of quality' in environment, education and general social values. The writers of the articles tended to be more agnostic on this question, regarding the

gains, whether social (Fyvel) or political (Curran) as at least balancing the cultural problems. Secondly there was the problem of how to place those working-class areas of England which did not fit the 'New Estate' model. In very broad terms this could be viewed as a North v. South issue. When Orwell had sketched his social geographical map in 1941 he had deliberately shifted attention away from the traditional heavy industry areas of Britain to the South East and South and West Midlands as providing the defining image for the 'condition of England'. Such a shift did not deny the continuing existence of older forms of working-class community and culture, but saw them as of decreasing importance. By the mid 1950s, however, with the arrival of the welfare state, full employment and the spread of consumer durables, much more substantial claims were being made about transformations within the older working-class communities. The opening article in the *Encounter* feature, 'Return to Wigan Pier' by Wayland Young, began with such a claim: 'Since George Orwell published *The Road to Wigan Pier* in 1936, Wigan has changed from barefoot malnutrition to nylon and television, from hollow idleness to flush contentment.'[40] In the market-place commerce ('brisk buying and selling') had replaced politics ('angry speakers' and 'hungry listeners'). A former mayor felt that 'the working classes have come a long way. . . . There's not far to go now.' The article's clear implication was that if this change had happened in Wigan (which, with Jarrow and Salford, was one of the accepted reference points for 1930s poverty and unemployment) then it was universal – 'life there was as bad as anywhere, and now is as good anywhere. Wigan is at the centre of the Labour tradition which emerged into unhampered control of the country from 1945 to 1950: what Wigan wanted to be, Wigan has become (with a bit of a lag on the housing).'

Housing and the physical environment generally, in fact, formed one of the two major obstacles towards the alignment of this image of affluence in Wigan with the general 'New Estate' model (the other was that Wigan was still solidly Labour territory). There was, even in Young's descriptions, considerable dissonance within the images of affluence: 'the stubby plantation of smoking chimneys along the slum roofs

is now diversified by those spindly exotics, TV aerials'. In Young's view 'the housing is the worst thing now'. The problem was that affluence in Wigan was a grafting of a series of new elements on to a recognisably older substructure (specifically terraced housing and heavy industrial landscape). There was then visibly an open question as to the social and cultural relations between the new and the old. The question remained an awkward one for affluence rhetoric right through the late 1950s. In October 1959 Barbara Castle wrote that 'Mr Macmillan has boasted that the TV set is the badge of prosperity. In the back streets of Blackburn the TV aerials are there all right; what we lack are thousands of decent houses to put under them.'[41] These remarks related primarily to the requirements of the Labour strategy (much more still needed to be done to create an equal and just society) and the 1959 election results did respond to this message to a degree, for while the national swing was to the Conservatives, in some of the older industrial areas (including Lancashire and Scotland) there was a small swing to Labour. Regional unemployment here had risen quite sharply in the year preceding the election. The contrast drawn in Barbara Castle's remarks between the television aerials and the housing beneath thus suggested the limitations of affluence imagery as a guide to fundamental social transformations.

Nevertheless (accompanied by these unresolved questions) the image of 'This New England' as constructed in *Encounter* in 1956 was sustained through the rest of the decade and, in many of its features, right through to the 1964 election. Within the general image the relative weight of different elements changed. While television remained central, other consumer durables came to occupy a more prominent place as their ownership spread. This was particularly focused by Mark Abrams's radio talk 'The Home-Centred Society'[42] in November 1959 (the timing ensuring that its arguments could be taken to explain the Conservative victory). Abrams argued that there had been, since the late 1940s, a growing equalisation of working-class and middle-class life-styles in patterns of spending, housing and eating habits. In particular 'we find manual workers ready to describe themselves as middle-class because they already own or soon will own a car, a house

with a garden, a refrigerator, a washing machine, a vacuum cleaner, and of course a television set'. 'Home-centredness' for Abrams involved a higher profile for women (or rather 'housewives') as consumers as well as a 'domestication' of the husband (even the car was frequently treated as a 'detachable extra room'). The husband was losing his ties with outside groupings (whether political or leisure-based) and the work-place was becoming less important since 'the working-class home has at last become more attractive than most factories'. This analysis endorsed the decision to base the Conservative election strategy on the family and home as the key images. According to the *Economist* in May 1959:

> The modern Conservative should be one who looks up at the television aerials sprouting above the working-class homes of England, who looks down on the housewives' tight slacks on the back of the motor-bicycle and family side-cars on the summer road to Brighton, and who sees a great poetry in them. For this is what the deproletarianisation of British society means.[43]

During the early 1960s the Conservatives experienced increas-ing strain in their ability to continue presenting themselves as the party of modern Britain. This was particularly evident in the succession of the massively anachronistic figure of Lord Home to the party leadership in 1963; the contrast to the new Labour leader – Harold Wilson, the epitome of the classless meritocrat – was striking. The period 1961–4 has been described as one in which a Labour social-democratic variant of the Conservative consensus ideology became increasingly prominent.[44] After Wilson's succession to the party leadership in February 1963 Mark Abrams was recruited to help formu-late the strategy for a new Labour publicity campaign – emphasising youth, dynamism and progress. This provided the keynote for the Labour election campaign in 1964 with a particular stress on the need for modernisation and reliance on technology. When the *Sun* launched itself in September 1964 (then as the middle-market successor to the *Daily Herald*) it recognisably reproduced in its first edition all the elements of the 1950s affluence imagery now attached to the new Labour

rhetoric of modernisation. The *Sun* promised to campaign for 'rapid modernisation', to be radical and a paper for those with 'a zest for living'. It offered its own view of the state of British society:

> Look how life has changed. Our children are better educated. The mental horizon of their parents has widened through travel, higher living standards and T.V.
>
> Five million Britains now holiday abroad every year. Half our population is under 35 years of age. Steaks, cars, houses, refrigerators, washing-machines are no longer the prerogative of the 'uppercrust', but the right of all. People believe, and the *Sun* believes with them, that the division of Britain into social classes is happily out of date.[45]

Social Change in Britain 1945–64

The view that social class was 'out of date' rested on the assumption that major changes had taken place in a number of areas of working-class life, particularly employment, education, housing and domestic consumption. In each area an examination of the evidence suggests that important developments had occurred, although not necessarily in ways that provided support for the embourgeoisement case.

Within employment changes had occurred since the 1930s in three main areas – unemployment, the size of occupational groupings and wage-rates. The transition from persistently high levels of unemployment to virtual full employment in the 1940s (and its maintenance under Conservative governments in the 1950s) was indisputable. In 1932 unemployment stood at 22 per cent (2.7 million) and even by 1939, when rearmament was underway, remained at 11.6 per cent. Between 1951 and 1959 it rarely went above 2 per cent, reaching a post-war peak of 620,000 in February 1959, which rapidly fell again to 413,000 by June. The return in the late 1970s and the 80s to increasingly high levels of unemployment comparable to those of the 1930s has clearly invalidated the Labour revisionist assumption of a once-for-all structural change in the nature of capitalism, but has equally demonstrated why a period of

apparently stable full employment should have been heralded
with such a degree of self-satisfaction.

There had also been (between 1931 and 1961) significant
shifts in the composition of the labour force. White-collar
workers had increased from 23 per cent of the work force (4.8
million) to 36 per cent (8.5 million) while the numbers of
manual workers had reduced both proportionately (from 70
per cent to 59 per cent) and absolutely (14.7 million to 14
million). Further, within the category of manual work there
had been a shift towards skilled occupations. Unskilled manual
workers reduced from 15 per cent (3.1 million) to 9 per cent
(2 million) in the period.

Finally there had been clear increases in real wages.
Compared with a base of 100 in 1930, manual wage rates had
risen to 331.5 by 1960, and actual earnings (including overtime
and bonuses) to 502.2; in the same period the cost of living
had risen to 268.8. So even where manual workers had not
been transmuted into white-collar workers, their earnings were
sufficient to enable them to purchase goods of a comparable or
superior kind. Taken together all these three areas of change
suggested the replacement of the classic 1930s proletarian,
intermittently employed in heavy manual labour on poverty-
line wages, with a skilled operative with plentiful overtime
and considerable excess income.[46]

However, much had not altered and other, different changes
had also taken place. While full employment *was* maintained,
the 'local difficulty' of the early months of 1959 (caused mainly
by a slump in the Lancashire cotton industry) indicated that
unemployment or short-time working at points of slump were
the obverse of high overtime at moments of expansion. Many
manual jobs, particularly in manufacturing industry, were in
the long term much less secure than most white-collar jobs.
The shift to white-collar occupations itself also needed
interpretation; many jobs in this sector were occupied by
women at correspondingly lower rates of pay.

The growth in white-collar work (particularly at the lower
end of the scale) had also been accompanied by a relative loss
of position in wage-rates. Earnings of clerks which in the
1930s were comparable with those of skilled manual workers
were only 85 per cent of them in 1960. More strikingly the

earnings of the 'lower professions' (a group including teachers, vets, librarians, draughtsmen, lab. assistants) had now virtually fallen to the level of skilled manual workers. Westergard and Resler have argued that what occurred was not so much embourgeoisement but rather 'a "proletarianization" of large sections of the petty bourgeoisie. The position of low-grade office and sales employees as workers who live by the sale of their labour power has been accentuated – whether or not they themselves recognize this – by the loss of the wage advantage from which they previously benefited.'[47]

The comment of reservation ('whether or not they recognize this') is, however, a crucial concession to the embourgeoisement case – since stability or decline in *relative* wage rates can be experientially overridden in periods of absolute increase. This applies equally to wage rates and the overall distribution of wealth. In both cases the relative situation at the end of the 1950s was not substantially different from that at the beginning of the 1930s. Apparently higher manual wages were frequently due to longer hours of work (including overtime) and took little account of higher professional and administrative fringe benefits (employers' welfare schemes, company cars) as well as the fundamental differences in terms of security of income between hourly-paid wage employment and salaried work and, just as important, between jobs paid at a flat rate regardless of age and experience and those on an incremental scale. Whatever the immediate and very tangible improvements of the 1950s the basic structural conditions of wage-labour were still in operation.

Educational change figured in two ways in the deproletarianisation thesis. There was a presumed general improvement at all levels and a supposed equality of opportunity in access to educational qualifications and higher education. Educational achievement was to be the route to social position – the creation of meritocracy, a system of social stratification and differential rewards based on ability not heredity.

A reformed educational system was a cornerstone of the idea of the welfare state. The 1944 Act, as implemented by the Labour government, established 'secondary education for all', the abolition of all tuition fees at state-maintained schools, the raising of the school-leaving age to 15 (in 1947) and the

tripartite system of secondary schools (grammar, modern and technical), this becoming by the 1950s effectively bipartite (grammar via the 11-plus, or secondary modern). By the end of the 1950s state education clearly had a higher standard of material provision than before 1939: a rise in real expenditure; reduction in class sizes; and a much higher proportion of 15–18 year-olds still in education (20 per cent in 1961 as against only 6 per cent in 1931).[48]

Such improvement was frequently cited as evidence of the general well-being, both material and spiritual, of the whole population. More particularly as regards the idea of changes in class composition it suggested the achievement of equality of opportunity. In July 1956 Charles Curran argued that 'Britain, in fact, is now very close to the point where it will be true to say that there is a general correlation between social status and mental ability'.[49] Such a view had, however, little supporting evidence.

The first generation to be significantly affected by the post-war reforms was that born in the late 1930s. The massive class differences which continued to operate within the educational system were then reflected in the contrast in the mid 1950s between the 40 per cent of children from professional and managerial families still in formal education at 17 as against 3 per cent of children of semi-skilled manual workers. The differences operated even more firmly at university level. Here, in 1961–2, 18 per cent of the entrants came from independent schools (attended by only 6 per cent of the country's children – drawn up to 85 per cent from social class I and II), while only 25 per cent of undergraduates were drawn from families with the head in manual occupation, a proportion which was almost the same as in the interwar period, despite a virtual doubling of the overall student numbers from 50,000 in 1938–9 to 118,000 in 1962–3.[50] In fact the success of the post-war education system in reproducing existing class inequalities became clear very early to many sections of the Labour Party. The concerted drive for comprehensivisation from Labour in the 1960s was predominantly an attempt to revise the failures of the post-war education settlement. However, in the 1950s all too often the greater number of children from working-class homes achieving post-15 and university education diverted

attention from the static *relative* position as between working-class and middle-class access to the higher levels of education and the kinds of employment which developed from it.

At the heart of the 'New Estate' variant of the embourgeoisement thesis were changes in patterns of housing. This was not merely a matter of new houses but of their siting (the new estate usually on the outer fringes of the older cities), styles of building (Fyvel's 'standardised and endless, small semi-detached houses with gardens') and ownership.

Between 1945 and 1964 there were three distinct phases in government housing policy and achievements. Under Labour the major immediate post-war housing crisis was met by a short-term policy (repairs, conversions and 'prefabs') and a long-term strategy – council housing. By 1951 over 1.5 million units of council accommodation had been completed. During the same period privately built new houses totalled only about 150,000. Between 1945 and 1951 the proportion of households in council housing increased from 12 to 18 per cent. The second phase occurred during the first Conservative post-war administration. A key election promise of 1951 had been the completion of 300,000 houses per year; this was achieved in 1953 largely through council-house building (over 200,000 per year between 1952 and 1954), including the implementation of housing standards below those used through much of the late 1940s. A 1953 White Paper on Housing then pointed the way to the third phase, a switch to emphasis on private building and owner-occupation. By the late 1950s council housing was reduced to a residual role (rehousing slum dwellers) as Conservative rhetoric switched away from the number of houses built to the importance of owner-occupation by the individual family. Private sector completions increased from 25,000 in 1951 to 150,000 by 1964. Owner-occupation increased from 29 to 41 per cent during the same period. By contrast council housing completions had fallen to 100,000 by 1959, and the average floor size of each dwelling was only 85 per cent of that ten years earlier. By 1964 there were still almost 3 million people in Britain in slum accommodation, because they were unable to afford to buy and there was insufficient property available for private or public rental.[51]

Even where the 'New Estate' pattern of development had

occurred there was a lack of clarity about the proposition that this had automatically produced changes in class composition or self-image. The switch from council housing to private ownership in Conservative policy suggested that after all the important political dimension of housing was not the physical shape or location of the dwelling but the relationship (of ownership or tenancy) of the family to their house. Alternatively, if the argument held that 'working-class virtues are in some measure the product of physical propinquity' then it was possible to reverse the process of embourgeoisement by a conscious choice to build in a different way. In February 1962 Reyner Banham noted that many younger architects were now regarding 'the workers as possessors of a vital culture that must be nurtured by architectual and all other means'.[52] Banham reported on attempts being made to reproduce the structure of street communities through new kinds of building. One development in Preston included a terraced block of four-storey flats, three-storey maisonettes (with an inner play-court and a 'street-deck' at first-floor level) and a more traditional cluster of two-storey cottages. The small 'semi' was then not necessarily the long-term future pattern of working-class housing and arguments which premised class changes on this assumption were clearly questionable. Finally it began to be suggested that the social patterns discerned in the mid 1950s on the new estates were occurring because they *were new* (not because they were council houses or subtopian semis). When such communities developed over a longer period, it was argued, then more 'traditional' patterns of working-class life were likely to reassert themselves. Taken together all these qualifications to the simplicity of the 'New Estate' model suggested the need for a much more detailed look at what kind of life was actually being lived *inside* the new (and older) dwellings of post-war Britain.

Assumptions about what was going on inside the home focused largely on the growth of possession of consumer durables. This in turn was dependent on connection to the electricity supply. The major developments here had been in the 1930s; in 1920 only 730,000 households were connected. This had risen to 3.3 million by 1930, and nearly 9 million by 1938 (although this still left about one-third of dwellings

unconnected). By 1939 there were radios in 75 per cent of homes, but other consumer durables were less widely spread. Perhaps 60 per cent of homes had electric irons, but only 25 per cent had vacuum cleaners while washing-machines and refrigerators had hardly begun to penetrate even the middle-class market.[53] During the late 1940s and early 50s, while more homes were brought within the national grid, rationing, import controls and the financing of rearmament all retarded the expansion of the market for domestic electrical goods. In April 1951 purchase tax was raised to $66\frac{2}{3}$ per cent on refrigerators, washing-machines and vacuum-cleaners and was still standing at 60 per cent in April 1957. The reduction to 30 per cent in April 1958 and 25 per cent in April 1959 was, hardly by coincidence, synchronised with their full inclusion as representative elements in the imagery of affluence.[54]

Ownership of domestic appliances spread at quite variable rates. Over half the homes in Britain already had vacuum-cleaners by 1956; this had extended to 81 per cent by 1967. Washing-machines, by contrast, were owned by only 19 per cent of householders in 1956; this had increased to 61 per cent by 1967. Refrigerators in 1956 were a rarity, owned by only 7 per cent of householders; even by 1967 less than half of all households and just over a third of manual workers' families possessed one.[55] Differences between sectors and regions were also quite marked. In 1958–9 Ferdinand Zweig found that only 1 per cent of workers at the Workington Iron and Steel Company and 3 per cent at Dunlop in Birmingham owned a refrigerator as against 30 per cent at Vauxhall Motors in Luton and 26 per cent at a radio valve company in South London.[56]

Other supposed indicators of class spread more slowly over a much longer period. Telephones were in 1.5 million homes in 1951, but still only 4.2 million by 1966.[57] The relatively slow rate of dispersal meant that this particular home-centred appliance was not available for inclusion in the imagery of affluence. Cars, however, were central. In 1934, 1.3 million private cars or vans were licensed; this had only increased to just under 2 million by 1948. By 1958 the figure was 4.5 million and by 1964 over 8 million.[58] While car ownership

spread less quickly than that of many domestic consumer durables it was more important in the imagery of affluence precisely because of its unavoidable visibility. The car out the front (or, even better in the drive) together with the television aerial above symbolised the new way of life within. Television was, of course, the defining symbolic object of affluence. In 1951 there were still only 650,000 sets in Britain; by 1964 this had increased to 13 million – a rate of increase outstripping every other domestic appliance.[59]

By 1960 even the New Left (virtually the only political grouping attempting to challenge the basic tenets of the myth of affluence) had to admit that something had changed. Stuart Hall wrote:

> Even if working-class prosperity is a mixed affair, often vastly magnified by the advertising copy-writers, it is *there*: the fact has bitten deep into the experience of working people. The experience of the post-war years is no longer that of short-time and chronic unemployment. ... There has been an absolute rise in living standards for the majority of workers, fuller wage-packets, more overtime, a gradual filling out of the home with some of the domestic consumer goods which transform it from a place of absolute drudgery. For some, the important move out of the constricting environment of the working-class slum into the more open and convenient housing estate or even the new industrial town. . . . Above all, the sense of security – a little space at last to turn around in.[60]

Some things *had* changed but for there to be a judgement as to whether these changes were transformations at the level of social class two further kinds of investigation were necessary. There had, firstly, to be a clear sense of what kind of category social class was taken to be; generally it is possible to say that this clarification did not happen. It implied a style of systematic theoretical reflection inimical to virtually every political complexion of British political and social analysis in the 1950s. The second requirement was for empirically specific accounts of the life-conditions and experience of working-class people in Britain, not simply the *assumed* state of working-class, 'New

Estate' or affluent-worker life read off from either statistics (whether electoral, questionnaire or market research) or journalistic observations based on whatever was most manifestly visible. If weak on theory, British social analysts (both professional and amateur) were strong on commitment to the empirical. Well before the full articulation of affluence as a social image a considerable body of research into the condition of the post-war working class was already in process.

2. Social Science and Social Exploration

It has always been a major task of sociology to discover and analyse the condition of the working class. Indeed it has frequently been asserted that the origins of sociology in the nineteenth century lie precisely in the need to find ways of understanding and imposing order on a new urban industrial society stripped of its traditional bearings and attitudes. The history of British empirical sociology up to 1939 is largely a matter of surveys of urban working-class life with particular reference to the problems of poverty and unemployment. There is, however, no necessary reason why sociological texts dealing with the analysis of any social group should be concerned to offer direct evocations or experiential accounts of the everyday life or the physical environment involved. Such kinds of writing are, rather, frequently avoided on the grounds that they tend to preclude analysis, to be subjective or idiosyncratic, to fail to offer data for subsequent comparative analysis and to confuse the work of the social scientists with that of the reporter, documentarist or novelist.

During the late 1950s there was, however, a body of work which in defining itself as sociological analysis of working-class life did present its material, in part, in a descriptive, evocative and experiential form – as, in effect, a kind of realist writing. At one end of the spectrum this shaded off into more 'rigorous' quantitative and tabular modes of research and presentation, while at the other it gradually merged into documentary, personal reportage and semi-fictional narrative. To understand the appearance of these different kinds of work, it is necessary to consider some of the divergent and convergent strands in British sociology in the early 1950s.

Sociology, anthropology and community studies

British sociology in 1945 was hardly an established and accredited academic profession. Only the University of London had sociologists employed; through most of the 1950s the only professorial appointment was at the London School of Economics (LSE) and as the subject developed during the late 1940s and 50s it was frequently by means of infusions of personnel and paradigms from neighbouring fields: social psychology, demography, geography, anthropology, applied social work among others. However, a major area of research was continuous with the earlier work of such figures as Charles Booth and Rowntree – the social survey of large, representative samples to discover the extent of particular kinds of deprivation and inequalities. An important change here had taken place between the pre-war and post-war emphases, exemplified by the difference between Rowntree's 1936 survey of conditions in York, *Poverty and Progress* (1941) and his survey conducted in the late 1940s, *Poverty and the Welfare State* (1951). According to Rowntree whereas in 1936, 31 per cent of the working class in York were in 'primary poverty', by 1950 the figure was 2.8 per cent. Poverty, it was argued, had disappeared through a combination of the welfare state and full employment. Attention then shifted away from absolute material deprivation to relative inequality of opportunity. The two major works of the mid 1950s, drawing essentially on work done in the early 1950s organised from the LSE under the general leadership of David Glass (Professor of Sociology and former Reader in Demography), were *Social Mobility in Britain* (1954) and *Social Class and Educational Opportunity* (1957).[1] Both indicated firmly that movement of individuals between classes had not changed significantly under the new post-war settlement; their main mode of analysis and presentation was the systematic correlation of data from a range of representative national samples. They avoided both the elaboration of major theoretical issues and reliance on qualitative data. Drawing on an established tradition of the social survey, supplemented by the more precise orientations of the Population Investigation Committee, these works sought to move forward from the 'tradition

of social accounting' to the establishment of sociology as a firmly empirically based form of scientific inquiry.

Running counter to this in the 1950s was an alternative method of social enquiry: with roots in both geography and anthropology, and a specific emphasis on local studies, a range of work came to be grouped under the umbrella title of 'community studies'. Social anthropology was the most important model here with the transference of styles of work developed in the description of 'primitive' societies (usually village, tribal communities) into advanced industrial societies. It is important to distinguish this from the different (and equally significant) importation of 'social explorer' models into descriptions of working-class life from the mid nineteenth century onwards. Here, as in William Booth's *In Darkest England*, the emphasis is on the journey of 'one of us' into the alien depths of the 'people of the abyss' with much reference to the exoticism, and the otherness of the discovered world. As Kent argues: 'The data that emerge from social exploration are typically qualitative, often emotive, frequently narrative and utilise the imagery of exploration primarily to draw attention to inequalities in society and to force upon the reader an awareness of his social blindness.'[2]

A number of texts which fall into this category (and in doing so fall well outside any claims to be sociologically respectable) are considered later in this chapter. In contrast the social anthropologist characteristically seeks invisibility within the material and the research – an observer rather than an explorer. The Mass Observation organisation, from the late 1930s, was an early and highly distinctive attempt to import anthropological methods into the study of British society. A more orthodox body of work was grouped together by Ronald Frankenberg in his book *Communities in Britain* (1966). Frankenberg, originally a social anthropologist, noted that the book was written 'partly in response to the challenge issued by a leading sociologist attending a conference of the Association of Social Anthropologists',[3] the inference being that it is intended to illustrate the contribution which anthropological kinds of work can make to sociology.

Frankenberg attempted to employ a relatively strict

definition of 'community', describing it as 'an area of social living marked by some degree of *social coherence*. The bases of community are *locality* and *community sentiment*' (p. 15). This meant, in effect, concentrating on the one-fifth of the population who lived outside towns of over 50,000 people. Although the definition was extended to consider also work done on working-class 'urban village' areas (for example, Bethnal Green) and new housing estates, the majority of studies considered were of village communities, many in the Celtic fringe areas. These included the Irish studies of the 1930s, a number of studies of Welsh villages (including one by Frankenberg himself) in the early 1950s and accounts of villages in Cumberland and Devon. A key element in Frankenberg's definition of community study was the research method it implied:

> my dividing line is between those areas of social life which can best be studied by face-to-face methods – personal observation supplemented by questionnaire survey; and those which it is more economical to study door-to-door, by questionnaire survey supplemented by personal observation. (p. 15)

Essentially community study was not to be based on the amassing of significant quantitative data. The ideal method was a kind of absorption or 'immersion' in the community – a method which became increasingly problematic, as Frankenberg noted, in societies where life did not go on in public, observable, collective ways. 'In my early days in the village I would often climb a hill and look sadly down on the rows of houses on a housing estate and wonder what went on inside them' (p. 16).

In Frankenberg's book the first study discussed which was devoted to the condition of the post-war working-class was *Coal is Our Life* (1956).[4] The book, subtitled 'An Analysis of a Yorkshire Mining Community', was based on fieldwork in 'Ashton' in 1952–4. 'Ashton' was a mining village with a population of 14,000 in the West Riding; its size, relative isolation and single employment domination (over 60 per cent of employed men worked in the mining industry) all allowed

the study to proceed on the basis of anthropological models. Two of the authors were anthropologists by training and, although the book itself contained few accounts of its methodology, in the Introduction to the second edition (1969) Henriques recognised that the book's 'community-study technique' was 'strongly influenced by the monographs of social anthropology'.[5] As the book's title implied, however, the 'community' was seen from the beginning in terms of a clear hierarchy of determinations. Work – the mining industry – was the central area of concern. The book moves from an account of the miners' work situation and experience to trade unionism, leisure and, finally, the family.

The account of the work situation of the miner combines a number of features: the sheer physical difficulty and effort required; the diversity of roles and the complicated piece-work payment system; the social relations of solidarity (between men in the same team) and opposition (to management, a situation not radically altered by nationalisation); and the collective and individual memories of the past (unemployment, short-time working, strikes). The authors' conclusion is that, despite nationalisation, full employment and higher wages, the fundamentals are unchanged: 'For the miner, his improved position is a reversal of the initiative within a continuous framework of conflict, not an end of the contradictory framework' (p. 78). Patterns of leisure and family life are then mapped in relation to attitudes derived from work experience. Leisure for the miner is 'vigorous and ... predominantly frivolous' – drinking at the pub or club, sport (particularly Rugby League), gambling. This is reflective of general insecurities in the miner's level of income. Long-term plans cannot be made when long-term income is not secured, 'life must be lived from day to day and whatever surplus income there is over everyday needs should be spent in securing whatever pleasures are possible' (p. 130).

In the discussion of leisure, major divisions between men and women are apparent. Women are marginal to or excluded from the major male activities (exceptions being cinema-visiting or weekend visits to the pub or club). Leisure for women is listening to the radio, reading or callin' (visiting friends for a gossip). This division is reproduced within the

family which becomes a site of intermittent but structural conflict. The husband's control over money and identification with work together with the wife's lack of opportunity for independence lead to a 'rigid division between the activities of husband and wife' which 'make for an empty and uninspiring relationship' (p. 183). 'The row' then becomes a 'natural and regular feature of married life' (p. 195) – a way of expressing conflict, and a release.

Coal is Our Life presented a community where work was determining, where little had changed in terms of values, attitudes and way of life from the interwar period and where changes in patterns of consumption would be unlikely to effect any major transformations since they would fail to transform the work situation or experience in any way. In 1969 Henriques noted both that 'the technique of research upon which it was based, that of community-study, has not been either generally used or further developed in the years since 1956' and that at the time of first publication the book was seen as having 'a somewhat morbid preoccupation with the miners' past' (pp. 7, 8,). Certainly, despite the book's prominence in both Frankenberg's *Communities in Britain* and Klein's *Samples from English Cultures*,[6] both its methodology and findings were pushed to the periphery of British sociology in the late 1950s. It is not hard to see why. 'Ashton' was, as the authors recognised, not a typical industrial (or even mining) area. The 'community-study' project required a situation where patterns of work and of residence were relatively integrated; in a larger urban area where work groups, leisure groups and residential groups would be increasingly dissimilar it would be impossible to grasp the totality of relations through an anthropological village-study observation model. Comparison with the Banbury study – Margaret Stacey's *Tradition and Change* (1960)[7] – is instructive. Although the population of Banbury (19,000) was not much greater than that of Ashton, the mix of employment, of class groups, of traditional and non-traditional attitudes meant that there was no single line of determination from work which could be followed. Further, mining itself was likely to be seen as not typical. The occupational shifts and general social imagery already discussed meant that even if *Coal is Our Life* were accepted as

true for mining, this would only serve to confirm that this was an older way of life being surpassed. In Klein's *Samples from English Cultures, Coal is Our Life* is seen as a 'preliminary' study, to be set apart even from other studies of 'traditional' working-class life in major urban centres. A different, but related, point was the sense that the study, even by 1956, had already been overtaken by the onrush of affluence. Despite the fundamental argument of the book, the footnote which pointed out that 'At the time of this study T.V. was something of a novelty in Ashton. It was thought that a study of its effects after so short a time would be of little value,'[8] indicates why in the late 1950s, when arguments about changes in working-class life were often premised on the influence of television, the book was frequently regarded as the product of a past period.

While *Coal is Our Life* had no immediate sociological antecedents there seems to be a direct contradiction between Henriques' claim that 'community study' hardly developed after 1956 and the progress of that major success story of the late 1950s, the Institute of Community Studies, with its prolific series of research reports (particularly on Bethnal Green) from 1957 onwards. The contradiction is more apparent than real. While the Institute took particular communities as points of reference they rarely produced total community studies in the 'Ashton' sense. Further, 'community', for the Institute, frequently had a prescriptive as much as a descriptive meaning. It was assumed that, in general, localities with a 'community' (shared aspirations, norms, habits, face-to-face contact) were preferable to those with no 'community' feeling or network. The Institute was founded in 1954, based in Bethnal Green with support from a variety of non-academic sources (including the Elm Grant Trust and the Ford Foundation). Of the four founders none was trained in sociology, although early work was done under the general direction of Professors Titmuss and Shils. From the beginning the work was defined in terms of the need to provide information and assessments of need for the purposes of influencing social policy and advising policy-makers. In this respect the Institute's work situated itself in relation to 'a tradition of social investigation going back to Edwardian and Victorian times',[9] rather than to an anthropological tradition of 'community studies'. There was

nevertheless a strong pull towards anthropological methods and concepts in much of the Institute's work, particularly in its first and most influential publication, Young and Willmott's *Family and Kinship in East London* (1957). It was this book, above all others, which was the major contribution from sociology to the terms of the debate about changes in working-class life in the late 1950s.

The research project which led to the book began (in 1952) by asking the apparently most central question about social change in post-war Britain: 'what happens to family life when people move to an estate'. This involved a comparative study of a metropolitan borough (Bethnal Green) and a post-war estate in Essex ('Greenleigh'), during which 'we were surprised to discover that the wider family, far from having disappeared, was still very much alive in the middle of London'.[10] The book as it appeared became then centred not on estate life but on the extended family in Bethnal Green, its structures, complexity and variety – against which was set Greenleigh life, seen predominantly in terms of the losses and absences of elements present in Bethnal Green.

Methodologically the book, like much of the Institute's work, was a 'hybrid'[11] attempting to 'bring some of the strengths of anthropology to sociology, combining personal observations and illustrations with statistical analysis'.[12] Questionnaires and in-depth interviews were the major sources of data, entailing reliance on what people said as evidence for their actions and behaviour. This was backed up by a general immersion in the area (Bethnal Green, but not Greenleigh) in an anthropological manner:

> We think there is a chance of obtaining a sense of 'feel' for the people in an area from repeated work in it which is difficult to get in any other way, even if this sense has never yet been achieved by an investigator in modern society as completely as it has been by some anthropologists.[13]

The mix of methods can be related directly to the book's mode of presentation. The text mingles statistical tables, general commentary, particular descriptions of individual scenes and environments and a considerable amount of direct

quotation from those interviewed. There is, however, a definite element of reservation and, almost, apology concerning the inclusion of non-quantitative material, and a real uncertainty about its status. This is part of a general unease about the book's relationship to the discipline of sociology. Richard Titmuss's supportive Foreword sounds a warning in this respect. The book has, he notes:

> raised some difficult questions of presentation. Ultimately they resolved, to put it simply, to favour readability. But though this has meant that some chapters now have an impressionistic flavour the effect is, in my view, more than balanced by the warmth and vividness in the main body of the work which gives meaning and reality to the statistical material.[14]

Titmuss's comments are ambiguous in not making it clear whether he is defending 'vividness' as a way of sugaring the pill for a general readership or, in the reference to 'meaning', implying the insufficiency of the statistical material (even when interpreted) for the book's purposes. The same uncertainty runs through the main text. In the Introduction the authors defensively record that the extracts from interviews are 'solely ... illustrations' and not necessarily representative. Later in the book a highly evocative and detailed account of the streets and houses of Bethnal Green ('pram-sheds, boxes of geraniums and pansies, hutches for rabbits and guinea-pigs ... children were playing hopscotch or 'he' in the roadway') is prefaced by the comment 'an illustration may help the reader to visualise the houses we are talking about'.[15] The place of such 'visualisation' as part of the book's central case is, however, never discussed (it remains placed, by Titmuss's comments, as an optional atmospheric addition to the reading experience). There is repeatedly a reluctance to claim that qualitative evidence (whether observation or interviewee's comments) does anything other than exemplify, illustrate or make 'vivid' the basic truths deduced from the statistical data. Perhaps the nearest the authors come to making such a claim is in a comment on the nature of the mother–daughter relationship in Bethnal Green:

the number of contacts is less important than their content. To convey some indication of what really goes on between the two people, we have to fall back on the accounts given to us in our interviews and order the impressions left upon us by the people to whom we have talked. The accounts are examples, no more.[16]

Here, despite the double apology ('fall back', 'examples, no more') the underlying sense is that it is *only* through non-quantitative data ('what really goes on') that the significance of the meetings can be understood. Ultimately in fact the argument of the book, concerning changes in the *quality* of the people's lives, depends on such data for its case to be sustained.

In discussions of *Family and Kinship in East London* this issue has frequently become obscured because it tends to be collapsed into the equally important issue of the book's projected audience. Titmuss in referring to 'readability' implied a non-specialist audience. The authors themselves have subsequently declared that 'the audience we were aiming at were the architects and planners, the social workers and the housing managers, the civil servants and the politicians',[17] but not primarily professional sociologists. This has often seemed a reasonable defence (or excuse) for the not quite legitimate 'warmth and vividness' and it is true that the book's 'readability' has been evidenced by its considerable success as a Penguin paperback. However, this should not be taken to indicate that the non-quantitative material is merely peripheral to a central core of more serious 'scientific' data; rather it is at the heart of the picture of the changing nature of working-class life presented in the book.

This picture was very different from that shown in *Coal is Our Life*. It largely excluded the experience of work and the consideration of work as a determining factor of working-class life in general. It was an essentially comparative study – the traditional community against the new estate. The traditional community was, however, distinctly post-war, removed from the worst excesses of early twentieth-century and pre-war poverty and unemployment. The marital relationship, in early 1950s Bethnal Green, was 'an emerging partnership'. Where *Coal is Our Life* perceived structural conflict between man and

[margin handwritten note: How the working classes were represented for a "non-specialist" audience.]

wife (with the wife as the perpetual loser), Young and Willmott saw a situation where the excluded husband (excluded by the central mother–daughter relationship) could nevertheless still be accommodated with the extended family as 'some form of adjustment, some equilibrium is usually achieved, in Bethnal Green as elsewhere'.[18] Looking out from the home on to the outside world, rather than from the male world of work back into the home, Young and Willmott constructed a picture whose difference from that of 'Ashton' reflected not merely the different social situations (the mixed-occupation urban village against the physically isolated single-occupation community) but equally the different angles of vision. In Bethnal Green the extended family was the bridge between the individual and the community; there was then, 'a sense of community, that is a feeling of solidarity between people who occupy the common territory, which springs from the fact that people and their families have lived there a long time ... familiarity breeds content ... they know the faces in the crowd' (pp. 89, 92).

At Greenleigh Young and Willmott studied couples who had moved from Bethnal Green. Without close proximity to other members of the extended family (particularly the wife's mother) the bridge to community had been severed. The second half of the book argued the loss of quality of life centrally through a number of short but powerful comments from interviewees:

It's like being in a box to die out here.
The tellie keeps the family together. None of us ever have to go out now.
You seem to centre yourself more on the home.
Everybody lives in a little world of their own.
(Husband) – I'm only interested in my own little family. My wife and my two children – they're the people I care about ... (Wife) – It's all right for you. What about all the time I have to spend here on my own? (pp. 108, 117, 119, 123)

At Greenleigh status became increasingly specialised to the 'trappings of the man rather than the man himself' (p. 134).

Community life collapsed – 'at Greenleigh practically no-one goes out at night' (p. 116) – and by 1955 television sets had been acquired in Greenleigh at twice the rate of Bethnal Green. In acknowledging the clear material gains of better housing Young and Willmott implied a major cultural loss: the loss of community.

The basic structure of the book – the then-and-now comparison, the balance of material gain and cultural loss, the sense of a new life-style emerging on the new estate – made it easily available for co-option in support of the 'New Estate' thesis (if necessary the book's qualitative judgement could be relegated to the status of cosy sentimentality). In fact the concluding analysis and specific proposals indicated a rather different and more complex picture. While noting the significance of the different kinds of housing stock ('low density housing does not encourage sociability') and the serious lack of amenities on the new estate, Young and Willmott attributed the change in life-style not to new estate housing as such but rather to the creation of a locality in which the three-generation family structure had been seriously disturbed. Their proposals (premised on their findings that daughters generally wished to live near their mothers after marriage) argued both for rehousing within the inner city and a deliberate policy of allowing sons and daughters of Greenleigh inhabitants to remain within the estate. According to this analysis the shift to the new estate was not a once-for-all break into massive privatisation but rather a disruption of a pattern which was likely to be restored given a degree of stability in housing provision, with some help from social planning. A later study by Willmott, *The Evolution of a Community* (1963), of the Dagenham estate (which had been settled in the 1920s and 30s), claimed to prove this point by demonstrating how despite all the unfavourable circumstances (particularly lack of collective facilities and amenities of all kinds) the 'fundamental regularities of working-class life will re-assert themselves'.[19] It was striking, said Willmott, how similar Dagenham's patterns of life were to those of Bethnal Green (and how unlike both were to middle-class suburbia).

Family and Kinship in East London was one of three studies produced by the Institute in 1957–8 which as a collective

project aimed to 'make policy-makers and administrators aware of the needs or views of working-class people who form the bulk of users of the social services'.[20] The underlying assumptions were that even where sufficient public resources did exist it was worth discovering whether they were being properly directed and even whether assumed improvements were real improvements in quality. Critcher has commented that 'the crisis to which these texts belong is essentially that of a group of social-democratic intellectuals faced with the contention that capitalism works'.[21] It was this that generated these texts' attention to questions of quality rather than quantity in the area of welfare provision.

This investigation of the paradox of material improvement accompanied by cultural loss was even more explicitly at the centre of Brian Jackson and Denis Marsden's *Education and the Working Class* published under the auspices of the Institute in 1962. Although formally an Institute text this book had rather different origins in three respects. It dealt with a northern industrial area (Huddersfield), it had an input, via Brian Jackson, from a clearly non-sociological method of approach, that of 'creative' English literary educational thinking, and it had a clear personal component. The authors studied a sample of 90 working-class children who had gone to grammar schools in Huddersfield in the late 1940s and early 50s; 2 of the 90 were themselves.

Both the personal stake in the enquiry and, in particular, Jackson's commitment to the value of qualitative evidence led to considerable differences of attitude to research data from that of Young and Willmott. Likely *Family and Kinship in East London, Education and the Working Class* employed both statistical evidence and considerable quotation from depth interviews. In defining their method as going for 'the middle territory', however, Jackson and Marsden clearly struck a different balance:

much of this survey is in the form of quotation, scene incident. When we use this material we are not 'illustrating' the figures, or decorating a theme. The speaking voices are as basic as the tables. They *are* the theme. And in them lie the truths, often perhaps overlooked or missed by us, that

make 'education and the working class' a subject that matters.[22]

This was a much bolder assertion of the primacy of the participants' (and observers') experience as at the centre of the enquiry. It also declared that in part the material in the book was deliberately being presented in an untreated form, to let it 'speak for itself' to the reader who might with full legitimacy see more in it than the writers. In fact the 'middle ground' of *Education and the Working Class* was situated not so much between two different kinds of sociological method as between sociology and literature (specifically the novel, the realist novel). In the revised Introduction sociologists were reproved for having 'no conception at all of what the great masters of prose fiction have yielded to our central store of knowledge about the workings of our society' (rev. edn, p. 17). In contrast Jackson and Marsden defined their own writing in relation to this tradition:

> What we have done is try to go behind the numbers and feel a way into the various human situations they represent ... we would ask the reader to try, as we have tried, to keep in play a certain sceptical habit of mind. ... The invitation is, after all, not so much to observe with us the people of Huddersfield, as to observe us observing them. (Ibid., p. 26)

The book is studded with accounts of events which took place during the interviews, detailed evocations of the life-style of the interviewees and carefully constructed character vignettes: 'Mrs Chapman, a worn and quiet woman, seldom crossed her husband's flow of talk, but smiled support and looked longingly at her interrupted novel *Hearts in Paris*, laid politely on one side' (1st edn, p. 17). Here, in a recognisably novelistic manner, it is the adjectives and adverbs which create an effect of deference and cultural impoverishment, while retaining sympathy for the woman's plight. It is this kind of writing that the authors had in mind when they wrote of their wish to 'catch the texture and feel of life' (ibid.,

p. 15). Considerable attention was paid to the descriptions of
home interiors, including one particularly squalid scene:

> On the table stood a mixture of jam jars, opened packets
> of biscuits, half-emptied pint mugs of tea thick with leaves,
> and all the remains of the last three meals. The floor was
> scattered with scraps of paper, a child's ball, small toys,
> more biscuits, a tube of Smarties. In the middle of it sat
> the baby sucking a dirty dummy and sharing its biscuits,
> bite for bite, with two collie dogs. This was not an instance
> of poverty. (Ibid., p. 49)

This commitment to a qualitative method of research and
presentation was fully consistent with the purpose of the
overall enquiry. Where upward mobility had occurred, 'Was
it altogether worth it? Did the child gain or lose in winning
through to middle-class life, and growing away from working-
class origins?' (rev. edn, p. 16). Gain and loss here were to
be measured in terms of personal, almost spiritual, satisfaction.
The language employed to convey the quality of working-
class life suggested not so much the anthropologically-based
perspective of Young and Willmott as the organicism of
the early D. H. Lawrence mediated through F. R. Leavis.
Explaining the mother's predominance in influencing socially
mobile children, Jackson and Marsden commented that this
was not a matter of the individual mother's particular back-
ground: 'Its roots seemed to push much deeper into the basic
rhythms and expectations of working-class life, belonging to
that whole pattern of social living in which the mother rather
than the father was the organic centre' (1st edn, p. 83). With
this terminology, the grammar school experience and demands
could be figured as a divisive, almost unnatural, intrusion:
'These long homework hours, even more than "accent", cut
into the vital centres of family life, dislocated the whole
household's living' (ibid., p. 102). The predominant weight
of the assessment was then firmly towards 'breakdown and
loss':

> The ignorance of the school child had turned too frequently
> into an adult *malaise*, into a drifting, rudderless existence.

The question of pursuing a chosen career assumes an attitude, a state of being that might be called living to some purpose. This living is, for most of us, nourished from the affective securities of family life and the social strengths of the neighbouring community – just those supports and potencies which were increasingly strained or lost to sight during the process of growth. (Ibid., p. 158)

This severing of connection with the family of origin was judged a loss of equal significance to that discovered in *Family and Kinship in East London*, even if the causes were different. The research report section of the book closed, characteristically, with a highly charged quotation from an estranged father: 'I feel more akin with them when we're silent. I can get on with them better when we walk silent together. It's when we start talking that we notice the difference' (ibid., p. 189). Like *Family and Kinship in East London*, *Education and the Working Class* ultimately offered a defence, and even a celebration of certain 'traditional' working-class life-styles and values which became easily lost in the move to more modern, expansive and materially comfortable ways of life. In arguing, in their conclusion, for a programme of comprehensivisation in secondary education, a major aim of Jackson and Marsden was the achievement of an education system which 'accepts and develops the best qualities of working-class living' (ibid., p. 224).

From Social Science to Social Exploration

Education and the Working Class managed, if only barely, to remain within the boundaries of sociology. By the mid 1960s, in fact, its chief defect was seen not so much as the reliance on non-quantitative evidence as its failure to work within a properly sophisticated theoretical framework. Its reference to novels was particularly suspect. Ruth Glass's now canonical comment that often community studies are 'not much more than the poor sociologist's substitute for a novel'[23] suggest a clear difference between novels and proper sociology as kinds of writing. Indeed Jackson and Marsden's comments on their

method of work drew on (as well as such texts as *Family and Kinship in East London*) that other seminal text of 1957 on working-class life, Richard Hoggart's *The Uses of Literacy*, a book which disclaimed 'the scientifically-tested character of a sociological survey'.[24] Hoggart had also begun by both stressing the value of novelists (particularly Lawrence) in bringing us 'really close to the quality of working-class life' and inviting the reader to note the writer's own involvement with the material – 'the reader sees what is intended to be said and also, from tone, from the unconscious emphases and the rest, he comes to know the man saying it'.[25]

The Uses of Literacy had made its own particular contribution to the debate about the nature of working-class culture and the gains and losses involved in post-war changes.[26] The inside cover of the first Penguin edition (1958) suggested that the book sought 'to remedy our ignorance' about 'how the other half lives'. This was hardly how Hoggart himself would have put it and it implied a rather closer link between the book and the 'social exploration' genre than actually existed. Hoggart made his case through description and summary rather than sustained dramatic recreation; he argued rather than narrated. Social exploration texts worked precisely by dramatisation and narration, by offering to carry the reader directly inside the working-class experience through the very process of reading.

The figure who was repeatedly invoked as a model for such texts was Orwell. As Young's article in *Encounter* in 1956 indicated, *The Road to Wigan Pier* had become a central text in the 1950s view of the 1930s. In fact only a relatively small part of the book had been presented as dramatised experience; much of the text was in the form of either social survey or political essay. However, in the folk-memory of the 1950s intelligentsia the Orwell of *Down and Out in Paris and London* was overlaid on to *The Road to Wigan Pier* so as to present him as *the* chronicler of the older northern working-class world of deprivation and poverty against which post-war accounts were to be measured. This was absolutely explicit on the back cover of the paperback edition of Clancy Sigal's *Weekend in Dinlock* (first published in 1960): 'the road to Wigan Pier has changed

since Orwell walked down it in the thirties. Clancy Sigal has suited his exploration of a Yorkshire mining village to the conditions of today'.[27]

Weekend in Dinlock presented itself immediately as on the borderline between documentary and fiction. The prefatory author's note referred the book to its origins in Sigal's experiences in mining villages, adding 'Dinlock is imaginary in that it is many places I have seen and its people are not "real" except in the sense that they are the sum of the total of what I wish to say about what I saw' (p. 7). The semi-fictional form was recognisably that of 'social exploration': Sigal's journeys from London to Dinlock, the South to the North, the civilised to the primitive. As the genre demanded, Sigal's creation of himself as a particular character was central. He was an outsider (American, writer from London) but shared enough with the miners (working class, held his drink, sufficiently tough) to be accepted, a bohemian intellectual (an exile from the 'beat' culture of America) and a socialist. The book was united by Sigal's developing consciousness, a loss of naivety and gaining of experience, symbolised in the first few hours of his stay in the village:

> A year ago, on 14th Street in New York, for twelve dollars, I bought a white duffel coat which I'd just had cleaned in London. It is still cream-white. The colour seems to dazzle them; it is clean, without dirt or greyness, hence, I must have come from another world, where you did not breathe coal dust. ... (Two hours later I look down at the coat and it is lightly smudged. The next day I am one of them: grey.) (p. 25)

As social explorer Sigal was moving beyond normal civilisation 'to the incredible universe, at the edge of the world ... this isn't darkest Africa. Or is it?' (pp. 15, 16). More prosaically the gap between London and the North was repeatedly invoked. The book opened with Sigal's adventures in London, shared with Davie, a miner-artist who was trying to live in both worlds. Sigal and Davie between them were then able to compare the two. London was first a source of opportunity (one possible route of escape for Davie was an art scholarship

there) and a place of greater openness – the only woman in Dinlock with any independent spirit or opinions was Louise, a Londoner – 'Wish to God I was there now . . .' (p. 134). Sigal also at times regrets his journey North: 'I am furious, that I should be here, shambling so clumsily about in these fetid dungeons of coal, instead of having a coffee in Torino's in London' (p. 161). Sigal's comment implied, however, the opposite way of valuing the contrast – Yorkshire 'reality' against Southern effeteness, as Davie says, reacting angrily to Sigal's criticism of his painting – 'Ah don't paint fancy lahk they do in London. Ah paint the truth Ah Know' (p. 142). Yorkshire life, in itself, was more vital also:

> In London's miserable pubs, the customers sit morosely from opening to closing time like respectable mummies. Here, it begins that way, but the Yorkshire personality, acted upon by the week's labour and thousand arrows of tension, flushes and inflates and begins to make its own raw music. (p. 43)

The ultimate 'raw' reality was Sigal's own journey down the pit where he discovered simultaneously the massive physical discomfort of the miners' world ('a diabolically cramping underworld prison cell') and the extraordinary resilience of the miners themselves. He also, in the narrative climax, discovered Davie back in the pit; the book has no conclusion other than Sigal's departure by bus from the village.

As an account of a mining community *Weekend in Dinlock* had clear limitations. In a discussion of the book, transcribed in *New Left Review* in the summer of 1960, one miner commented on the appropriateness of its title: 'It's about all you could find out in a weekend'.[28] Criticisms included the overemphasis on violence, the depiction of a life-style of '20 years ago', the dependence on miners' own views of themselves ('miners are leg-pullers' said one miner's wife) and the failure to portray the women in any depth. Sigal had recognised this himself:

As soon as I touch on one of the thousand rawly sensitive

subjects coveted and nourished by Dinlock females Loretta clams up. . . . You LSE firsts in sociology, come on up here and find out what these women are thinking. Where are you?.[29]

They had of course already been there. The worlds of Ashton and Dinlock are recognisably the same. The mining village community, the male world of leisure, female subordination within the family, the fundamental insecurity of the working situations and conditions, the role of the trade union (including the potential gap between men and leaders) – all are present in both books. The work experience is at the centre of both, but while in *Coal is Our Life* it is discussed first (as the primary element in a hierarchy of determinations) in *Weekend in Dinlock* its discovery is the climax of the narrative, approached gradually and finally revealed as the heart of darkness of the mining community. Sigal's account of the community only noticeably differs in its recognition of the onset of affluence; it is clearly the late rather than the early 1950s of life in Ashton. Television was now a highly visible and widespread phenomenon:

Half the miners' families own a set, and the other half desperately wants one. ... If I had to live in Dinlock I would worship at the desire to get a set. Telly is the road *out*. And if anyone worries about the corruption of native Yorkshire culture consequent on the fragmentation of primary societies, I want him to show me exactly what has been corrupted; life in Dinlock before, during and after telly, is dingy, narrow, primitive, with the enforced virtues of primevalness and riddled with inherent outrages. (p.20)

If television had made an impact, it was on the margins, not transformative but an addition to the material forms of the existing way of life. In the *New Left Review* discussion a miner enthusiastically endorsed Sigal's view that Dinlock was still a genuine community, still had a 'genuine *public* ... not an inert, apathetic mass'. The problem for Sigal was that this positive element was structurally linked to the fundamental insularities and insecurities of the village community. Further,

as *Coal is Our Life* recognised more explicitly, it was a community based on the structural subordination of women. Both books looked in on the home and the family from the working miner's perspective; however, while the anthropological study attempted to indicate the underlying conditions producing the women's behaviour and attitudes, the social exploration genre demanded fidelity to surface detail. *Weekend in Dinlock* thus tended to present the women's subordinate position as weakness, lack of initiative and general helplessness. In the *New Left Review* discussion the wives return repeatedly to the problems of this perspective:

> I think he's given us a faceless characterless picture, and that miners' wives are not like that. They're tough and hard and they've so much character. *Weekend in Dinlock* tries to make out that the woman is very subordinate, but in reality she's the very pivot of the community. She bolsters him, he hands over his money to her, she runs the home without any interference from him. She herself brings up the children.[30]

Such comments did not so much contradict Sigal's view as show the same situation from a different perspective and with a different set of priorities. As *Family and Kinship in East London* had demonstrated, by beginning analysis inside the family and defining the woman's role as central an alternative version of community might be recognised.

Sigal's central emphasis on work, male leisure and the public world of Dinlock did, however, lead to a clear refusal of the fundamental assumptions of affluence imagery. Full employment, higher wages, consumer durables – all these as determinants of the way of life were seen as of little significance beside the sets of relations generated in and through work. In following through the implications of Barbara Castle's suggestion to move from the television aerials to the houses beneath. Sigal's book demonstrated the fragility of the embourgeoisement thesis when it was placed alongside a detailed account of northern working-class conditions and attitudes.

A distinctive feature of *Weekend in Dinlock* was the idea that it was the complete outsider (not just a member of the

indigenous middle class 'slumming') who would be most able to gain entry to the enclosed working-class world. This idea was central also to Doris Lessing's *In Pursuit of the English* (1960). Lessing, like Sigal a foreigner and a writer, presented herself as both observer and participant within an account of working-class life in one house in London. Her initial naivety and subsequent education (particularly in the area of domestic labour – 'What was your mother thinking of, sending you out into the world so ignorant?'[31] asked Rose, a young unmarried fellow-lodger) – were essential to the narrative's perspective of discovery and revelation. Rose, like Davie in *Weekend in Dinlock*, was a central *alter ego* figure and, like Davie, she is left inside the closed world of the book as the narrator departs at the end of the narrative. This world is that of the extremely localised urban village:

> the half-mile of streets where she had been born and brought up, populated by people she trusted. ... She knew every face in the area we lived in. (p. 103)

However, this was not (unlike Dinlock) a contemporary world; the period of 1949–50 was delineated very precisely by references to rationing, the Labour government and the aftermath of the war. The book charted the gradual restoration of the house's war damage, a sequence of botching, culminating in the repairs to Lessing's own room:

> it could be seen that bombing had loosened the walls so that they stood apart from the angles from half-way up to the ceiling, between a quarter and a half inch. They pasted strips of paper over the cracks and wallpapered over the whole. (p. 225)

The moment was that of the exhaustion of the Labour post-war effort at social transformation, the sense of reconstruction only half achieved and the moment of affluence about to emerge. All social groups seemed to look back with nostalgia; the working classes had got 'out of hand ... since the war' according to a con-man pimp; an old colonel harked back to the glorious days of pre-1914 Empire, while Rose recalled the

Blitz as a time of 'warmth, comradeship, a feeling of belonging and being wanted, a feeling she had never been given before or since' (p. 123).

The immediate social conditions are portrayed in an unsentimental way. Male predatory sexuality, regular abortion and consistent child neglect were persistent features. The 'Welfare' and its accompanying ideology of the family were wholly peripheral; when Flo (the landlady) asked if her 3-year-old could go to a council nursery, 'the reply was that Flo had a nice home and it was better for small children to be with their mothers. Besides the council nurseries were closing down. "Women marry to have children", said the official' (p. 135). As Flo pointed out things had been very different in war-time.

The book's climax was a court case in which Flo achieved the eviction of an old couple from part of the house so as to effect improvements and increase the rent. The court victory was celebrated by the acquisition (on hire purchase) of a television set. Previously the house had been filled with continuous radio music, while Rose had been a frequent cinema-goer. Now 'the age of the radio was over' and Rose changed her appearance after seeing a fashion programme on television; she began to copy her favourite television announcer's 'manner of ingratiating propriety' (p. 226). Despite Rose's concluding comments to Lessing ('We should all be kind to each other' [p. 240]) the general situation remained depressing rather than invigorating, with affluence seen as unlikely to effect any significant positive transformations.

Necessarily the genre of social exploration relies for its effect on the dramatic, the revelatory, the shocking; it cannot tell us either what we already know or the details of a bland, wholesome life-style. In *Wellington Road* (1962), Margaret Lassell described her observations while lodging in a house on 'a modern estate on the outskirts of one of England's biggest cities',[32] recognisably in the North. She revealed not the affluent classless 'New Estate' but rather the dark side of 'This New England', the lack of independence and responsibility in the welfare state ('this passive docile mass of citizens eager to contract out of responsibility into fantasy'[33]). *Wellington Road* depicted a situation of unredeemed squalor borne not

out of material deprivation but of collective psychological inadequacy. Malcolm Muggeridge found it 'nightmarish beyond anything by Dante' while the Penguin paperback cover notes placed it in a more recent tradition – 'an Orwellesque study of primitive life in the slums of the Welfare State'.

The book is tightly structured by Lassell's presence in the house of the Johnson family in Wellington Street (the first sentence is 'I arrived about 5.30' and the last 'I left about eleven'). The other worlds from which she comes are mentioned (her home, the Lake District for a holiday and job-hunting in the South), but not specified. Unlike Sigal or Lessing, Lassell's emphasis is never on her own response. She seems to learn nothing new, is not herself surprised or disturbed by anything she sees. She has no solidarity with her hosts and certainly no feelings of inferiority; the gains in the relationship are all one way (she helps the 7-year-old to read, takes Mary, the wife, to the Family Planning Clinic, baby-sits frequently). The diary presents scenes and incidents directly, but with relatively little commentary, although the effect intended is clear from the report of a meeting with two local church workers who were:

> not very well informed about the lives of people among whom they were working. ... One of the women was appalled that she herself had no idea that there were people like those I described living here. ... The other woman, who had only just come, was more condemnatory of the families than of herself, said she thought some of the people were committing terrible crimes.[34]

Life at Wellington Street certainly consisted of the systematic transgression of all respectable norms. Within the first thirty pages details are given of the wife's prostitution (suggested by the husband), masturbation and sexual precociousness by the children (aged 7 downwards), children hitting each other with iron bars, breaking up the mattresses, bedclothes and bedroom walls, theft, abortion and chickens kept in the bathroom. The husband had frequent blackouts (as a result of a fight with a neighbour), no job and, apart from the

lodgers' rent, the total income appeared to come from various welfare agencies.

The Johnsons seemed to have no positive values at all. While Lassell regularly attended church, their indifference to religion was such that that they were surprised that one lodger intended to send a Christmas card with 'a woman on it, with a little baby! ... not the sort of thing you could send to a fellow, it'd be soft' (p. 166). Typically the acquisition of a television set was a significant moment in merely confirming existing attitudes. Mary and Joe were very anxious to get a set, particularly after Mary's parents had bought one; they made regular night trips across the city to watch, although not always to their satisfaction: one week 'a whole hour of television was taken up with a concert, which they couldn't bear and turned off. ... "It's not our class. ... We wouldn't go to that sort of thing, and I don't see why we should have to look at it on TV"' (p. 77). Eventually they buy their own set (with two years' hire purchase to pay). Joe hopes this will keep Mary in during the evenings, although 'she finds many of the programmes rather boring as she hates "talking"' (p. 138). Television becomes absorbed into the routine, being left on all the time but rarely with much attention paid to it. In her 'Epilogue' Lassell noted that, on a brief return three years later 'little was changed', although the Johnsons now had a broken-down car and a telephone (cut off for non-payment).

Wellington Road, in its implicit critique of the achievements of the affluent society, drew on two different strands of contemporary thought, both stressing the lack of deep-rooted values. There was first the view that the relative material security of post-war society had produced a situation in which individual responsibility and striving had been made unnecessary; secondly there was the sense of the failure of 'society' in general and education in particular to provide a mental and spiritual climate to match the materialism of contemporary culture. The success of *Wellington Road* in providing evidence for either of these positions depended largely on how representative a case the Johnsons were taken to be. Reviewers were divided on this point. In the *New Statesman* John Morgan felt that Wellington Road 'may not be a Coronation Street but, then, what working-class street is?',

adding 'more people live like this than it's now fashionable to suppose'.[35] The *Times Literary Supplement* reviewer was unconvinced. The Johnsons were a 'very odd family indeed' and the book as a whole had 'no sense of social perspective'; there was no attempt to 'see the family as part of a social *system*'.[36] The problem of typicality was, in fact, inevitable in all 'social exploration' writing, but particularly acute where only a single family or household was involved. In his review of *In Pursuit of the English*, Keith Waterhouse saw the characters as 'some rather untypical people in an untypical house'. He linked this comment to the other recurring issue concerning texts of 'social exploration', that of their epistemological claims and consequent forms of writing. The house, said Waterhouse, was 'some sort of depot where characters awaited their turn to be dispersed into contemporary novels'; the book was then 'an invaluable notebook for Mrs. Lessing, the novelist, but it doesn't really add up to a book by Mrs. Lessing the social observer'.[37]

Other reviewers were less worried by this formal hybridis- ation; by the time (mid 1960) *In Pursuit of the English* appeared the issue had already been widely discussed in relation to *Weekend in Dinlock*. Sigal's book had been variously described as 'somewhere between fiction and social survey', a 'study-in- depth rather in the manner of that fashionable television form, the "fictionalized documentary"'[38] and, by Angus Wilson, as on the 'very borderline of reportage and fiction'. Wilson noted the consequent likelihood of being 'open to criticism from both sides'.[39] Generally texts of social exploration took considerable pains to distinguish themselves clearly from pure fiction, as in Sigal's 'Author's Note' and Lassell's direct disclaimer in her Prefatory Note: 'This is not a novel. ... None of the incidents or conversations has been invented.' Such claims were important since they absolved the writer from the need to provide a unified reading experience or pleasurable aesthetic structure.

In a review of *Wellington Road*, however, Sigal expressed reservations about both the claims and the methods of presentation in Lassell's book. In particular he worried about the apparent abnegation of responsibility for the selection and

shaping of the material. There was, said Sigal, a 'problem with books of intimate social reportage':

> To colour and shape the material responsibly you must be terribly careful of your grip on personal sympathies and the sociology of the situation. A synthesis of these two approaches, the intimate and the objective (which perhaps ought to be in inverted commas, and where I think the best new work is to be found and done), must involve the writer in *selection*. We can no longer pretend that Orwell, Sillitoe, and the Institute of Community Studies do not exist as an already existing platform from which to launch social observation and writing.[40]

In arguing for a contextual awareness, Sigal, through the inclusion of Sillitoe, effectively recognised the existence of a continuum of modes of writing concerned with providing experiential accounts of working-class life. There was, implied Sigal, no absolute distinction between fiction 'pure' and necessarily selective sociological accounts. Within the fields of both social science and literature such a claim suggested a blurring of distinctions between the real and the fictional which, while it provided opportunities for breaking new ground, was more usually regarded as a serious threat to the maintenance of properly constituted intellectual boundaries. By the early 1960s the 'novelistic' quality of social exploration and some sociological writing was on a par with the 'sociological' qualities of working-class fiction in their mutual transgression of dominant categories.

3. Fiction: Communities and Connections

In December 1955 John Lehmann, in an editorial in the *London Magazine*, responded to a criticism that he was publishing very little working-class writing. The comment was particularly pertinent since Lehmann in the 1930s and especially in the 1940s (with the very successful *Penguin New Writing*) had been instrumental in the publication of a good deal of short story and documentary material concerned with working-class experience. Lehmann rejected the implicit charge of deliberate editorial bias and went on to suggest two reasons why good working-class writing was not forthcoming. It might be that 'the conception of "working-class literature" is itself out of date in the age and country of the Welfare State. We are very much nearer a classless society in 1955 than we were in 1935. The social structure where good class is identical with good education is crumbling away.' There was then the opportunity for 'intelligent and ambitious children' to move up the 'social ladder' so that by the time they started writing they would no longer be working class. To this 'rise of the meritocracy' explanation of literary change, Lehmann added an 'embour-geoisement' version. In the 1930s the 'dynamo' behind working-class writing was the sense of injustice, idealism and 'comradeship in adversity' of the 'old working-class struggle'. Now the dynamo had 'gone dead' leaving behind only 'inex-perience in writing, monotony of scene, paucity of incident'.[1]

Lehmann's observations, both in their acceptance of British society as conflict-free (the message of the 1955 election) and in their assumptions about the proper business of working-class writing, reflected a widespread view that in post-war Britain both working-class writing and political literature were obsolete forms. This position had evolved through a number of stages since the 1930s. After 1939 many positions which

sought to link the political and the cultural had become dissolved into the general humanist, patriotic and frequently religious rhetorics which constituted the official legitimisations of the war effort. All literature was now committed by definition; the very acts of writing and reading represented those values of humanity and culture which were being defended. In January 1943 Harold Laski, in an article 'In praise of booksellers', wrote that: 'If I had to put the purpose of this war in one sentence I should say that we fight it that men and women may freely choose themselves the books which give them nourishment and pleasure. In Germany they burn the books; in Britain we sell them.'[2]

There was certainly, during the early 1940s, a considerable amount of material published (mainly in journals) dealing with the reporting of ordinary life both in the Services and on the Home Front, but after 1945 this increasingly died away, reflecting its associations with conditions of war and austerity, which were seen variously as factors inhibiting properly free artistic creativity or as experiences to be put out of mind in favour of defining the new reconstructed post-war society. The Left Book Club closed in 1948 and *Penguin New Writing* in 1950; in January 1956, Clifford Tolchard, in a letter responding to John Lehmann's editorial, suggested that, contrary to Lehmann's view, there *was* a lack of journals which were prepared to welcome working-class writing. Compared to the pre-war situation 'now both the stimulant and the encouragement have gone'.[3] This inhospitability of cultural climate was accompanied, particularly in the immediate post-war years, by the economics of austerity which affected publishing as much as other industries; the number of possible new titles remained restricted and publishers had neither the incentive nor the facility to take risks on new authors.[4] It was not surprising then that in the decade up to 1955 so little fiction dealing with contemporary working-class life had appeared.

Even where such fiction had been published it was frequently criticised as an anachronistic attempt to revive 1930s forms and perspectives; this was particularly the case with those novels which closely identified themselves with the position of the Communist Party. By the late 1940s the party was finding itself (as against the Popular Front moment of the late 1930s

and the latter war years) increasingly isolated from the mainstream of the Labour Party and having to fall back on its own separate political positions and cultural institutions. Through the late 1940s and early 50s its cultural magazine *Our Time* (and its successor publication *Arena*) worked hard to define a distinctive cultural position, often centring round the discovery and perpetuation of a 'national popular cultural tradition ... one founded on a pre-war, literary notion of "the British cultural heritage"'.[5] The post-war fiction of Jack Lindsay recognisably adopts a similar perspective, particularly in his first three novels of 'the British Way', *Betrayed Spring* (1953), *Rising Tide* (1953) and *The Moment of Choice* (1955), which dealt with the period from 1946 to 1951. Here the underlying theme was Labour's betrayal of the popular support for socialism which brought them victory in 1945; illustrated through a wide range of social situations from industrial conflict to the Peace Movement against the Korean War. However, by the mid 1950s, novels dealing with working-class life, whether explicitly political, such as Len Doherty's *A Miner's Sons* (1955) or not, like Sid Chaplin's *The Thin Seam* (1949), were facing increasing difficulty in being accepted as worthwhile contributions to the business of contemporary fiction.

This was not due to any general revulsion against social realism as a form; indeed the idea that fiction should (with the minimum of formal 'experiment') represent contemporary social reality was very much back on the agenda.[6] Rather, as Lehmann's comments suggest, reality was perceived to have changed. The route to the new phase of fictional representation of working-class life – in the novels of Sillitoe, Storey and Barstow – was then to lie not through continuities with pre-war modes of writing, but rather through the gradual downward slippage of a particular post-war genre, that of the young male hero on the make in the fluid social situation of a new Britain. This hero had been prefigured in Philip Larkin's *Jill* (1946) and William Cooper's *Scenes from Provincial Life* (1950) but came to maturity in the two defining 'Movement' novels, Wain's *Hurry on Down* (1953) and Amis's *Lucky Jim* (1954). Significantly, while both recognisably dealt with the 'jungle of the nineteen fifties' (as Wain's novel put it), their

perspective, like that of Iris Murdoch's *Under The Net* (1954) and Amis's subsequent *That Uncertain Feeling* (1955), was essentially comic rather than documentary and their area of concern (particularly in the much more influential *Lucky Jim*) was the upper middle-class world of snobbery and privilege, with a lower-middle-class or 'outsider' hero ambivalent as to whether to opt for rejection or emulation.

Lucky Jim remained a highly visible cultural reference point throughout the 1950s. It received a new charge of energy (and an effective redefinition of meaning) following the impact of *Look Back in Anger* in 1956;[7] Jim Dixon, like Jimmy Porter, now became an 'Angry Young Man'. It was Osborne's play also, and the whole extraordinary media and publicity episode of 'Anger' that created the conditions for the immediate success of John Braine's *Room at the Top* (March 1957), which in turn became the crucial linking text between the 'Movement' novels of the mid 1950s (with their recognisably educated and intelligent, if down-at-heel, heroes) and the working-class protagonists of Sillitoe and Storey. Braine's Joe Lampton was clearly on the move from working-class origins to a comfortable middle-class future and while the novel reproduced the *Lucky Jim* pattern of a young male hero choosing between two women (and simultaneously between two ways of life) it offered itself also both as more directly 'realistic' (avoiding the comic and set in the industrial North) and as an ambivalent commentary on the material gains and moral losses of the new affluence. On both these counts *Saturday Night and Sunday Morning* could be taken as its successor, apparently outstripping the achievement of Braine's novel to such an extent that, according to the *Daily Telegraph* reviewer, it made '*Room at the Top* look like a vicarage tea-party'.[8]

Problems and Conditions of Publication

Braine had not found it easy to get *Room at the Top* accepted for publication. His first synopsis had been rejected in 1951 and the novel was not accepted until 1955 (after the success of *Lucky Jim*).[9] Such a pattern was, and is, not unusual for a first novel and suggests the importance of distinguishing between the writing of fiction and its publication as two

distinct stages within a whole process. Particularly in the area of new fiction the publishing industry does not need (unlike film and television) to provide a large investment for a carefully planned product; rather it can select its preferred products from a range of diverse material on offer. This is, of course, not to suggest that such writing takes place free from social determinations (including internalised assumptions about, and conscious orientation towards, publishing norms), but rather to indicate that new cultural conditions do not automatically generate new kinds of writing – it is, rather, often a case of publishers allowing certain kinds of writing already in existence to go public. Alan Sillitoe, for example, had been drafting the material which was to form *Saturday Night and Sunday Morning* from 1950 onwards. He had attempted unsuccessfully to get some of it published as short stories in literary magazines, including the *London Magazine* which (with Lehmann as editor) had rejected the book's first chapter in mid 1955.[10] The final version of the novel was completed in August 1957 and accepted by the fifth publisher who saw it, at the beginning of 1958.

David Storey's experience was similar in many respects. *This Sporting Life* was rejected eight times up to 1958;[11] in fact all his first three published novels were written in the mid 1950s. Subsequently the first two of these came out within a year, *This Sporting Life* in February 1960 and *Flight into Camden* the following October. The appearance of the former coincided perfectly with the continuing success of *Saturday Night and Sunday Morning*, the film and paperback edition of which appeared later that year. Stan Barstow's *A Kind of Loving* (published July 1960) was also able to follow in the wake of, particularly, Braine and Storey as another contemporary 'West Riding novelist'. In the early 1950s Barstow, making his own way in writing while working as an engineering draughtsman, had decided that he 'ought to write about ... the kind of working-class life I knew from my own experience'. However, he found that 'very few people' (publishers and editors, in effect) 'wanted to know about this kind of life'.[12] Through the whole of the 1950s Barstow sold only four short stories.

Like Barstow, Raymond Williams had his first novel pub-

lished in 1960 (*Border Country*, the first of many versions of which had been completed in 1947). Williams's case was rather different in that it was his success with another kind of book, *Culture and Society* (1958), which created the conditions for *Border Country* to be taken as a significant contribution to the new generation of working-class writing. In reflecting on his own fictional practice Williams has noted one further significant constraint on contemporary novelists:

> The economics of commercial publishing now impose extraordinary restraints on writers. The first reaction of a publisher to a novelist these days is 'Fine, but not more than 80,000 words'. . . . I kept building up something which I thought was the right pace, and then found that what was intended to be one movement in the novel was already longer than anything a publisher would accept. So much of the work was then looking for condensations or formal solutions to knit the materials in a more economical way.[13]

In Williams's view such constraints were particularly damaging in discouraging the contemporary novelist from dealing with a 'broad band of social experience'; by contrast what they did allow was 'the novel of escape . . . from the working class – moving to the room at the top, or the experience of flight'.[14]

If, however, publishing assumptions and attitudes restricted the availability of working-class fiction in the mid 1950s, by the end of the decade much had changed. The intensification of affluence imagery from 1957 onwards forced the question of the relation between older and newer life-styles, but there had also been important developments within cultural institutions themselves. The degree to which Sillitoe, Storey and Barstow (their first novels in particular) achieved much greater public visibility than any others as representatives of contemporary working-class life was directly related to the way their texts escaped the confines of hardback publication. It was through film versions and paperback editions that they achieved the greater part of their audience, and these two forms were closely interrelated. *Saturday Night and Sunday Morning* appeared in Pan paperback in 1960 and was reprinted

thirteen times by 1964. The first novels of Storey and Barstow were published in Penguin in 1962. *A Kind of Loving* was reprinted four times in that year (the film version being released in April); as against this Storey's novel was not reprinted until the following year (when its film version was released). This suggests not only the comparative attractiveness of the novels for a general readership (although Barstow's novel might well have been more 'accessible' in this respect), but also the critical importance of the film version in securing a wide readership. The paperback covers took maximum advantage of this by frequently using a still from the film on the front. This conjunction of a period of expansion in paperback publishing (particularly important was the dramatic increase in the speed with which new hardback fiction was allowed into paperback)[15] with a situation in the film industry favourable to the production of British films about contemporary working-class life,[16] led to a very unusual situation in literary production and evaluation. It was a situation in which a new novel might simultaneously be a paperback best-seller and be regarded as at the forefront of 'serious' contemporary fiction. While this moment began to evaporate almost as soon as it appeared it did provide an opportunity from which *Saturday Night and Sunday Morning*, especially, profited considerably.

Within the Closed Community – Sillitoe, Storey and Barstow

Saturday Night and Sunday Morning, unlike many previous novels dealing with post-war working-class life, did not seek to avoid or minimise the affluence case about social change. Rather the presentation of Arthur Seaton's life and environment simply accepted the fact of all the material improvements which had taken place and asserted their relative unimportance beside the centrally determining and circumscribing situations of factory work, family and local community. The novel here draws on and assumes a quite specific historical perspective, one articulated on the basis of personal and family experience of pre-war working-class life. The key oppositions are 1930s/50s, pre-war/post-war and dole/prosperity. This

anchors the novel in a generally 'known' social reality of which a particular reading is made. Arthur is a recognisable figure. Almost a Teddy boy, he is a young affluent worker: affluence here referring to regular employment, adequate food and housing, and spare income for leisure (television, alcohol, smart clothes). The novel then clearly addressed a contemporary question – what had the new working class to complain about?

The roots of the novel's answer to this question lay in fact in the 1940s rather than the 1950s. Sillitoe has repeatedly pointed out, in answer to queries as to whether Arthur was based on himself, that although the novel was set 'against the backdrop of what was my reality in life', by the time of the final version he 'had not been in a factory for ten years'.[17] After being called up to the RAF in 1946 he was stationed in Malaya for two years, spent a further sixteen months in a Wiltshire hospital recuperating from tuberculosis and in December 1949 was discharged with a disability pension. After periods in Nottingham and on the South Coast he lived abroad, mainly in Majorca, between 1952 and 1958. In Sillitoe's own words he was then, in his first novel, 'bringing my experience from the Forties up into the Fifties'.[18] This helps to account for the occasionally unstable sense of period in the novel, particularly when the experience of the war seems to be very recent. It also suggests the origins of much of the generalised anti-authority sentiment that permeates the novel. Sillitoe has recalled that 'Lots of my family went into the army and they were all deserters.... There's a working-class tradition which says you join the army because that's the only way of getting out of your local area. Another tradition says that you never join the army under any circumstances.'[19] This fundamental, almost instinctive, refusal to be brought within any national consensus, surfaces in the novel in a late 1950s context, where it comes to signify something rather different: both 'that sort of rebellious mentality' which Sillitoe in 1960, deemed appropriate to a writer who had experienced working-class life, and a rejection of the 'bread and circuses' approach by those at the 'factory bench' who still 'show some sign of being beyond the reach of dead symbols and false values'.[20]

The form of the novel also exhibits traces of its lengthy period of gestation. Material which was originally written as short story, sketch or poem contributes to a text which is episodic in structure and lacks a single strong narrative direction. Unlike *Room at the Top* which emphasised Joe Lampton's conscious drive for material success (and his contradictory desire for personal fulfilment) in Sillitoe's novel Arthur's progress is unplanned and he drifts almost unconsciously from one social role (single young man) to another (husband) – from Saturday night (unrestrained leisure) to Sunday morning (domesticity). Arthur himself has only one major goal: 'To win meant to survive; to survive with some life in you meant to win.'[21] His daily (and yearly) routine of work and leisure is totally closed and outside his control and because of this the activities it generates are not called into question in terms of alternative narrative possibilities. The novel is not concerned with social mobility; not because the mainspring of this routine (his job) is assumed to be irrelevant, but precisely because it *already* defines the limits of Arthur's world: 'a brief glimpse of the sky at midday and evening, a prison-like system pleasant enough because he could be happy in knowing that by this work he never had to worry where the next meal, pint, smoke, or suit of clothes was coming from' (p. 131). The only alternatives to this which Arthur can conceive are winning the pools or atomic war. His relationships with women are then conducted within this frame of reference. The prospective marriage to Doreen is simply the obvious next step: 'if you went through life refusing all the bait dangled before you, there would be no life at all. No changes would be made and you would have nothing to fight against' (p. 220).

This sense of marriage as a necessary and pre-arranged obstacle to be negotiated is part of the novel's general conception of time. Arthur's personal future is not an empty space to be filled by his own chosen actions but a series of events to be encountered. A Saturday night is 'one of the fifty-two holidays in the slow-turning Big Wheel of the year, a violent preamble to prostrate Sabbath' (p. 7). Each week has its rhythms and routine (including 'Black Monday' and pay-day Friday), as does each year:

The future meant things, both good and bad, to look forward to, like the coming of summer (good); military training at the end of August (purgat'ry); Goose Fair in October (smash'n); Bonfire Night (good if you didn't get blown to bits); and Christmas at Christmas. Then the new year swung its fist and dragged you blindfolded and by the neck-scruff on to the high crest of another wave. (p. 130)

Arthur is the object, not the subject of his future. Even beyond the cycle of each year is a further sense of the whole trajectory of life as pre-defined: 'Life went on like an assegai into the blue, with dim memories of the dole and schooldays behind, and a dimmer feeling of death in front, a present life' (p. 129). Here the limits of mortality combine with specific social conditions to impose the particular setting of Arthur's life. He lives in the immediate present because it is only over this that he has any control. His concern is not to act, but to react: 'It's a hard life, if you don't weaken.'

This reaction frequently takes the form of violence – a casual, normal, almost everyday violence, particularly connected with drinking. Winnie smashes a bottle at a party, Arthur thumps the wayward darts-player, the tuneless pub-singer is punched, a man smashes a shopwindow ('the sound of breaking glass . . . synthesised all the anarchism' [p. 110] within Arthur), Arthur shoots Mrs Bull, the soldiers beat up Arthur, Jane slashes her husband with a beer-glass – all such violence is localised, occasional and not directed systematically at any target. It is rather an expression of 'the common battleground of the jungle' where such violence is accepted – as Arthur reflects, of the pub-singer, 'there was no need to make a noise like that and it served him right that he had been clobbered' (p. 94). The resort to violence is a direct means of living in the present in its provision of quick solutions. In Arthur's case it is linked to his attitudes of 'couldn't care less', 'don't care about anything' and 'no use saving'.

Arthur's general lack of concern for others has led, from the book's first appearance, to charges that Sillitoe was writing irresponsibly in apparently endorsing his main character's perspective. Nigel Gray has suggested that 'Sillitoe is too much taken with the working-class hero cult' and also argues

that 'He can't seem to make his mind up what relationship he has with the "hero"'.[22] This, as Gray recognises, is largely caused by a radical instability in the novel's narrative point of view for it is certainly not the case that the novel unproblematically assumes Arthur's point of view with any consistency. There are, firstly, a number of passages in which a view of Arthur from other characters is offered. His brother Fred's vantage-point is adopted to show Arthur's fight with the darts-players and his encounters with Mrs Bull ('There were times when Fred was forced to admit that Arthur was not a very nice bloke'[23]) and there is a decisive shift at the opening of Chapter 11 to Doreen's perception of Arthur (as relayed to her work-mates): 'She created his image: a tall young man of the world nearly twenty-three and already a long way past his military service, a man who had been a good soldier and who was now a good worker'.[24]

Such instances clearly indicate the 'origins' of their information and language in the consciousness of a particular character. There is, however, also a sense in which a great deal of the writing in the novel refuses to restrict itself (in vocabulary and metaphor) to Arthur's consciousness. Sillitoe has noted that one of the problems of the novel was how 'to write a book about a man who has never read a book'.[25] To solve this he employed a number of strategies. There is the clear omniscient perspective ('July, August, and summer skies lay over the city, above the rows of houses in the Western suburbs, backyards burned by the sun with running tar-sores.'[26]) – presenting the general context of Arthur's experience, rather than how *he* is experiencing. Less straightforwardly, there is a tendency for point of view to shift erratically within a single episode, as in the opening chapter. Here, in addition to Arthur's experience, there is the man who steps over Arthur as he lies drunk (and thinks 'how jolly yet sinful it would be' to act like that), there is the 'objective' observation ('the rowdy gang of singers ... must have known that he was dead drunk'), the 'different point of view' of the waiter and Brenda's view, who saw Arthur 'push back his chair and stand up with a clatter, his grey eyes filmed over, so that he looked like a tall thin Druid about to begin a maniacal dance' (p. 8). Logically this image has its source in Brenda's perception (she

saw his eyes in a particular state), but it also corresponds to a general 'objective' fact about Arthur; at that moment he 'looked like' that to anyone (there is no necessary presumption that Brenda was especially interested in Druids). This strategy is similar to that employed as Arthur falls down stairs laughing 'at the dull bumping going on behind his head and along his spine, as if it were happening miles away, and he an earthquake machine on which it was faintly recorded' (p. 9). 'As if' here functions to free the writing from a subjection to Arthur's language. It is not that Arthur *felt* like, or *thought* himself to be like, an earthquake machine; rather the phrase suggests how the incongruity of his behaviour might be interpreted. The image does not reflect an articulated meaning drawn from Arthur's consciousness, it is a construction of the writing itself, whose terms are not necessarily those of Arthur.

It is by such strategies that the novel's discourse, while still centrally concerned with the reproduction of Arthur's experiential world, liberates itself from any possible limitations of that language or range of metaphorical allusion which might 'plausibly' be derived from Arthur himself. Even where his consciousness is apparently directly reproduced, the area of relevance often becomes extended beyond the individual through the frequent use of 'you' – 'now … you got fair wages', 'no use saving your money', 'you earned your living in spite of the firm'. The slippage between 'I' and 'you' in Arthur's reflections indicates how often they involve not so much his personal problems as his general condition – as a semi-skilled factory worker on piece-work. At such times it is frequently not clear whether such reflections are directly attributable to Arthur at all: 'the effect of a week's monotonous graft in the factory was swilled out of your system in a burst of goodwill. You followed the motto of "be drunk and be happy"' (p. 7). Generally, while *Saturday Night and Sunday Morning* is not a novel which has any sense of collective action as a way of transforming the conditions described, it does, through such strategies of the writing, present those conditions as collectively experienced; it is this which, above all, differentiates it from the heavily emphasised individualism of *Room at the Top*.

By contrast David Storey's *This Sporting Life* followed

Braine's novel in its adoption of a first-person 'autobiographical' narrative. There is, however, a considerable difference between the status of the two discourses. In *Room at the Top* Joe is explicitly reminiscing (almost writing his memoirs); Joe-narrator often interrupts the narrative to comment on the performance of Joe-hero. In Storey's novel Arthur Machin does not confront and judge his own actions as he relates them; indeed the whole status of the account is indeterminate, there is no sense of an audience or reader being addressed.

Unlike Arthur Seaton, Arthur Machin does have a specific aim to pursue: success as a Rugby League player. In the earliest view of his life (in flashback) he is 20, has left his parents' home and is working in a semi-skilled engineering job. His prospects are neither promising nor exciting, 'I could barely keep myself afloat', while Maurice, a fellow worker, by being a League player does manage to keep 'his head above the general level of crap'.[27] As the language indicates, Arthur's ambitions have general rather than specific goals – to be a 'hero', somebody 'pretty special'. Money is a part, rather than the main attraction, of the new status involved: 'I know what occupied Frank most – the fear of letting go of football, of the popularity, the money, and the friendship maybe, and subsiding into the obscurity of his fellow-players'.[28] Maurice's plans for a business venture show how, unless the players use their temporarily higher income to secure their future, their status quickly evaporates. Their position is dependent on the weekly repetition of exceptional physical ability (Storey has suggested that the game is 'extremely hard ... almost a natural extension of the experience that a man undergoes in digging coal underground').[29] It is totally different from the position and wealth of the local businessmen who control the club.

The game itself is an occasion for barely controlled physical violence. Arthur has 'a kind of anger, a savageness that suited the game very well'.[30] In his third game he hits his own hooker in the face, while the fourth is a 'brawl'. Physical strength becomes his trademark as a player: 'I'd throw them neatly over the touchline and against the concrete balustrade' (p. 213). The violence here is largely impersonal, institutionalised into the game even if officially secondary to its aims (scoring points). The novel's title is then clearly an ironic

comment on the world of Rugby League where players can deliberately deprive their own colleagues of the ball or can take a rest, leaving the work to their team-mates: 'I carried on a straight course, knowing that I could give the impression of strong attack without having to do anything' (p. 250). The 'impression' created, particularly on the crowd, is central to any status achieved as a player: 'I listened to the tune of the crowd, a sound I'd never heard before.... I raised noises from them as I might have done with a trained animal. I was big!' (p. 16). It is from the crowd that Arthur derives his sense of identity as conqueror and hero, an identity which he then attempts to transfer to his relationship with Mrs Hammond, particularly through his purchases of a television, a fur coat and a car. At the heart of the relationship, for Arthur at least, lies his lack of articulacy and understanding, a frustration which ultimately surfaces as violence. Before their final quarrel he reflects (unusually) on their relationship: 'I couldn't understand what she wanted from me.... I felt like a big ape given something precious to hold, but only squashing it in my big clumsy, useless hands.... I was a hero. And I was crazy because she seemed the only person in the world who wouldn't admit it' (pp. 161–3).

The extent to which Arthur's feelings towards Mrs Hammond become intermingled with his general ambitions is indicated by his attempts to define their relationship in terms supplied by the pulp fiction he reads. In *This Sporting Life*, a novel with a lack of dense, detailed social or cultural reference, the accounts of these novels stand out, marking the entry into a different world where physical strength and sexual fulfilment go naturally together without any of the emotional problems which Arthur finds so intractable. This popular fiction performs a number of functions in Storey's novel. Generally it 'guarantees' to the reader (through contrast) the truth and realism of Arthur's story; more specifically there are direct parallels with Arthur's own situation. He is 'impressed' by the 'tough hero' of *Blood on the Canvas*, contrasting Ted Williams's 'domestic routine' ('his blonde sample' was 'laying it on thick') with Mrs Hammond's unimpressed response to his success: 'I wondered how Williams would have handled her. Beaten her up? Slapped her down' (p. 26). Later, after

their first sexual encounter, Arthur starts reading *Tropical Orgy*. Instead of a smell of 'soap powder, steam and damp cloth', with Mrs Hammond resuming her washing 'as if nothing had happened', in *Tropical Orgy* it is 'a moonlit night on a calm tropical sea and Captain Summers had just come on deck after leaving his sample "fully satisfied and utterly contented" in his cabin' (p. 94). Here the gap between 'reality' and 'fiction' is so wide it is almost as if Storey is seeking to justify his own totally anti-romantic treatment by presenting the alternative as absurd fantasy.

The most extensive use of this device concerns Arthur's whole situation, not just his relationship with Mrs Hammond. After he has left her, been dropped from the team and stopped going to work, he reads *Love Tomorrow*, a detective novel at the end of which the hero's girl friend gets killed:

he looks round him and realizes there's nothing left. The girl's dead. He just doesn't want to go on living any more. At the end he's in the car, driving out of town. He gets on the turnpike and steps on the gas.... The road's clear and open. The car's booming along. He begins to feel better, and he starts thinking about the next town, and the next sample it probably holds.

Arthur is impressed by this solution. He tries driving out of town fast, but 'I'd only go a couple of miles, hardly leaving town behind, before I was in the next bloody place. One town started where another left off.... I was on a chain and wherever I went I had to come back the same way' (pp. 191–2). The landscape of the industrial North deflates the fantasy and constrains the possibilities of Arthur's whole life.

Subsequently the novel's close reverses that of *Love Tomorrow*. It recreates the opening scene (even down to the hunch-backed groundsman), with the match set in a landscape of grey industrial mist. Arthur, after ten years, is near the end of his career. After the parting with Mrs Hammond and now, again, after her death, Arthur suppresses all thoughts and feelings, although now there is nothing left to think about: 'I tried to think of something to occupy my mind, but as usual nothing came' (p. 246).

Storey's graphic account of how the book came to be written refers to an exceptionally sharp series of oppositions which structured his experience in the mid 1950s: oppositions between two sides of his 'temperament' (the 'self-absorbed intuitive' against the 'physical, extroverted'), between being an art student and a professional rugby player, between South (London) and North, between mental work and physical work, and between son and father. Writing then became a way to 'exorcise' the consequent 'feeling of alienation', particularly in the construction of the figure of Arthur Machin who 'represented all the alien, physical forces of this life'. This was a conscious isolation of one half of Storey's 'temperament'. *Flight into Camden* was then an essentially complementary work, exploring the other half. In *This Sporting Life* the 'northern terminus' of Storey's experience became 'associated with a masculine temperament'; the southern element ('the intuitive, poetic and perhaps precious world to which I felt I had escaped') then became associated with 'femininity, with a woman's sensibility and responses'.[31]

However, this suggests a rather less complex novel than *Flight into Camden* became. The very fact that Margaret (the narrator and central character) represents the 'mental work' half of Storey's division makes her a much more self-conscious, analytical narrator than Arthur. She is able to see how her parents' assumptions about her proper role as a woman and her brother's attempts to overcome his guilt at having left their parents' world have together blocked her life from any chance of following through the options which her grammar school education might have provided. The novel then expresses more fully the totality of the position out of which Storey was writing. As with Sillitoe, Storey's early novels are written from outside the experience they represent, but while Sillitoe's 'escape' had occurred in an idiosyncratic, almost fortuitous way, Storey's was more typical – the half-break of the 'scholarship boy'. The consequent tensions were then pushed to extremes by the intensity of the opposition between the worlds of Rugby League and mining on the one side and painting on the other (a dramatic opposition which Sigal, in *Weekend in Dinlock*, had also drawn on). Storey gave the resulting perspective on his material a precise geographical

location, one which appeared not only in his fiction, but also in many of the 'New Wave' films of the period:[32] 'often I climbed to the top of the hills around; and there poised above the industrial chaos ... wander down to the park, stare over the valley to where the railway track curled south'.[33]

While the film of *A Kind of Loving* employed this perspective Barstow's novel was more of an insider's view, although (also written in the first person) its central voice is more like that of Margaret than of Arthur Machin. Vic Brown is grammar-school educated, articulate and reflective and, unlike Margaret, he is (initially at least) well integrated within his family and community. As things go wrong the novel becomes, like *Room at the Top*, a case of 'special pleading',[34] where a series of actions which, if seen from the outside, appear inexcusable are explained and justified from the perspective of the hero. There is, however, no retrospective judgement (no effective distance is opened between Vic-narrator and Vic-hero) and no hint of Vic's disillusion with Ingrid until it appears reported within the narrative. This absence is not simply a question of supposed authenticity (the events as they happened), but also indicates that there is no definitive knowledge to be gained. Vic's closing reflections can only deliver the tautologies of incomprehension: 'the secret of it all is there is no secret ... and if you say what is life about I'll say it's about life and that's all'.[35] 'Life' is revealed as the aggregate of the infinite separate events which compose it and this becomes a principle of the writing, as many details and scenes (apparently irrel-evant to the central issue of Vic and Ingrid) are related. Vic tells of donating blood, how to shine shoes, of changing a punctured wheel and of inconsequential conversations with bus passengers and conductors.

If, however, *A Kind of Loving* were concerned only to argue the 'randomness and particularity'[36] of all experience then any ordered presentation of a particular social world would be irrelevant to its purpose. Instead what is demonstrated is the conflict between the given social norms and rituals, and Vic's actual experience. The narrative's opening is effectively inaugurated by Vic's decision 'to *do* something'[37] about Ingrid. The problem of *what* to do and what subsequently happens is constituted by Vic's simultaneous possession of three

contradictory perceptions of young women. With his family he is, conventionally, evasive and reticent ('She'll have to be up early to catch me' [p. 11]). At work and leisure (all-male domains) he sees women as sexual objects (as in the 'pin-up' books). The third area is his personal dream of the ideal partners: 'She'll be everything you could want in a girl: talking, laughing, sharing, making love, and everything' (p. 16). As the relationship with Ingrid develops these categories become disturbed, particularly as their mutual sexuality disrupts Ingrid's initial positioning as someone 'clean and pure and soft' (p. 29). Her pregnancy forces a resolution of the situation in accepted (if not approved) social terms, the quick marriage, and this is 'where all dreams end' (p. 197). As Vic comments of his own narrative, 'this is no fairy-tale and no miracle happened' (p. 215). The novel's 'realism' is then not merely a case of the assumed truth of commonsense perception, but an exposure of idealism – an exposure not through dramatic reversal, but via an appeal to the ordinary. Vic is continually reminded that his marriage is 'real and not a dream' and 'making the best of it' (a *kind* of loving) is repeatedly offered and finally accepted by Vic as the only option.

This acceptance involves a suspension of other options which the novel fleetingly offers, particularly that of 'culture' as a way of giving life meaning. In contrast to *This Sporting Life*, Barstow's novel is full of the empirical detail of late 1950s England (television, films, pop music, radio) and of the traditional working-class solidities of Vic's family. However, on the edges of this world are David (an English teacher who reads James Joyce), Conroy (with his private interest in literature and music) and Mr Van Huyten, who encourages Vic's love of classical music. While the music suggests a world which Ingrid cannot (or will not) share, David's possession of *Ulysses* (and, in particular, Vic's encounter with Molly Bloom's soliloquy) indicates that he has successfully reconciled sexuality, love and marriage in a way which Vic clearly has not. While the close of *A Kind of Loving* itself suggests either a coming to maturity or a defeatist acceptance, other elements in the novel point forward to that rewriting of Vic's future

which Barstow carried through in 1966 in *The Watchers on the Shore*.

Beyond the Closed Community – Rejection, Escape and Connection

Other novels of the late 1950s and early 1960s shared the concern to present newer life-styles emerging out of the older working-class communities. Sid Chaplin returned to novel publication, writing about 'the old streets and the old communities disappearing, and what this meant for working-class kids' and 'the fragmentation of working-class communities after the war'[38] in *The Day of the Sardine* (1961) and *The Watchers and the Watched* (1962), both set in Newcastle. More prominent were Colin MacInnes's accounts of new teenage and black life-styles in London and Keith Waterhouse's *Billy Liar* (1959). *Billy Liar* particularly asserted the urgent need to break out of the northern provincial community if the aspirant individual was to find fulfilment. Billy's particular aspiration (to be a writer) implied that this need might be as pressing for novelists themselves as for their fictional heroes.

Raymond Williams proposed and attempted a different solution. In his view the need was not to reject the representation of working-class community, but to make it part of a larger project. In 1961 this was expressed as the desirability of recapturing the breadth of intention of the nineteenth-century novelists (although not necessarily their technical forms), to rebalance the individual and the social as concerns of the contemporary novel.[39] Subsequent observations have clarified and specified this in relation to the 'working-class novel'. Neither the 'separated novel about working-class community' nor the novel of individual 'escape' would be adequate. The problem was rather to find a fictional form that would allow the description 'both of the internally seen working-class community and of a movement of people, still feeling their family and political connections, out of it'.[40] This might then involve 'the exploration of class relations and class developments ... contradictory class locations: not only intellectuals but technicians, some managers and adminis-

trators.'[41] In effect there was a demand to move towards the whole society.

Border Country (1960) and *Second Generation* (1964) were attempts to write such fiction, interconnecting different social elements, while retaining a central commitment to the representation of working-class experience. *Border Country* contrasts both the past (from the early 1920s) and the present, and different ways of life (the working-class loyalist, the university-educated son and the successful small businessman) through Matthew Price's return to his roots to visit his dying father. The geographical separation of the different worlds (and the fact that they grew from the same root) and the absence of contemporary politics made the novel seem, in the context of the moment of its appearance, a rather more straightforward novel of working-class community than was the case. *Second Generation*, however, set out to show 'contrasting worlds within a single city',[42] moving between car-workers and university academics, and seeking also to raise issues of the interrelation between familial, sexual and political commitments, particularly in the figure of Kate (wife of a shop steward and mother of a radical student). The novel's problems are mainly a result of its high ambitions – to connect, in a fully embodied realistic mode, a wide range of social situations and types. The novel had 'some of the faults of the working-class perspective ... that the farthest the ordinary perception of power can reach is some middle functionary. I have been continually struck by this limitation of horizon in working-class experience.'[43]

For Williams such a limitation constituted a problem to be worked at – in politics and in writing. From another perspective it has been viewed as an insurmountable barrier to any development of working-class writing. In the mid 1970s John Fowles was asked about the 'working-class novel':

> I've always argued that it was a kind of dead end. Once you've done one good novel about the working class, it becomes a very difficult field to go on with because culturally ... it is limited ... the thing with the middle class is that there are far more situations, middle-class people are far more complex than working-class people, and therefore, in a sense, it's just giving yourself more room.[44]

In his first published novel, *The Collector* (1963), Fowles had given dramatic form to this difference, partly in the direct contrast between the discourses of Miranda (the politically, culturally and morally aware art student) and Clegg (an essentially lifeless lower-class anti-hero), and more explicitly in Miranda's comments on *Saturday Night and Sunday Morning*: 'I hated the way Arthur Seaton just doesn't care about anything outside his own little life. He's mean, narrow, selfish, brutal.'[45] In the figure and fate of Miranda, Fowles (in a very different way from Williams in *Second Generation*) directly addressed the question of the repeated subordination and objectification of the women characters in the first novels of Sillitoe, Storey and Barstow; at the same time *The Collector* as a whole suggested the issues of working-class subject matter, realism and the celebration of male domination to be not merely connected but inseparable.

By the early 1960s, other texts besides *The Collector* had begun to take up these issues, particularly through a central focus on a new kind of woman character. Lynne Reid Banks's *The L-Shaped Room* (1960) had already reconstituted the elements of *A Taste of Honey* (pregnant independent girl, a homosexual, a coloured man, a vaguely bohemian menage) into fiction, Margaret Drabble had begun her long series of realistic presentations of young middle-class women and most significantly Doris Lessing's *The Golden Notebook* (1962) had clearly suggested the need for fiction which would problematise realism as a means of opening up a range of political, aesthetic and gender issues.

Working-class fiction was also under pressure from a different quarter – that of the reviewer and the critic. As the 'reaction against experiment' of the 1950s came to be deemed a regressive step[46] so writers such as Sillitoe, Storey and Barstow came to find themselves in a kind of double-bind. If they continued to write about working-class life they were criticised for lack of development, if they changed their subject matter and style they were reproved for not sticking to what they were good at. Sillitoe, in fact, with the title story of *The Loneliness of the Long Distance Runner* (1959) had initially managed to avoid this dilemma by a narrative which was both clearly set in a contemporary working-class context and

offered itself as a kind of existentialist parable. However, when he published *The General* (a novel about the fate of an orchestra in an unspecified war in an unnamed European country), much of which had in fact been drafted in 1953–4, he was told by Walter Allen that despite 'full marks for courage', he should, as the 'most exciting chronicler in fiction of contemporary working-class life' get 'back to your factory-hands and Borstal Boys'.[47] The novel was, said John Coleman, 'a sterile exercise in placelessness'.[48] On the other hand *Key to the Door* (October 1961), based very generally on Sillitoe's experiences in Nottingham, and particularly in Malaya, was placed by Simon Raven as not art 'but documentary of a high order'[49] and by Frances Hope as 'not a novel at all' but 'great slabs of raw material'.[50]

Through the rest of the decade Sillitoe's work can be seen as a particular version of (as Williams puts it) 'the experience of flight', particularly in the first two novels of 'Frank Dawley trilogy': *The Death of William Posters* (1965) and *A Tree on Fire* (1967) where the 'flight' is both away from the working-class Nottingham of Arthur Seaton and towards a kind of political commitment with the FLN in Algeria. Storey published no further fiction at all during the 1960s after *Radcliffe* (1963) which attempted to bring 'the two halves' of Storey's 'temperament', 'into the same arena'[51] in a novel whose explicit symbolical dialectical quality is suggested by its epigraph taken from a characteristically enigmatic Yeats dialogue between 'The Soul' and 'The Heart'. His novels of the 1970s, particularly *Pasmore* (1972) and *Saville* (1976), constitute a return to the issues of family, class, education and identity defined in *Flight into Camden* – answering Williams's call for a fiction which would combine the internal analysis of working-class community with the problems of the 'movement out'. Barstow's attempts to deal with the same problem in a more muted way are found in *Ask Me Tomorrow* (1962) (with its central figure an aspirant working-class writer) and, particularly, in *The Watchers on the Shore*, where Vic breaks with Ingrid, moves South and becomes involved with Donna, middle-class, intelligent and an actress. Here a figure of the 1950s novel who had been characteristically dismissed either comically (Margaret in *Lucky Jim*) or tragically (Alice in *Room*

at the Top) was released to serve as the representative of the wider world beyond the northern working-class community.

While Sillitoe and Storey have now generally been expelled from the canon of contemporary serious novelists,[52] Barstow was scarcely ever acknowledged as a possible candidate. From the first reviews of his work his writing was seen as lacking in any aesthetically interesting features. *A Kind of Loving* was 'deliberately limited to . . . flatly realistic description'.[53] His characters were 'flat but lifelike. Mr Barstow is a scrupulous naturalist';[54] the book was 'so true to life that it achieves no significant artistic effect'.[55] Barstow in particular suffered from his supposed transgression of the same category distinctions as had been used to criticise the novelistic features of certain sociological and social exploration texts of the period. In this respect John Fowles has commented that 'because these working-class novels that Sillitoe and all the rest wrote are sociological, this raises another question of whether modern sociology can't do all that better – can't it all be done better by the television documentary, and I think possibly the theatre – than the novel?'[56]

The assumptions here raise a number of questions (concerning the 'middle-class novel' and the nature of 'sociological' writing) other than that which Fowles notes. His comment does reflect, however, an influential position which, as a matter of principle, would exclude certain modes of realist writing about working-class life from the proper business of fiction; it was a position, moreover, which despite Fowles's suggestion, was equally, if not more, prevalent, within the theatre of the period.

4. In the Theatre – the Limits of Naturalism

WITH the return of a Labour government in 1945 those left-wing theatre groups who had managed to survive since the 1930s seemed to be entering upon a situation – a Socialist Britain – especially favourable to the development of a genuine people's theatre. The enormity of this misjudgement is clear only in retrospect. The decade following 1945 proved the most inhospitable and unproductive in the twentieth century (to date) for both socialist and working-class cultural activity. This was particularly marked in the area of theatre as demonstrated by the experiences of three of the most durable left-wing theatre enterprises of the period: London Unity, Glasgow Unity and Theatre Workshop.

Unity Theatre in London had managed to continue its operations throughout the war and in 1945 laid plans to 'launch a professional company ... along the lines of the famous Theatre Workshops in America and the U.S.S.R.'[1] By 1947 this had become established and was joined by a magazine, *New Theatre*, intended to serve as a focus for left-wing theatrical initiatives. For Ted Willis, the moment was one of optimism; he later recalled 'the flourishing position of Unity Theatre which then had forty branches, two professional companies and over a quarter of a million affiliated members'.[2]

During 1948 ('a very bad, breaking year, quite generally'[3] for many left-wing cultural projects) Unity's professional groups were wound up. Willis noted that 'the Labour Movement ... was not prepared to dig deep into its coffers to provide the long-term financial support necessary'.[4] However, Unity's marginalisation was not due only to general parsimony or poverty, but also to their perceived political affiliations. A satirical revue (*What's Left*) at Unity in 1948 was labelled by

T. C. Worsley as in the 'tradition of satire from the extreme left ... the satirical line is lifted more or less from the *Daily Worker*'.[5] Particularly after Unity resumed amateur status this political 'extremism' was linked to lack of theatrical quality. In 1949 *Theatre World* dismissed *Where's that Bomb?* as 'crudity in propaganda ... carried to the point of childishness'[6] and, in 1953, reviewing *The Bridge of Life*, it commented that while 'the play has great interest on account of its close connection with reality and its ability to show us "how the other half thinks"', there was 'no acting in the artistic sense'.[7]

Even during the late 1950s Unity's clear political position was still seen as a crippling deficiency. In 1958 Bernard Kops, one of the new generation of playwrights, argued that: 'What we lack is the spirit of experimentation and adventure. The unity of the old Unity Theatre should serve as an example. If we had that unity without political affiliations a vital theatre would be born once again.'[8] Later in the same year Wayland Young (in a letter supporting Theatre Workshop's claims for financial support) was more explicit in referring to Unity as 'a company dedicated to presenting Marxist tracts'.[9] The work of Unity was conspicuously never granted legitimacy as part of the post-1956 'vital theatre' movement.

Despite the similarity of name Glasgow Unity was not, like London Unity, a product of the Popular Front period of the late 1930s, but rather of the wartime conditions when loss of personnel and facilities necessitated the amalgamation of five socialist theatre groups in 1941. While the political and aesthetic aims were broadly similar to London Unity there was also a specifically Scottish dimension to the project: 'Glasgow has great need for a Real Theatre where life can be presented and interpreted without prejudice or without being biased by the controlling interests which have so far strangled the professional theatre.'[10]

In 1946 they also turned professional and in September 1946 they first staged Robert McLeish's new play *The Gorbals Story* which was to prove virtually the only play about working-class life to make any inroads into the dominant theatre culture of the late 1940s. The play presented one day in the life of eight families sharing a Gorbals slum kitchen; there was no single plot line but rather an emphasis on social detail and

atmosphere. During 1946 and 1947 the play toured extensively
in Scotland and helped to place the professional company on
a sound financial footing. *The Gorbals Story* was seen by nearly
100,000 people by April 1947. In January 1948 the play was
brought to the Garrick Theatre in London's West End, where
it gained a varied response from critics. In *Tribune* the
comments foreshadowed those made about aspects of the post-
Osborne theatre of the late 1950s; it was 'a play of honest
coarseness, rich in comic and pathetic incident, a play about
life in 1948 – and how welcome it is after the elocutions of
genteel phantoms from rectories and country houses that
people the West End stage.'[11] This relatively encouraging (if
rather patronising) comment contrasts with the aggression of
T. C. Worsley in the *New Statesman*. The play represented 'the
elsewhere happily outmoded convention of Socialist Realism.
This depressing school of writing gave us many drab pages
before the war. Let us pray that the infection at this late date
won't invade the theatre. For the extreme Left anything else
would, one supposes, count as heresy. . . . The characters don't
do anything. This, I think, is what makes Socialist Realism so
appallingly dull.'[12] This double handicap of politics and
realistic representation of working-class life (both seen as
outmoded, part of a pre-war world which had been surpassed)
proved insuperable in terms of Glasgow Unity's chances of
being accepted as part of West End theatrical culture. There
were other, internal, stresses also; the move of the professional
company to London and elsewhere in 1948 meant a partial
severance of their community base and by 1951 both the
professional company and its sister amateur company had
folded completely.

Of the three groups discussed here Theatre Workshop
would, from 1945–8, have seemed the least likely to survive
to make a major impact on established theatre ten years later.
The group had existed in Manchester in the 1930s (under the
joint leadership of Ewan MacColl and Joan Littlewood), had
totally dissolved during the war and reformed only in 1945.
During the late 1930s they had been relatively isolated from
more well-known left groups, such as London Unity, where
an emphasis on content (whether social realism or political
satire) had displaced the attention to theatrical forms of the

earlier Workers' Theatre Movements. It was this, however, which had characterised the group's approach and its post-war manifesto (in which it took the title of Theatre Workshop for the first time) stated its intention to 'create a flexible theatre-art, as swift moving and as plastic as the cinema, by applying the recent technical advances in light and sound, and introducing music and the "dance theatre" style of production'.[13]

Between 1945 and 1953 (when they moved to Stratford East) these techniques were applied to a very considerable range of material in a great variety of venues. The dramatic representation of recent and contemporary working-class life constituted a significant, but never dominant, intention during this period, particularly through plays by MacColl. The first post-war production was *Johnny Noble*, a ballad opera set 'against the background of 1930's unemployment, the Spanish Civil War and the war years'. The treatment was, however, by no means social realist: 'all transitions in time and space were made by sound, light and sung narrative'.[14] During the period their most successful and enduring play was *Uranium 235*, explaining 'the whole history of Atomic Energy' with comic sketches, songs and gangster movie elements. Among plays which did attempt direct contemporary social representation were *The Long Shift* (by Littlewood and Gerry Raffles) about miners at work, where the set was painted with real coal dust and the play performed in genuine miners' shorts (donated by the miners themselves) and MacColl's *Landscape with Chimneys*. However within the context of Theatre Workshop's whole repertoire such plays were relatively unsuccessful and when the move to London came in 1953 the emphasis shifted even further towards classical and recent European plays. MacColl's departure from the company at this stage was a crucial factor in this. He left because he feared the loss of a political dimension through integration into the established theatre and his departure left the group without a regular playwright – a gap never to be filled. Between 1953 and 1956, as Theatre Workshop gradually built a reputation centred on Littlewood's style of production, the key plays were *Volpone*, *Richard II*, *Arden of Faversham* and *Edward II*. Beside

these an attempt at a local play about Stratford life, *Van Call*, was poorly supported and lasted only three weeks in 1954.

Without Arts Council support or a strong community base the finances of Theatre Workshop were always under threat and, equally, as long as it remained essentially a 'fringe' theatre (outside the West End) its impact on the theatre world was inevitably slight. Only by transferring plays to the West End could it survive and this (from 1956) is what increasingly happened. The second such transfer was particularly success-ful and constituted a major breakthrough. Brendan Behan's *The Quare Fellow* (as adapted and re-written in rehearsal by both Littlewood and Behan) was first produced at Stratford in May 1956 (the same month as *Look Back in Anger* at the Royal Court) and transferred to the West End for a three month run in July. It was this play which established Theatre Workshop firmly as part of the new wave of 'vital theatre' and also associated them with the idea of producing plays concerning contemporary situations. Nevertheless, with the exception of a three-week run of a new play by Henry Chapman in October 1957, *You Won't Always Be on Top* ('a day in the life of a building site'[15]), between mid 1956 and mid 1958 Theatre Workshop's programme consisted again of a mix of classic plays (Webster, Shakespeare, Molière, Synge, Shaw) and modern plays from abroad (Pirandello, Sartre, Tennessee Williams). It was not until *A Taste of Honey* in May 1958 that they produced a play by a new British playwright which could be viewed as part of the post-Osborne revolution. As Tom Milne pointed out approvingly in September 1958, 'in the thirteen years of its existence, Theatre Workshop has produced some 70 plays, a catalogue of which reads remarkably like the repertory one would hope to find at our hypothetical National Theatre'.[16] It was in fact precisely a condition of Theatre Workshop's success in breaking into established theatre that it did *not*, unlike both London and Glasgow Unity Theatres, give particular prominence to plays depicting contemporary working-class life.

Vital Theatre 1956–60

The considerable change of mood and direction which took place in British theatre between 1955 and 1958 resulted from the conjunction of a number of different developments. Theatre Workshop's modes of performance were an important factor. Among others were the influences from America of (since the late 1940s) Arthur Miller and Tennessee Williams and (more latterly) the new 'Method' acting, the first English staging of *Waiting for Godot* in 1955, the visit of the Berliner Ensemble in 1956 (together with a growing sense of the importance of Brecht) and, of course, the arrival of the English Stage Company, launched under George Devine at the Royal Court in 1956.

The very diversity of these elements makes this moment difficult to map, partiularly in terms of defining any common goals which the emerging generation of playwrights (and their producers) shared. However there was some agreement as to what they were against – predominantly the well-made middle-class play of Coward, Rattigan and Bagnold and, as a secondary target, the abortive earlier attempt to provide an alternative to this in the verse drama of Fry and Eliot. The lack of common positives was somewhat masked by the adoption of the phrase 'vital theatre' as a shared aspiration. 'Vital theatre' was the phrase selected to reflect the programmatic aspect of the journal *Encore* (begun in 1955) which became the chief theoretical medium of the new theatrical generation. The very generality of the phrase was its greatest asset (Ted Willis suggested that it meant 'strong, energetic, powerful, lusty and essential to life ...'[17]) and this enabled the journal to conduct a lively internal debate as to the character and achievements of the new theatre. Among the issues raised (although significantly not the most prominent) was that of its social representativeness. In September 1957 David Watt noted that although *Look Back in Anger* had both reflected and appealed to a specific social group it was only 'a small lower middle-class intelligentsia whose frustrations and bayings were reflected'. He pointed out that for 'a perfect balance to be reached' there would need to be 'two London theatres for Mr. Douglas-Home and the nobs; half-a-dozen

for Mr. Osborne and the espresso bar egg-heads; a dozen for the yet unborn genius from Harlow and his friends from the housing estates'. He concluded that 'we must concentrate upon making the English theatre more representative'.[18]

Shelagh Delaney's *A Taste of Honey* was the first play of the post-Osborne era which seemed to answer this need. The central concerns of the play – the predicament of Jo, her pregnancy, her relations with her mother, with the coloured boy and with her homosexual lodger, Geoff – were presented through an amalgam of naturalism and Theatre Workshop self-conscious theatricality.[19] It was, however, rather the general setting – northern, lower-class, contemporary life – which marked the play as an important new departure. For Lindsay Anderson, in *Encore*, it had: 'all the strength and none of the weaknesses, of a pronounced, authentic, local accent. Going north in Britain is always like a trip into another country, and *A Taste of Honey* is a real escape from the middlebrow, middle-class vacuum of the West End.' The review continued by reinforcing this idea of the play as the authentic and unmediated presentation of experience. It was 'written in vivid, salty language and presented without regard for conventions of dramatic shape ... we simply respond as to the experience itself'.[20] Other reviews of the Stratford East production stressed the social realism rather less and were more inclined to see it as a typical Theatre Workshop production. Alan Brien in the *Spectator* saw it as a 'boozed, exaggerated, late-night anecdote of a play',[21] while *Theatre World* announced that Theatre Workshop was introducing 'another Irish writer to the English stage' who was 'an angry young woman'.[22]

The play was revived early in 1959 at Stratford and transferred to the West End in February 1959 where it ran for nearly a year. It was now viewed more consistently as a realist project. Alan Brien changed his perspective, now seeing it as 'unlike almost any other working-class play in that it is not scholarly anthropology observed from the outside through pince-nez, but the inside story of a savage culture observed by a genuine cannibal'.[23] The double guarantee of authenticity through the combination of personal knowledge and close observation suggested the equation of artistic success with

truth to social detail. In the language of 'social exploration' the working class were an unknown community ('another country' as Anderson put it) needing investigation. Colin MacInnes's review in *Encounter* (April 1959) was a more sustained development of this interpretation, valuing the play precisely for its accuracy in describing a range of usually ignored social types and experiences with 'no patronage, no drama – just the thing as it is taken straight'. Much of MacInnes's review (entitled 'A taste of reality') compared these achievements favourably with the general state of British 'culture': 'as one blinks unbelievingly at "British" films and stares boss-eyed at the frantic race against time that constitutes the telly, it is amazing – it really is – how very little one can learn about life in England here and now.' In the face of this situation, Shelagh Delaney was presented as a symbol of hope: 'down from Salford comes this splendid young prophetess who, with typical good sense . . .'.[24] Salford itself was profoundly suggestive as a symbol; it was the 'classic slum', the setting for such archetypical northern texts as *Hobson's Choice* and *Love on the Dole*. In the very idea of 'a play from Salford' the three connotations of realism, working-class life and the North were fused together.

MacInnes reviewed the play from the perspective of a writer who was himself committed to the depiction of 'life in England here and now' in both fictional and social exploration forms. *Theatre World*, on the other hand, considered the play from the perspective of established West End theatrical norms: its review combined qualified praise with a subtly patronising tone: 'the author has set her play in her home town in Lancashire because this is the setting she knows well and the dialect she can work most easily in until she has a wider experience of life. But her characters are universal.' The implications of cultural slumming, acceptable for a time, but only within limits, are clear. The review went on to describe the setting of the play as 'admirably sordid',[25] while a photo-feature in the next month's issue had captions referring to 'a mother's sordid liaison with a younger man' set in a 'sordid furnished flat'.[26]

Aspects of the judgments of both MacInnes and the *Theatre World* reviewer appeared in T. C. Worsley's reflections on the

play in the *New Statesman*; however, Worsley went further than either in trying to place the play's commercial success in a wider perspective:

> The English play can now break through the class barrier at will. That objective has been achieved. Now the question is what is going to be done with the ability? Those who were young in the Thirties will remember much the same thing happening with prose writing. What a sense of liberation we felt when the 'proletarian' writers seemed to have burst through the barrier of the sensitive novel! And doubtless, young writers for the theatre now feel the same thing. It is an exhilarating sensation, but they had better make the most of it for it is, as Wordsworth found and history shows, shortlived.[27]

This kind of assertion had all the makings of a self-fulfilling prophecy, with its assumption that the gaining of the supposed first objective (the presentation on stage of contemporary working-class life) had to be immediately superseded by something further. These comments attracted an immediate response from one of the most recently arrived of these 'young writers' – Arnold Wesker. Wesker denied that the presentation of working-class experience was a self-conscious project – it was simply that 'Kopps, Delaney, Behan and myself and others have written out of our own experience. ... I didn't write *Chicken Soup with Barley* simply with "working-class types" but because I saw my characters within the compass of a personal vision.'[28] Wesker's response illustrated how far the situation had developed between the original Stratford East production of *A Taste of Honey* (May 1958) and its West End run (beginning February 1959). There was now sufficient evidence of contemporary working-class life being represented on the stage for general definitions and debates to begin to emerge. By 1961 John Mander could write of 'the breakthrough of a new working-class drama on the West End stage ... today there are a dozen working-class dramas as good as the standard fare of the West End playgoer,'[29] while in the *Sunday Times* Noel Coward recognised a similar situation – even if his valuation of it was diametrically opposed:

A very large proportion of English people, even in our tax-ridden Welfare state contrive to live, if not graciously, at least comfortably. . . . For all the eager young talent of today to be encouraged to dwell exclusively on the problems of a fast-diminishing proletariat seems to me to be not only foolish but definitely very old-fashioned.[30]

A somewhat later, but similarly negative judgement was made in 1965 by Robert Brustein concerning the 'new plays, many of which reek with sentimentality about the working class'. According to Brustein 'the dominant style of recent English drama has been social realism' which 'has long been exhausted as a medium for fresh dramatic insights and has long been abandoned by the more adventurous dramatists of Europe'.[31]

All these comments implied the existence of a significant body of work which by the early 1960s was, through 'social realism', committed to the presentation of contemporary working-class life on the stage. As well as Delaney and Wesker (whose *Chicken Soup with Barley* was first produced in July 1958), the authors and plays characteristically invoked were Bernard Kops (whose first play, *The Hamlet of Stepney Green*, was staged in the same month as Wesker's), John Arden's *Live Like Pigs* (September 1958), Alun Owen for *Progress to the Park* (February 1959) and the comedies of Willis Hall and Keith Waterhouse, particularly *Billy Liar* (September 1960). While this constituted a considerable range of material it hardly represented, however, a dominant tendency within the new 'vital theatre'; Osborne's plays could not be seen in this way, nor Pinter's, nor indeed most of Arden's. Further, even those plays mentioned above could, for the most part, only with difficulty be accommodated within Brustein's formula of 'social realism' about the 'working class'. Kops's plays may have had their points of departure in East End naturalism but they characteristically moved away from these very swiftly. Arden's *Live Like Pigs* provided a more complicated case. Simply described, the setting and issues of the play suggest a dramatisation of the negative version of Curran's 'New Estate' thesis; the stage represents two neighbouring houses in a 'post-war Council Estate in a north-country industrial town' where

two families representing 'different ways of life'[32] are brought into conflict. The play, however, refuses the category of 'social realism' both by its stylised language (particularly in the case of the nomadic Sawneys) and the use of song to introduce each of the seventeen scenes. The problems that this posed both for the original production and for contemporary audiences and reviewers are suggested by Arden's subsequent comment that 'the singing of the ballads should be in some way integrated into the action or else cut out. At the Court they were unsuccessful because the singer was put on the stage between the scenes and quickly taken off again so that no one was really clear whether he was in the play or out of it.'[33]

The plays of both Owen and Hall and Waterhouse were also set clearly in the North, but posed less extensive problems with regard to their status as naturalism. Owen's *Progress to the Park*, however, centred as much around the observing and commentating figure of Teifion (a Welsh Liverpudlian on a visit home from London where he has established himself as a television scriptwriter) as on Liverpool life itself. Owen himself went on to write his major works of the period for television. The hero of Hall and Waterhouse's *Billy Liar* (based on Waterhouse's novel) was less successful – the desire to be a television scriptwriter remaining as only one of his fantasies. Waterhouse and Hall were quite clear that the play was not about the working class but rather the 'lower middle class'; they also recommended that in the culminating third act where Billy's verbal fantasies take over, the lighting of the set should be used to move away from the 'complete naturalism' of the earlier acts to 'underline Billy's escape into a world of fantasy'.[34]

When the dramatic productions of the period are considered in detail it becomes clear, in fact, that there was never such an extensive body of work devoted to the naturalistic representation of contemporary working-class life as was implied by the comments of Mander, Coward or Brustein – or indeed as occurred in the fiction and cinema of the period. This is perhaps not surprising given the major obstacles such work would have faced in making headway within both the established (West End) theatrical institutions and the 'vital theatre' movement itself. In the latter case these obstacles

arose out of three closely related issues – the limitations of naturalism, the nature of the audience and the general relation between class and culture.

Naturalism, Class and Culture

Within 'vital theatre' there were two impulses which, although often appearing together in any individual position, tended to produce direct points of contradiction – the desire for greater social representation and the reaction against naturalism. David Watt's call in 1957 for a theatre for the people from 'the housing estates' remained a frequent plea in *Encore* well into the early 1960s. In 1962 Philip Hobsbaum was still calling for more local playwrights who 'should be encouraged to hold the mirror up to nature – not that of Mayfair but of Rotherham, Barnsley, Scunthorpe or Salford'.[35] Characteristically for the early 1960s the issues of realism and class representation became here fused into a direct North/South opposition. In 1959 Ted Willis, in a live debate with George Devine on 'Vital Theatre' (sponsored by and reported in *Encore*), had been equally convinced of the need for this kind of theatre – and not at all persuaded that it had yet been achieved:

> Never was there such a period with so much material for dramatists, and never was so little of it reflected in our theatre. There has been a social revolution which is still going on. ... I live on the fringe of a big L.C.C. estate full of ordinary working-class people. Before the war, one in every three houses would have an unemployed man, an unemployed son. Now they are all working, and there's quite a bit of money coming into the house. A working-class woman who lives near us has a husband who is a steel erector, and they have just bought a car. Well I can't tell you the difference this has made.[36]

By implication Willis was calling for a direct theatrical presentation of this 'difference'. Willis himself, through his involvement with Unity Theatre, his own stage plays and his television work (both single plays and the series *Dixon of Dock*

Green) had shown a commitment to the transcription of contemporary social reality within the general framework of theatre naturalism. By 1959, however, he was seen as part of an older generation of theatre which had been superseded.

For if there was one theatrical opinion on which almost all proponents of 'vital theatre' agreed it was that they were against 'naturalism'. The precise reasons for, and terms of, this opposition varied. Raymond Williams had expressed his reservations firmly in *Drama from Ibsen to Eliot* (1952) and in the late 1950s he extended these into an assessment of the post-1956 developments; referring to himself as a 'critic of naturalism' he defined the form of *Look Back in Anger* as naturalistic and connected this to the play's theme, 'the traditional liberal revolt – the break-out of the frustrated individual – which this form has always best served'. He argued that after 1956 there had been two kinds of break – a new content within realism and an assault on naturalist theatre. It was the latter, he asserted, that in 'the long run is probably the decisive trend'.[37] Stuart Hall expressed similar reservations, if also some ambivalence, in summing up the positive elements of the post-1956 achievements: 'naturalism in any pure sense has never been an adequate form: but the attempt to capture the rhythms and situations of real life has always been there as a mainstream.'[38]

The politically agnostic sector of 'vital theatre' had no such problems of a split response. John Whiting felt that 'the substitution in literature of the bed sitting room for the drawing room, and the dustman for the duke is no achievement for realism. ... We face the prospect of having nothing in this kind of theatre but plays for peasants.'[39] Charles Marowitz, in his 'Cynics' Glossary' defined naturalism as 'Like when the guy talks like everyone else like'[40] – by implication the unselective reporting of uneducated speech – while Peter Brook commented, 'what was bourgeois and still is bourgeois in our theatre is its approach to people. We still think of people in naturalistic terms.' To make his aesthetic preferences even clearer, Brook noted that: 'I want one day to make a documentary about a film being dubbed.'[41]

The strength of feeling against naturalism led to a number of attempts to differentiate between the new social realism

and 'naturalism pure', not merely in terms of a new social content, but also of their being two entirely different formal enterprises. In November 1957 Lindsay Anderson reported that in his theatre work he was consciously drawing on 'the anti-dramatic poetic concentration on the everyday which has characterised some of the later developments of neo-realism'[42] – specifically within European cinema. In 1961 Albert Hunt searched for similar terms in attempting to define 'a poetry of physical reality':

> Objects in the naturalist theatre do not exist in their own right. They are there simply to convince us that what we are seeing is 'real'. In other words, they are not objects, but conventions.
>
> Before 1956 British theatre had become conventional in the emptiest sense of the word. . . . The poetic realism I have been describing, far from being little more than naturalism . . . restores physical reality in a theatre, on a stage, to its rightful importance.[43]

While Hunt's arguments were not entirely convincing he did at least try to break through the impasse which the fear of naturalism had caused in the development of theatrical forms which would 'capture the rhythms and situations of real life'. The difficulties here were, however, even more deep-rooted than the contemporary debates acknowledged. Looking back on his own position in that period Raymond Williams has offered a detailed analysis of the issues involved. Initially he had preferred 'expressionism' to 'naturalism' as 'an effort to reform the play itself to capture a wider social and historical experience than the naturalist limitation to the single playing space permitted'. In practice naturalism implied a room or a set of rooms 'overlooked' by the audience:

> The most powerful physical image created in the period of major naturalist drama is the living room as a trap. People look through the window to see what is happening in the world beyond, which cannot be shown. Messages come through the door from the world outside, but the centre of dramatic interest is inside. A passive sense of the environ-

ment, not merely as forming – which in my view is a progressive notion – but as totally determining – which in my view is not – is eventually embodied in this immobile, trapped form.

Despite this Williams argues that the overall naturalist project ('of a drama attached to history, society and secularity') was and is correct and progressive. What was problematic was its operation within the institutions (historically variable) and technical possibilities (less so) of live theatre:

> far more mobile forms are possible within film and television, ... the camera now precisely allows television or film to do what the theatre in the 19th century could not. It permits the resumption of public actions in fully realized locations of history, moving drama out from the enclosed room or the abstract plain space to work-places, streets and public forums.[44]

At root the point here is very simple. Plays such as *Look Bank in Anger* and the Wesker Trilogy were essentially a continuation of the naturalistic form in that they remained within the domestic room. The move out beyond that was only possible in theatrical terms by starting from a totally different point formally – a point which would not allow a central stress on 'realization' (Williams's term) or, as Hall put it, on 'the rhythms and situations of real life'. In practice, in the post-1968 period, when theatre began to move out into the streets in another sense, these formal problems were addressed in a totally different way.

In the retrospective *Politics and Letters* Williams has also recognised the long-term problem of the composition of theatre audiences: 'high naturalist drama was never achieved precisely because of the constriction of the form by the nature of the London theatres as institutions, and the class character of the audiences they represented.'[45] In the mid 1960s Robert Bolt put one aspect of this problem (the absence of a working-class audience) in fairly bald terms; perhaps they had come once, 'but that was in the days before they had telly and cinema ... as long as the distinction "working class" exists with all it

implies in terms of education, type of work and physical circumstances, I greatly doubt whether they will come.'[46]

This absence was noted even in the case of Theatre Workshop whose situating of themselves in the East End was seen by some as evidence of a desire to reach a working-class public. For MacColl of course it had indicated precisely the opposite:

> Before this the level of discussion had been 'What are we doing wrong when we take a play about mining to a Welsh coal village and the miners don't care?' This is a perfectly valid question. ... But the new questions were going to be 'How are we going to get Harold Hobson? What is he going to think of us?'[47]

Views differ as to how far Theatre Workshop ever attempted to build a local working-class audience at Stratford East and, if so, how far they succeeded. According to Harry H. Corbett: 'We never appealed to the working class. All I could ever see were beards and duffle coats every time I peered into the audience.'[48] Allowing for exaggeration there was clearly sufficient truth in this to raise doubts in the minds of the politically concerned proponents of 'vital theatre' as to the nature of their target audience. In 1959 Ted Willis queried the relevance of Tynan's famous comment on *Look Back in Anger* that over 6 million people (all the population between 20 and 30) would identify with Jimmy Porter: 'I've never heard such damn nonsense in my life. This is what a small section of young people were thinking, but it certainly isn't what six and a quarter million of our younger generation were thinking.'[49]

This issue of presumed audience was directly linked to the question of the kind of dramatic material to be written and produced. Assuming that it was desirable (and possible) to attract a working-class audience what plays were they to be offered? The answers here ranged along a spectrum. At one end was the view that a working-class audience required a working-class drama – whether directly representing aspects of working-class life or constructed in the interests and on behalf of the working-class. This, to generalise, was the

position of Unity Theatre in the whole post-war period and also of Theatre Workshop up to 1953. This position did not necessarily require a naturalistic form or contemporary social content (as Theatre Workshop had shown in both cases), but it did demand a theatrical policy with a political dimension of a fairly explicit kind. It was this dimension which a post-1956 'vital theatre' could not easily accept.

At the other end of the spectrum was the view that precisely what was at stake was the separation of the working class from the achievements and experience of high-quality art. This was eventually the position adopted by Arnold Wesker. It was ultimately in the figure and activities of Wesker that all the debates over naturalism, over the composition of the audience and concerning the relations between class and culture coalesced. Wesker more than anyone else, articulated, experienced and bore the weight of all the seemingly insoluble problems of the attempt to make live theatre responsive to the changing conditions of working-class life in the period.

Wesker – The Trilogy

Of all the post-Osborne playwrights Wesker seemed most clearly to be a product of the new opportunities created. He recorded that it was after seeing *Look Back in Anger* that 'I just recognized that things *could* be done in the theatre, and immediately' went home and wrote *Chicken Soup*'.[50] The play progressed through the influence of Lindsay Anderson (whom Wesker had met at a Free Cinema show) to Coventry's Belgrade Theatre and to the Royal Court in July 1958. *Chicken Soup with Barley*, more clearly than anything before, confronted the question of the difference between the 1930s and the 1950s. This was not however the difference between depression and affluence (consideration of which Willis was to call for in the following year); it was rather the loss of political certainty. The form was clearly naturalistic with its setting of the main family living-room in each of the three acts (set in 1936, 1946–7 and 1955–6) and the importance Williams attributes to the door and window as points of connection with the outside world is clearly in evidence. In the first act, the shouts of the anti-Fascists outside and the reports of characters rushing in

support the sense of unity between community and family, as the Kahns' living-room serves simultaneously as a place for everyday living and political organisation. During the Second Act decline in family solidarity and political direction go hand-in-hand. By Act Three the community has fully disintegrated – the family is reduced to Sarah (who alone believes that 'the fight still goes on'[51]) while now the 'messages ... from outside' are the cries of a girl who has 'just spent the evening watching television with Philip and it was a horror film or something and he kept frightening her'.[52] Instead of political activity expressing links between community and family there is the trivialisation of mass culture signalling the collapse of community in the new flats, 'these flats are a world on their own. You live a whole lifetime here and not know your next-door neighbour.'[53]

The play in fact began to address explicitly a whole range of political and cultural questions central to the New Left, and suggested that any solution was a matter of emotional response and engagement rather than specific political action ('You've got to care or you'll die'[54]). However, precisely because it dealt with what Hoggart had called 'the politically conscious minority' within the working class (as well as the Jewish community) the play did not invite a reading as direct representation of the contemporary working-class condition (indeed the *Theatre World* reviewer referred to the play as 'a realistic study of middle-class family life'[55] – although this was hardly a general opinion).

Roots (June 1959) was a different matter. Here Wesker presented directly both the cultural condition (wretched) of the contemporary working class and the terms in which it might be criticised (through Beatie, particularly in her report-ing and imitation of Ronnie's speeches). Again the form was naturalistic – various rooms within the cottages of Beatie's family where, as Wesker's stage directions indicate, 'through-out the play there is no sign of intense living from any of the characters – Beatie's bursts are the exception'.[56] Despite the figure of Stan Mann the play does not suggest that the present cultural vacuity of the working class is a specifically contemporary phenomenon. Rather a cultural deprivation

which derived from economic deprivation is now being maintained by popular music, television, apathy and lack of self-questioning. Beatie's final speech now puts the question of 'caring' in a general cultural context as well as laying out the analysis (if not the tone) which Wesker was to bring to his involvement in Centre 42:

> The writers don't write thinkin' we can understand, nor the painters don't paint expecting us to be interested – that they don't, nor don't the composers give out music thinking we can appreciate it. 'Blust' they say 'the masses is too stupid for us to come down to them. Blust', they say, 'if they don't make no effort why should we bother?' So you know who come along? The slop singers and the pop writers and the film makers and women's magazines and the Sunday papers and the picture strip love stories. ... The whole stinkin' commercial world insults us and we don't care a damn.[57]

This is more like the analysis of 'difference' that Ted Willis had asked for, although it contradicted his optimistic assessment of the material advances of affluence. *Roots*, above all, did not merely analyse or summarise the state of working-class culture, it presented its substance (in the family scenes at the Bryants and Beales) for the audience's observation. There was then, as John Mander pointed out, a common acceptance that the play should be judged with reference to such presentation: 'there is often agreement on this point between those who admire and those who dislike the play. The latter condemn the play as "naturalistic" in the pejorative sense. The former praise it for being a faithfully recorded slice-of-life.'[58] So while Walter Allen claimed it as 'the best and most faithful play about British working-class life that has appeared for a long time',[59] for Peter Hall 'it merely exchanged the convention of the drawing-room for the convention of the kitchen'[60] and John Russell Taylor complained that Wesker had failed to 'resolve that perennial dramatic problem, how can one represent bores dramatically without at the same time boring one's audience?'[61]

Roots was, however, not simply a more-or-less accurate depiction of Norfolk life – it also defined a central New Left dilemma, as Michael Kaye noted in *New Left Review*:

> *Roots* tells us the truth about ourselves in the New Left ... there is us, which is Wesker or you or me. There is Beatie, the girl who has left her working-class agricultural background, and who is that Trade Unionist we might be trying to convert. And there is Beatie's family, the mass, the cause of our moments of despair.[62]

It was the conjunction of this political/cultural analysis with the naturalistic presentation of working-class life that made *Roots* simultaneously a significant contribution to that body of work which, in a variety of media, was concerned to analyse the claims of the affluence version of contemporary Britain, and also one of the least typical of 'vital theatre' projects. Wesker's next two plays – *I'm Talking About Jerusalem* (the third of the trilogy) and *Chips with Everything* – applied the analysis to different areas of contemporary life. The former presented would-be William Morris socialists, seeking a private solution – 'to live' socialism – 'not talk about it'.[63] The necessary interconnection with the wider society forces them back into industrial, capitalist and urban society as they are driven to modernise their craft workshop, respond to the demands of the market and return to London. *Chips with Everything* connected the analysis more directly to political authority through the play's setting in a National Servicemen's camp. The play provoked even more hostile comment than had *Roots*. John Russell Taylor was particularly harsh: 'Is he not attacking the music, the food, the way of life of the working-class life just because they are not acceptable to a middle-class point of view? Why shouldn't people eat chips with everything?'[64]

Centre 42 and After

Wesker's answer had already been given in a lecture in April 1960, in which he argued that 'The economic barriers of class may be less definable, but the cultural ones are still there.'

The 'stultified worker', said Wesker, 'is only enjoying half of life; he may be enjoying body, but he's not engaged soul in this process of living'.[65] The extension of access to cultural products was then at the heart of Wesker's vision of the Centre 42 project – the title coming from Resolution 42 of the TUC Conference of 1960:

> Congress recognises the importance of the arts in the life of the community especially now when many unions are securing a shorter working week and greater leisure for their members. It notes that the trade union movement has participated to only a small extent in the direct promotion of plays, films, music, literature and other forms of expression including those of value to its beliefs and principles.[66]

In fact the degree of support from the unions was, subsequently, notoriously small and the Centre 42 organisation was formed centrally around a group of practising writers, actors and playwrights.

From the beginning Wesker was very aware of the potential criticism that they were proposing to thrust 'culture down people's throats' and he was adamant that 'we did not want to go anywhere unless we were invited'.[67] It was in fact in direct response to invitations from Trades Councils in 1962 (following one festival in Wellingborough in 1961) that Centre 42 organised its one and only major enterprise – a series of week-long festivals at Nottingham, Leicester, Birmingham, Bristol, Hayes and Southall.

Each festival was composed of three areas of work. There were, first, visual exhibitions: of local artists' work, children's art and a Trade Union exhibition featuring John Bratby murals and 'photographs of the daily life of a workman'[68] set against the history of the movement. Secondly there were theatrical events: Kops's *Enter Solly Gold*, Wesker's documentary play *The Nottingham Captain*, the National Youth Theatre production of *Hamlet* and, the most innovative work, Charles Parker's *The Maker and the Tool*, based on recordings made with workers of representative industries in each town. This performance involved edited tapes, new songs, films and slides, poems and music; it had its roots in the radio ballads which

Parker with Ewan MacColl and Peggy Seeger had already made for the BBC. It was 'by far the most under-rehearsed and rough work in the festival'. The emphasis was not on professional performance since 'the point is not we on the stage and you in the audience, because, as Parker says, the work is yours; the pictures are of you; the voices are your voices'.[69] The third area was music: the folk-singing of (mainly) MacColl, Seeger and A. L. Lloyd, poetry and jazz and a jazz dance.

Despite the very considerable achievements of 1962 (which resulted in twenty invitations being received for 1963) the legacies of that year undermined the project's future. At Nottingham Kops's play opened to audiences of eighteen and nineteen while Parker's 'Theatre Folk Ballad' 'got small enthusiastic houses, although rarely many of the people whose work it dealt with'.[70] Such disappointments, however, were not decisive in persuading Centre 42 not to respond to further invitations. The two major reasons were concern about the quality of their work and problems of finance. In 1966 Wesker reflected that:

> we weren't putting on work of a high enough standard ... and this laid us open to a lot of attack. Also because we insisted on having folk-singers as part of the festival, suddenly the press descended upon us and took photographs of bearded folk-singers, and the whole movement developed this image of being a folksy movement, which is something that we have had to try and live down.[71]

It is clear that an uncertainty about the *nature* of the artistic material as well as its quality lay behind Wesker's remarks. Although the decisive factor in Centre 42's failure was lack of finance (the 1962 operations left a deficit which was never cleared) the unresolved problem at the heart of the project was that of artistic policy. In 1964 Wesker polemically asserted that 'we are not looking for a working-class art – we do not know what this is. There is only good and bad art.'[72] This was a rather more simple answer than he had often given previously (particularly up to the period of the 1962 festivals). It was also diametrically opposed to the conclusions reached

by Geoffrey Reeves in early 1963 that if 42 'is merely an attempt to make what we know as good art available ... for anyone who wants it, then all we are doing is propagating Tory Party policy into fact'. The work should rather make direct connections with the experience of a working-class audience by making 'a real effort to see into *their* lives, into *their* roots, so that we produce something compulsive for both of us. Something popular.'[73] The programme of the 1962 festivals had in fact reflected something of both positions, certainly including material which was simultaneously serious and 'popular' (in the sense of being of and from 'the people'). Jazz, folk music and Parker's folk ballad in particular neither adhered to accepted high cultural standards nor were simple reproductions of commercial forms. A further criticism of Centre 42, however, argued that its position (whether in the Wesker or the Reeves version) did not acknowledge the possibility of work which might be both popular and valuable emerging from within the commercial sector of the entertainment industry or the mass media. John Garforth, in 1963, alleged that Wesker 'shared the cultural snobbery of his audience' in assuming automatically that 'popular equals bad'. He proposed that the starting-point of any transformative cultural project should be neither accepted cultural standards nor the folk-based alternative apparently offered by Centre 42 ('Does Wesker honestly imagine that Arthur Seaton would be uplifted by a ballad opera on working his lathe?'), but rather already existing working-class culture – football, pubs and *Coronation Street*. The answer, he claimed, was 'to understand more clearly what working-class culture is, and to transform it from the reassurance of *Coronation Street* into something more dynamic, but from within'.[74]

There is a case for seeing Theatre Workshop in the period 1959–63 as fulfilling Garforth's aims. The successful West End transfers of plays by Behan and Delaney had indicated a model for survival through the development of productions which would be both within the style of Theatre Workshop and commercially successful. In particular it led to the production of a number of musicals which situated themselves on the terrain of working-class culture not so much by the direct representaton of working-class life as by the

reworking of popular cultural forms. The first and most commercially successful of these was Frank Norman's *Fings Ain't What They Used to Be*, with music by Lionel Bart. This was set 'in a small tatty gambling den inhabited by ex-members of a razor gang, small-time thieves, prostitutes and ponces',[75] the title song was a direct comparison between 'then' and 'now' in working-class life-styles (Southend against Paris as resorts; local palais v. bowling alley). It opened at Stratford East in February 1959 and subsequently ran for two years in the West End. A deliberate follow-up was Wolf Mankowitz's *Make me an Offer*, although by now 'the cast . . . had in it very few Theatre Workshop actors and it was chosen with the possibility of a West End transfer very much in mind'.[76] By mid 1961 this pattern of West End transfer had given Theatre Workshop a period of considerable financial stability and simultaneously destroyed the basic elements of its long-term project – a collective of actors and theatrical support workers who developed particular theatrical principles and skills over a long period of time. In the summer of 1961 Joan Littlewood went abroad and Theatre Workshop effectively disbanded for two years – re-forming in 1963 for what became its final major success, *Oh What A Lovely War*.

Oh What A Lovely War, opened at Stratford East in March 1963 and subsequently ran for over a year in the West End. Charles Marowitz regarded it as the final product of an extraordinary stylistic synthesis:

> The technique which produced this result grew out of the Living Newspaper productions of the '30s, the English Music Hall in its pre-war heyday, the satirical revues of the early Unity Theatre, the Pierrot tradition of the Manchester school (the city where Littlewood began) and the tardy influences of Piscator and Brecht.[77]

John McGrath, in the late 1970s assessed Theatre Workshop in general and *Oh What A Lovely War* in particular as effective and influential in terms of its transmission of a specific political message via popular forms.[78] The production did however change its emphasis somewhat on transfer to the West End – the original sombre ending being replaced by a reprise of the

more tuneful songs and Ewan MacColl's retrospective view is uncompromisingly hostile:

> Here was a show ... which was ostensibly an anti-war show. Yet it was running in the West End ... a theatre which sets out to deal with a social and human problem like war and which leaves the audience feeling nice and comfy, in a rosy glow of nostalgia, is not doing its job ... It was at this point that we could say farewell to the dream of creating a working-class theatre.[79]

In March 1964 Theatre Workshop staged Frank Norman's latest low-life musical, *Kayf up West*. It was a commercial failure. With no support from the Arts Council, there was no way forward; the company leased out the theatre at Stratford East for three years and there were no further Theatre Workshop productions until *MacBird* and *Mrs Wilson's Diary* in 1967. By then Joan Littlewood was preoccupying herself with what proved an abortive (but typically late 1960s) project to create a Fun Palace: 'an enormous space framework would enclose many leisure pursuits and experiences. Included would be warm air curtains, vapour zones, optical barriers and a variety of new and exciting gadgets. ... A place of toys for adults, a place to waste time without guilt or discomfort.'[80] Such a project, more likely to appeal to Richard Neville than Ewan MacColl, was clearly a long way from *Landscape with Chimneys* or even *A Taste of Honey*.

By 1964 Centre 42 was also virtually in abeyance. Its own projected home – the Roundhouse at Chalk Farm in North London – was never fully developed for Centre 42 purposes and by mid 1967 was housing all-night sessions of UFO (the definitive 'underground' club) and acting as the venue for the 'Dialectics of Liberation' conference, with speakers including such late 1960s luminaries as R. D. Laing and Herbert Marcuse. Out of this new cultural and political moment an exceptionally active alternative theatrical movement was to develop which depended more than has often been recognised on what had been learned from the successes and (more often) failures of the early 1960s. Within the period 1957–64 itself the contribution from theatre to the general representation of

changes in working-class life was remarkably uneven. There was relatively little solid achievement in terms of specific plays. By contrast the role of 'vital theatre' was crucial in the provision of material, personnel and theoretical concerns which could be taken up in other media, particularly television and cinema. In the latter case, while novels provided much of the raw material for British 'New Wave' films, it was the post-1956 theatrical transformation which supplied many of the key directors and actors, as well as the initial institutional space (through the link between the English Stage Company and Woodfall Films) for the substantial achievements of the early 1960s.

5. Life Here Today – British New Wave Cinema

THE period 1959–63 was marked by the appearance (and subsequent sudden disappearance) of a 'New Wave' of social realist films which seemed to signal a renaissance of seriousness and contemporary relevance within British cinema. One immediately apparent paradox is that this was also precisely the period in which the collapse of cinemagoing in Britain as a mass leisure pursuit became confirmed as a long-term trend. To understand this curious situation it is first necessary to consider the economic and institutional structure of the British cinema industry in the post-war period.

Cinemagoing in Britain 1945–63

The all-time peak year for cinema audiences in Britain was 1946. Admissions totalled 1635 million at a total of 4709 cinemas. Despite a slow decline through the late 1940s, attendance in 1950 still stood at 1396 million (well above the 1939 figure of just under 1000 million); it merely seemed that the post-war boom had subsided to give a more normal long-term pattern. Even by 1955, when attendances stood at 1082 million, there seemed little cause for concern. It was only after 1955 that the decline in admissions began to accelerate at an alarming rate. By 1959 audiences had been cut by half to 581 million and cinemas began closing extensively, only 3414 remaining open (a drop of nearly 25 per cent since 1955). The pace of decline in admissions subsequently slackened (reducing to 357 million by 1963), but the long-term consequence of the drastic slump were still working through to the cinemas (only

2181 remaining in 1963). Between 1955 and 1963 over two-thirds of the audience and over half of the cinemas disappeared from the industry.[1]

In 1962 John Spraos analysed the causes of this decline. He accepted the conventional wisdom of the industry itself that television (although not especially commercial television) was to blame and noted three phases of the decline. Before 1955 a disproportionate number of television viewers were in higher income groups – groups which were less likely to attend cinemas regularly. The maximum impact occurred between 1955 and 1958. During this period, he argued, sets were being acquired by working-class families which '(a) were larger than average and (b) of an age composition which led to high cinema scores'[2] (essentially the 15–24 age group). In the third phase (after 1958) although sets were being acquired at the same rate (roughly a million a year) the impact on cinema was less as it involved smaller families with relatively older members.

The overall decline in admissions had the effect of increasing the proportion of the audience in the young adult category. This group had always had a disproportionately high representation among cinema audiences but by 1960 this position was one of absolute majority. Despite the general audience decline 44 per cent of those between 16 and 24 still attended cinemas at least once a week and a further 24 per cent at least once a month. Against this 68 per cent of reasonably habituated cinemagoers the figures for other age groups were considerably lower – 28 per cent for those between 25 and 34, and 14 per cent for 35–44. While the 'family audience' became the watchword of television programme policy, cinema was increasingly left with those who sought evening leisure outside the home. This was gradually grasped by the production end of the industry, not at first so much as a conscious policy as through following the trends of those films which (sometimes unexpectedly) were commercially successful under changed circumstances.

The scale of the decline makes it perhaps surprising that any major investment was still put into film production. There were, however, some forces at work preventing complete collapse, particularly 'the cushions provided by the reductions

in Entertainment Duty, by the British Film Protection Fund and by the National Film Finance Corporation [NFFC]'.[3] Entertainment Duty had been reduced in 1957 and abolished in 1960 as a deliberate attempt to offset the decline in box-office receipts. The other 'cushions', however, originated in the late 1940s and, together with the Quota system (first introduced in 1927 to ensure a minimum proportion of British-produced films within each cinema's programme), were not so much attempts to help the industry in general as to promote the production of British films, primarily as a defence against the threat of American cultural domination. In 1949 the NFFC was set up to provide finance for British film production, supplementing rather than replacing private capital and in 1950 (in return for a reduction in Entertainment Duty) the exhibitors agreed to pay a levy on their ticket receipts to be redistributed to British film production companies in proportion to their box-office earnings (this became statutory in 1957). Since all films (British and foreign) contributed, there was a direct transference of money earned by American films into the pockets of those who financed British production.

In America there were no comparable 'cushions' at a time of similar sharp audience decline, and by the late 1950s the proportion of British to American films showing in British cinemas had risen considerably. In 1950 there were 74 British 'long' films (over 72 minutes) to 260 American; by 1960 the British figure had slightly increased to 79, while the American figure had nearly halved to 142.[4] It was not necessarily the case that a 'British' film was a representation of British life, aimed at a British audience or even financed by British capital – the definition related to the predominance of labour costs being British. Nevertheless, by the late 1950s, in the context of an absolute decline in the industry, the relative opportunities for British films and for films aimed at a young adult audience were markedly improved. The 'New Wave' films of Richardson, Reisz, Schlesinger and Anderson met both of these criteria in full.

Projecting Britain 1945–55

The impact of the 'New Wave' was largely a matter of its clear

difference from earlier attempts at cinematic representations of post-war 'ordinary' and working-class life. British films, in the first post-war decade, were not especially concerned with this and, even within those that were, the dominant, inherited form inhibited rather than encouraged exploration of what was new in post-war Britain. The early 1940s had seen an increasing fusion between 1930s documentary style and feature film representations of civilian endurance and heroics. This both erased the specific projects of the documentarists (with a few notable exceptions, particularly Humphrey Jennings) and inaugurated a celebratory style which persisted in an attenuated form into the post-war period. Working-class life was frequently presented in terms which alluded to the experience of 1930s poverty (communal solidarity and struggle) or early 1940s endurance (communal/national effort and resistance), but which could locate no remaining oppositional forces (apart from the occasional spiv or upper-class parasite). A cosy affirmative tone surrounded such figures as the Huggetts who, in a series of Gainsborough films including *Holiday Camp* (1947) and *The Huggetts Abroad* (1949), embodied the post-war working class (with Kathleen Harrison and Jack Warner as Mum and Dad) enjoying an ultimately unproblematic and unified family life.

A more serious attempt to reflect the immediate post-war situation was made within the collective framework of Ealing Studios. Here between 1939 and the mid 1950s, under the direction of Michael Balcon, a small core team of writers and directors working in a co-operative, small family business atmosphere, made low-budget pictures which, while concerned to 'project' Britain to the world, were to be reliant on the home market to cover their costs. Central to many Ealing films was the idea of community – a knowable community threatened and reaffirmed. The wartime films characteristically evoked the national community (against Nazism) through a specific localised visible community (a ship, a village, firefighters, an army patrol). In the late 1940s this emphasis was retained and placed in a clearly defined post-war Britain in such films as *Passport to Pimlico* and *The Blue Lamp*. *Passport to Pimlico* fantasises the liberation of a few streets in London from the rigours of post-war austerity and

rationing by the discovery of an ancient deed which proves the area to be part of Burgundy. While much of the surface of the film suggests a criticism of petty bureaucracy, it is ultimately a critique of an unregulated competitive and acquisitive society. Pimlico is flooded by spiv traders, riven by internal dissension and finally very pleased to be reintegrated into British society, ration books and all. *The Blue Lamp* shows the disruption of an ordered East End community (personified by and identified with the ordinary policeman – Jack Warner as PC Dixon) by Riley, a rogue young spiv (Dirk Bogarde). Riley is identified at the opening of the film (in a spoken commentary) as a new post-war phenomenon, an 'extreme case ... who lacks the code, experience and self-discipline of the professional thief'.[5] After Riley's murder of Dixon the whole community, including the moderate 'professional' underworld, unite (visibly – as a greyhound stadium crowd) against the murderer.

Such films illustrated ordinary people enacting the value of co-operation and community, the need to pull together, as the dominant social ethic. In the 1950s at Ealing this position was increasingly presented as archaic and nostalgic rather than active and present. Films such as *The Titfield Thunderbolt* (1953), *The Maggie* (1954) and *Barnacle Bill* (1957) depicted eccentrics, marginal groups and quaint English artefacts (steam-engines, piers, old steam-boats) rather than contemporary urban communities. By 1955 the gradual loss of internal impetus at Ealing coincided with the first stages of the industry's general decline. Continuing cutbacks at Rank, which since the mid 1940s had underpinned Ealing's operations by its guarantee of favourable distribution and provision of up to 75 per cent of finance, forced the sale of the studios to BBC TV. A proposed relocation of Ealing productions at Rank's Pinewood studios did not materialise and Balcon moved, with some colleagues, to MGM until 1959 after which he was instrumental in the formation of Bryanston Films, a new co-operative of independent producers.

Looking at Britain 1956–59 – Free Cinema

While Ealing gradually atrophied into virtual self-parody,

alternative ways of representing contemporary Britain were emerging within the financially insecure sphere of non-commercial documentary film-making. During the late 1950s some of this work began to go public, in a limited way, under the umbrella title of 'Free Cinema'. *Free Cinema*, to be precise, existed only as a series of six film programmes presented at the National Film Theatre between February 1956 and March 1959. Only three of these – the first, the third (May 1957, under the collective title of 'Look at Britain') and the last – contained British films, predominantly short documentaries on specific aspects of contemporary British social life. It was here that three of the 'New Wave' directors (Tony Richardson, Karel Reisz and Lindsay Anderson) were first able to present their film work to a general audience. The first Free Cinema programme included Anderson's *O Dreamland* (a sour, ten-minute look at crowds in a seaside amusement park), and *Together* (the daily life of two deaf-mutes), the editing of which he had supervised. This, together with Anderson's role as chief propagandist, established him as the most clearly identifiable figure in the 'movement'. In the third Free Cinema programme two of the four films were Anderson's and he also supplied the programme notes:

> We ask you to view it as ... in direct relation to a British cinema still obstinately class-bound; still rejecting the stimulus of contemporary life, as well as the responsibility to criticise; still reflecting a metropolitan Southern English culture which excludes the rich diversity of tradition and personality which is the whole of Britain.[6]

Both Anderson's films – *Wakefield Express* (made in 1952 to commemorate the hundredth anniversary of the paper) and *Every Day Except Christmas* – addressed aspects of this problem. *Every Day Except Christmas* followed the loading, transport and delivery of goods to Covent Garden Market, market life, the sale of the goods and the aftermath. The film emphasised community (local and national) and the general dignity of labour. Despite stylistic differences, there were recognisable similarities in social stance to 1930s GPO documentaries (such as *Night Mail*) and the work of Humphrey Jennings.

Every Day Except Christmas was made with funds from the Ford Motor Company. Karel Reisz (who co-produced the film) had become film officer at Fords (making publicity and advertising films) and his contract allowed him to produce also a series of documentaries on subjects of his own choice. It was this which gave Reisz himself the resources to make the longest (52 minutes) of all the Free Cinema British films – *We are the Lambeth Boys* (1959). Reisz used Walter Lassally, who had already worked with Anderson on a number of films, as chief cameraman. Lassally had earlier worked on *Momma Don't Allow*, a twenty-minute short about teenagers in a London jazz club, made by Reisz and Tony Richardson in 1956 and financed by the BFI Film Experimental Fund (under the chairmanship of Michael Balcon).

We are the Lambeth Boys, which was the major film in the final Free Cinema programme, set the working-class boys (and, to a lesser extent, girls) of *Momma Don't Allow* in a more detailed context. It was shot in a youth club in Kennington, and showed club life (cricket, gossip, jiving, sewing, art classes), night in the streets (inside and outside the chip shop) and the daytime life of club members: schoolboy, butcher's boy, trainee postman, receptionist, factory worker. Work was shown as necessary ('Work is something that has to be done by everyone' says the well-spoken commentator), but hardly satisfying – the camera dwelt particularly on the repetitive tasks in the mass-production cake factory. This was contrasted with the exuberance of leisure time activity, including the extended episode in which the boys travel (in an old army lorry) to Mill Hill public school for their annual cricket match; the film ended with a dance at the club and the return home to the block of flats where most of the club members lived.

Richard Hoggart, in an open letter to Reisz, wondered how far the film had moved beyond the presentation of exteriors; he asked that such 'essays' should develop by becoming 'much more subjective ... to encompass the inner life'.[7] Reisz later commented that 'in a sense *Saturday Night and Sunday Morning* is an answer to Richard's strictures. The hero of the picture is, if you like, one of the Lambeth Boys. An attempt is made to make a movie about the sentimental and social education of *one specific* boy.'[8]

Commenting further on the problem of the documentary film-maker at that time Reisz noted: 'There simply is no money or audience for this kind of movie in the English cinema.'[9] Documentaries were, by 1959, almost the exclusive province of television where both funding and institutional support were available. In terms of its independent documentary mode Free Cinema ran out of energy; the last programme note commented that 'the strain of making films in this way, outside the system, is enormous, and cannot be supported indefinitely'.[10] However, by March 1959 developments within the commercial cinema had already created a space within which at least part of the Free Cinema project could be redirected to the making of feature films.

Life Here Today – British Cinema 1957–60

In October 1957 Lindsay Anderson contributed to *Declaration*, a collection of essays by a number of writers who were all associated with the current 'Angry Young Man' media and publicity label. Part of Anderson's essay concerned the state of British cinema which he characterised as 'Southern English ... metropolitan in attitude, and entirely middle-class'. As an example of its failure of tone he invented a typical scene:

> Mrs Huggett, the policeman's wife, is told of her husband's death in the course of duty. (He has been knifed while attempting to arrest a Teddy Boy for dancing rock-and-roll on the pavement at the Elephant and Castle.) There is a pause, pregnant with nothing. Then Mrs Huggett speaks, quiet and controlled; 'I'll just put these flowers in water'. Polite critical applause for another piece of truly British understatement.[11]

Anderson conflated here a particular scene from *The Blue Lamp* with both the Huggetts (the presence of Jack Warner in both made this possible) and a particular Free Cinema image (teenagers dancing in Lambeth) to suggest the need to challenge a particular version of essential Englishness. The very appearance and success of *Declaration* itself (reprinted twice in two months) indicated that such a challenge was

already well underway. In relation to cinema it is clear that developments in fiction (Amis and Braine) and theatre (Osborne), and their consequent media attention and commercial success, both created the space for Anderson to present his case to a more general audience and also suggested to the British cinema industry a source of potentially profitable script material.

In the same month as the publication of *Declaration* the Boulting Brothers' film of *Lucky Jim* was released. This was one of a series of satires on aspects of contemporary society, but transferred much of the novel's humour of interior monologue into knockabout farce. Anderson, reviewing the film, saw it as a chance missed. The film was 'conventional farce': 'the temptations of realist shooting have been consciously resisted, and the story has been wholly abstracted from reality.'[12] By the time of the film's appearance *Lucky Jim* had, in any case, been supplanted as the most typical and commercially successful 'Angry' novel by *Room at the Top*. Braine's novel, with its strong story-line, aggressive hero and two attractive women characters was clearly eminently filmable. The rights were bought by Romulus films and the film released in January 1959, directed by Jack Clayton and with a cast (including Laurence Harvey and Simone Signoret) which, while recognising the need for international appeal, did allow the opportunity for the creation of the specific northern locale. In fact, although the film's 'realism' was recognised by many critics, this was mainly in terms of its explicit handling of sexuality rather than its contemporary urban setting.[13] A few critics did, however, see it as breaking new ground more generally. Isabel Quigly in the *Spectator* described it as 'a British film that talks about life here today – not during the war, not in the jungle or in the desert, not in some unimaginable script-writers' suburbia or in a stately home',[14] while in the *New Statesman* William Whitebait heralded it as 'the forerunner of new masterpieces to come'.[15]

Neither Amis nor Braine scripted the films of their novels. Both films were clear instances of established cinema entrepreneurs seeing the commercial possibilities of specific novels and adapting them accordingly. It is conceivable that John Osborne's first two plays might have been handled in the

same way. However, a number of factors prevented this. *Look Back in Anger*, in particular, was not simply an individual property; it was the identifying work of the English Stage Company. Further it had originally been directed by Tony Richardson, who had worked in BBC Television before moving to the Royal Court. Both Richardson and Osborne were interested in being directly involved in film-making and the success of the play in New York in 1957 (where Richardson again directed) led to American interest in financing the film. This eventuated in the casting of Richard Burton as Jimmy Porter; the details of Burton's contract with Warner Brothers were such as to persuade them to provide a budget of over £200,000 for the film, to be produced by a new company, Woodfall Films.[16] The core members of Woodfall were Richardson, Osborne and Harry Saltzman, the American entrepreneur who organised the finance. Despite Osborne's involvement the film was scripted by Nigel Kneale (an experienced film and television writer) who extended the action beyond the one-room flat (the sole setting of the play) to a diversity of settings, including a hospital ward, a doctor's waiting-room and a street market. This allowed Richardson to transfer some Free Cinema concerns into a feature film context, although these remained on the edge of the central action, which was dominated by Burton. The film (released in May 1959), although critically well received, was financially unsuccessful and made any future funding of Woodfall by Warners extremely unlikely.

Instead Woodfall turned to Bryanston to finance *The Entertainer*. Partly due to Balcon's influence Bryanston retained distinct traces of the Ealing project, particularly the preference for low-budget films with a distinctively British character (Balcon later commented that the support of Woodfall by Bryanston was a case of 'just that co-operation for which it was founded'[17]). Problems of style in the film proved to be particularly intractable, however. The play itself was a much less clear-cut example of theatre naturalism than *Look Back in Anger* and the retention of Laurence Olivier in his leading stage role inhibited a major restructuring of the play's form. The conflict between the reproduction of the stage play and the use of outdoor 'realistic' locations caused both technical

and stylistic problems which were clearly discernible in the finished film. The film (released in July 1960) was unsuccessful, both critically and financially.

In the light of these problems it was fortunate that Woodfall's third project was just on the point of completion at the time of *The Entertainer*'s release. In 1958 they had bought the film rights to *Saturday Night and Sunday Morning* from Joseph Janni, an independent film producer, for £2000. Janni himself had previously bought the rights for £1000 but had failed to persuade either British Lion or Rank to fund it: 'almost everyone told me no one would want to see such a film.'[18] By mid 1959, however, the situation had changed, both through the success of *Room at the Top* and the emergence of Bryanston. Sillitoe himself was contracted to produce a script (partly because no one with any experience could be afforded), Richardson was to produce with Reisz as director and a shoestring budget negotiated, with Bryanston and the NFFC (as with *The Entertainer*) providing the major financial support. The film was shot in a period of about six weeks in the spring of 1960.

'Saturday Night and Sunday Morning' – Today's Working-Class World

Sillitoe did not find the task of scripting the film easy. Overall there were five drafts of both the synopsis and the full-length script. It was quickly accepted that the army camp interlude and the family Christmas party could be dropped as neither were involved in forwarding the film's two central threads: Arthur's relationships with Brenda and Doreen. More significantly the character of Winnie was dropped entirely. In the novel Winnie appeared as Arthur's equal in deception, manipulation and quest for immediate sexual pleasure; her presence in the film would have disturbed the clear pattern of an aggressive Arthur choosing between the essentially passive figures of an older married woman and a young unmarried girl (a reproduction of the pattern of *Room at the Top*). This exclusion of Winnie lends support to the view that the film tends to define problems and solutions in direct relation to the 'patriarchal principle'.[19] The major difficulty

at this early stage was the ending. The novel had concluded with Arthur fishing and meditating on the likely direction and quality of his future. Sillitoe's first idea for the film – 'a wedding scene at the registry office made into a travesty by Arthur's larking about[20] – was soon discarded. In July 1960 Sillitoe reported that the final scene would be a 'soliloquy, with Arthur's voice projected over him working at his lathe, balancing his acceptance and determination to keep on fighting'.[21] However, this too was eventually removed leaving a final scene set on a hillside behind a new housing estate on the outskirts of Nottingham. Arthur's final act of throwing a stone at the houses, while Doreen reminds him that one of them might well be their future home, indicates an unresolved ending which has been variously interpreted as deliberate ambiguity, unintended confusion and the product of a conflict of view between author and director.

Problems with the script were also encountered with the censors. The first script was submitted in November 1959. It was immediately clear that the film would have an 'X' certificate, but even then two major objections were made – to the successful abortion and the language (particularly 'bogger', 'Christ' and 'sod'). The supposed effect on women in the audience was an important consideration. A scriptreader's report claimed that 'a great many young married men choose the films *they* want to see; their wives come with them and often don't enjoy the language, or the violence', while in a letter to Woodfall it was suggested that the script 'shows a rather casual attitude to abortion and suggests to the young that if they got into difficulties all they need is to find a kind-hearted older woman'.[22] When the final shooting script came back to the Board in January 1960 there were alterations in the language and a complete reversal in the treatment of abortion (the attempt was now presented as a failure). The film was eventually seen and granted a certificate in July 1960.

In his first feature film Reisz drew heavily on his Free Cinema experience. He worked closely with Sillitoe on the script and when shooting began (on location in Nottingham) included Sillitoe's mother's house and the Raleigh bicycle factory among the settings. The factory scenes (although only four in number, fairly short and not central to the main

narratives) became crucial points of reference. While the film generally uses a Johnny Dankworth jazz score (as in *We are the Lambeth Boys*), the factory scenes take place against a solid wall of industrial noise, used as a major indicator of the factory's social power. As Arthur cycles, scowling, to work on Monday morning the noise gradually appears behind and around him before a cut is made to Arthur at his lathe; when he crashes a dustbin lid in frustration outside Doreen's house the noise is immediately swallowed by that of the factory as Arthur is seen about to receive his pay packet from the foreman.

The factory itself itself is firmly enclosed within the landscape of the industrial city. The panoramic shots of rooftops and factory chimneys are used as a preface to shots of Arthur cycling to work, as the backdrop to Brenda telling Arthur of the failure of the abortion, and as the introduction to the concluding 'Sunday morning' section leading towards marriage. The foreclosing of options which the urban/industrial setting imposes on Arthur is recognised by these and the factory scenes together.[23] Within this powerfully limiting environment the choice of shots and camera style emphasise the detail of physical mobility: Arthur cycling to and from work, and life in the city streets, particularly in the sequence where Arthur and Bert kill time (in cinema, pub and walking through the city at night). Unlike other 'New Wave' films there is no 'escape from the city' sequence. Partial temporary escapes occur in the two fishing scenes (in the first a factory on the opposite bank is clearly visible), the final scene (where the city still dominates) and the funfair episode (Arthur's final fling). The attempt to authenticate Arthur through a diversity of exterior and interior settings works within an overall presentation of closure and claustrophobia in his physical and mental environment.

A limited range of responses to this environment are offered. The film opens with Arthur's voice-over giving details of his job and its piece-work payment system, leading to a comparison of his own reckless attitude (get the money and spend it) with the older generation who got 'ground down' before the war and never recovered. This contrast is summed up near the end of the film when Arthur insists that he's still got 'a lot

more life in me than me mam and dad', who are like 'a lot of
sheep – a television set and a packet of fags but both dead
from the neck up'. The television reference connects with an
early scene where Arthur arrives home to find his father in
front of the set watching advertisements, completely oblivious
to Arthur's comments about an accident at work and his
bitterly intoned joke about a man who 'lost the sight of one
eye through watching too much television'.

The other comparison made in the opening scene is between
Arthur and Jack. Jack (a man who 'wants to get on') has a
cautious, conforming attitude, embodied in his defence of
marriage, his acceptance of the firm's tea ('if it's good enough
for the others it's good enough for me') and his willingness to
go on nights to earn more so that they'll be able to afford a
television. Although Arthur finally admits that Jack is 'not a
bad bloke really', he is also 'a bit of a dope' whose attitude of
general resignation is linked to his failure to satisfy his wife.

The third main comparison, considerably transformed from
the novel, is that between Arthur and Doreen. The recasting
of the plot brings Doreen in much earlier, about one-quarter
of the way into the film as against two-thirds through the
novel. Although a factory worker (Harris's hairnets), Doreen
embodies a rather more respectable life-style than Arthur.
Her mother is not, as in the novel, a bizarre eccentric but
rather a forerunner of Ingrid's mother in *A Kind of Loving*. In
a new scene set in Doreen's (semi-detached) house Arthur,
Doreen and friends are jiving when interrupted by her mother
who complains that they're carrying on as though it's a
'birthday party' and asks Doreen to clear up as she has 'people
coming to supper'. Arthur bitterly compares this to the
treatment Doreen would receive at his house: 'Drop into our
house – you'll be welcome there' (as happens subsequently).
After Arthur leaves this scene of two different sectors of the
working class in confrontation is continued as Doreen's mother
comments 'he looks a bit rough if you ask me'. It is this
contrast which the closing scene re-emphasises (Doreen's
house and street are themselves on a new estate on the edge
of the city). Whatever the confusions of the ending it does
suggest a further transition *beyond* Arthur's parents' acceptance
of material comfort and Jack's conformity towards a further

stage of affluence – a stage whose terms have yet to emerge.

The film opened in the West End in October 1960 and was immediately successful. By early 1961 it was well on the way to the recovery of its costs. The overall profit was eventually around £500,000 which both infused Bryanston and Woodfall finances and suggested to the industry a successful formula which might be copied. Critical discussion of the film tended to revolve around two issues – realism and morality. It was generally accepted that the film's strengths were those of social realism. It was, according to Isabel Quigly, 'the first British feature film in which today's working-class world has appeared ... people today with today's attitudes and outlook and today's money'.[24] On the issue of morality (both social and sexual) opinion was divided between those who saw Arthur's actions as being accounted for (perhaps excused) by his circumstances and those who saw the film itself as amoral. The most extreme version of the latter was implied in Warwickshire County Council's decision to ban the film entirely, while other comments included 'the most immoral, amoral film I have ever seen' and 'brutal and depressing'. A comment in the *Sunday Telegraph* was similar, though more neutral in tone; the film showed that 'affluence has not diminished the "revolt of the masses" '.[25]

In general the undemonstrative style of camerawork and editing were seen as essential strengths in the film's achieved realism. However, two separate (and generally favourable) reviews in *New Left Review* suggested possible limitations. Rod Prince wrote that the straightforward style ('the camera being used fairly statically at medium range') was 'responsible for the film's remaining at the level of observation, very good observation though it is'. He felt (echoing Hoggart's comments on *We are the Lambeth Boys*) that Reisz had failed to show 'something of the inner life' of Arthur.[26] Alan Lovell made similar criticisms:

> The film lacks a certain intensity because of Karel Reisz's desire to be sober and unsensational. I felt this particularly when Arthur and Brenda first realise that their relationship is at an end. The location (on top of a hill) was obviously chosen to emphasise the crisis in the relationship. The scene

doesn't make the point it should because the camera is too near the actors. The place is *there* but not *felt*. The same is true, to a lesser extent, of the rest of the film.[27]

These implicit requests for a more complex, diverse and exciting style of shooting and editing foreshadowed both the developments which took place within the British 'New Wave' and its subsequent loss of identity and dissolution.

'A Taste of Honey' – the Naturalistic Look

After filming *The Entertainer* Tony Richardson had returned to theatre work, including a Broadway production of *A Taste of Honey*. From Broadway he moved to Hollywood to direct *Sanctuary* for Twentieth Century Fox. This proved an unhappy experience, mainly because Richardson found himself heavily constrained by the prevailing studio conditions ('like working in a strait-jacket'[28]). In returning to Britain to film *A Taste of Honey*, he reacted against the Hollywood system and decided to film entirely on location. By early 1961 the success of *Saturday Night and Sunday Morning* ensured that Bryanston would continue to finance Woodfall and Richardson began his third attempt at filming one of the key plays of the 'Vital Theatre' movement.

The approach to filming *A Taste of Honey* in September 1961 was, however, very different from that to the Osborne plays. There the core had remained the stage-play settings. With *A Taste of Honey* there was instead a complete recasting of the play's setting. This was possible largely because of the play's highly ambivalent relationship to theatre naturalism. While the play did have only one set this was intended to represent simultaneously 'a comfortless flat in Manchester and the street outside'.[29] In fact only one scene was set in the street, but the transition between room and street there, the lapses of time ('a month or two later') within a single scene and the use of actors to shift scenery all broke down accepted naturalistic conventions of space and time. These elements were all part of the play's self-conscious theatricality, embodied especially in the use of music and song. In the middle of Act One, Scene Two, as the street encounter ends, the transition to action in

the flat is made in the following terms: the boy 'waves goodbye, turns and sings to the audience, and goes. Helen dances on to the music, lies down and reads an evening paper. Jo dances on dreamily'.[30] Similarly in the Second Act Jo and Geoff dance on and off with the props, while at the end of the play the audience is directly addressed by Helen: 'I don't know what's to be done with you, I don't really (To the audience) I ask you, what would you do.'[31]

This degree of distance from theatre naturalism allowed Richardson to by-pass completely the option of simply reproducing the stage settings. Instead he reconstructed the play in a cinematic style recognisably similar to that used by Reisz. The chief cameraman was Walter Lassally who 'lit *A Taste of Honey* so as to keep a naturalistic look throughout. I used a grainy stock for the indoor scenes, which gave the film its key feeling, then ordinary stock for the exteriors'.[32] Both the extensive use of exterior settings and the casting (particularly Rita Tushingham as Jo) emphasised the contemporary Lancashire urban setting. The success of *Saturday Night and Sunday Morning* allowed Richardson to operate without either star names or the need to consider the film's international appeal.

He located the action in its northern setting in three ways. First there are environmental shots unmotivated by the narrative – the city landscape through which Jo and Helen ride on their bus journey at the film's opening, as well as momentary vignettes such as Peter in his car salesman's office and Jo at school. Secondly there are extended scenes of narrative action containing new dialogue – the visit to Blackpool, inside the classroom at school and inside the shoe shop where Jo first meets Geoff. Finally there is the redistribution of existing dialogue across a whole range of exterior settings – the shop, the canal bank and the waste ground (for Jo and her boy friend), the visit to the country, under the railway arches, the yard outside Jo's new home, the canal bank (for Jo and Geoff) and inside Peter's house and car. The most significant change of setting is the virtual complete disappearance of the play's 'comfortless flat'. In the film, after Helen's marriage, Jo moves out of the lodgings she has been sharing with Helen to what appears to be a very large single-roomed loft, isolated at the back of a disused builder's yard. It is a

quasi-bohemian retreat, a clearly independent, idiosyncratic setting denoting a new start for Jo. This alters quite considerably the character relations and thematic pattern from those at the end of the play. There Helen's return, loaded with baggage, is an explicit echo (as the stage directions indicate) of the play's opening. In the film Helen's reappearance is clearly the intrusion into an environment which is not hers – into Jo's (and Geoff's) developed personal world.

These changed settings contribute to general transformations in the character relationships of the play. The exterior, lonely encounters of Jo and her boy friend (even their love-making takes place on a patch of waste ground at night) are contrasted with the noisy, public relationship of Helen and Peter (in a pub, a ballroom or at Blackpool). A typical shot of Jo and the boy kissing on the lonely boat-deck sweeps up to the stars which then merge into the ceiling lighting of the palais ballroom beneath which Peter and Helen are, inexpertly, dancing. The loft of Jo and Geoff (with the children playing outside) contrasts with Peter's new (all mod. cons) bungalow. There is in fact a general contrast between the excessive vulgar materialism of an older generation and the innocent authenticity of the younger. Jo no longer resembles Helen (as when, in the play, she takes a job in the bar in the evenings), but is rather aligned with the children who, as a group, figure strongly in the film. They jeer at Peter's flashy car, join Jo and Geoff in their country expedition, act as a point of positive reference at the end of the film with their bonfire and sparklers, and provide the dominant musical theme with their singing of 'The Big Ship Sails'.

The film's music (apart from Helen's pub singing) is not connected directly to the central characters; this is part of the move away from conscious theatricality. While the play was highly self-conscious of its relation to established theatrical and literary culture, the film presented itself as an unreservedly realistic narrative of contemporary Manchester life. The play's series of rather knowing theatrical references (to Othello, Oedipus and Ibsen's *Ghosts*) are replaced by a clear rejection of established literary culture, with Jo making fun of her teacher's attempt to give an impassioned reading of Keats's 'Ode to a Nightingale'.

The film's systematic 'naturalistic look' made it a clear successor to *Saturday Night and Sunday Morning*. The urban settings, regional locations and suggestions of a critique of contemporary affluence all confirmed the arrival of a new style and perspective. *A Taste of Honey*, however, was to be the only 'New Wave' film to give the central place to a woman character; a woman isolated, independent by force of circumstances and clearly not dependent on a strong male character. While Arthur stood at the centre of a clearly defined community emphatically refuting the assumption that affluence had engendered social conformity and emᵇourgeoisement, Jo was at the margins, an unmarried mother-to-be sustained only by a fitful, and apparently unfounded, youthful optimism.

'The Loneliness of the Long-Distance Runner' – the Clashing of New Waves

Richardson (and Woodfall) followed *A Taste of Honey* with *The Loneliness of the Long-Distance Runner* in September 1962. Sillitoe again adapted his own work although the problem now was not how to cut down a novel but rather how to extend a short story; a story which was essentially an impassioned interior monologue with relatively little action. The additions were considerable: increasing the number of characters, adding to the number of narrative strands, explaining Smith's behaviour in different terms and allowing perspectives other than Smith's own. The major new characters added are Audrey (Smith's girl friend), his mother's 'fancy-man', Brown (the Borstal housemaster) and Stacey (the Borstal 'house-captain') Each of these is used to broaden the understanding of Smith's character and the social context of his actions. Stacey, initially willing to 'play the game' has his status reduced by Smith's running ability: this leads him to attack Smith and finally to attempt (unsuccessfully) to escape. This serves to confirm Smith's superior cunning (he accepts the impossibility of escape), but also leads to his being regarded with suspicion by the other inmates. When Mike (his original partner in crime) arrives at the Borstal (another addition) he is surprised to hear that Smith is the Governor's favourite: 'Whose side are you on?' he asks. This has the effect of emphasising Smith's

isolation and independence which in the story is maintained automatically by the first-person narrative voice itself.

The character of Brown is developed from a single sentence in the story ('a four-eyed white-smocked bloke' who asks Smith what he's thinking about when he robs). Brown is the liberal alternative to the Governor's public school ethos, suggesting to him that perhaps life is more complicated than a football match. His method of analysing such complexity is the discovery of psychological motivation through word association. The film emphasises Smith's cunning in evading Brown's attempts (by deliberately replying with words of no significance), but eventually the method is shown to work as Smith answers 'Father' with 'dead'. Brown's position (the need for detailed psychological understanding) is in fact ultimately endorsed as the film itself attempts to offer such an understanding of Smith's actions. In this respect the father's character and death assume a much greater significance than in the story. There Smith was situated within a subculture of petty criminality. It was the example of his father's death (in defying all the 'in-laws') which provided the model for his own act of defiance in refusing to win the race. In the film the father's influence is apparently more political. He is remembered by Colin as a strike-leader and the strength of his memory is such that Colin registers great antagonism to his mother's 'fancy-man' (a character hardly present in the story, who bears close resemblances to Peter in *A Taste of Honey*). There is direct conflict about 'who is gaffer now' and after one row Colin retreats to his bedroom and symbolically burns a pound note in front of a picture of his father. The burglary itself occurs directly after another row between Colin and his mother (and the 'fancy-man') over watching the television (Colin and Mike want to turn the sound down on the party political broadcast and laugh at the consequent absurdity). Colin's choice of criminality rather than conformity is then linked to the loss of his father (a good worker, but politically active) and his replacement by a representative of the ethic of materialism and social acceptance.

Colin's seriousness and authenticity are further emphasised by his involvement with Audrey, another wholly new charac-ter. With Audrey, Colin escapes from the city, to a hillside

overlooking the industrial landscape and then to Skegness for a weekend. Here on a deserted beach Colin talks about his life as a child, while the film intercuts shots of the couple enjoying the isolation and freedom of the beach with shots of Colin running, at Borstal, alone in the early morning past trees and lakes. Subsequently Colin and Audrey are back in the Nottingham night-time streets with Colin, upset and depressed, explaining that there would be no point in getting a job simply to increase the bosses' profits. In the final scenes of the film (when a torrent of images 'flashes across' Colin's mind as he nears the finish of the race) the faces of both Colin's father and Audrey appear as crucial memories. Audrey, it seems, represents that basic level of human fulfilment denied to Colin by his environment; her character also helps to construct the film in terms of the typical 'New Wave' pattern in which the exploration of the conflict between youthful sexual desire and adult restraint was a recurrent element.

While the revised narrative of the film worked to structure it as contemporary social realism, other stylistic features apparently contested such a definition. The editing in particular suggested intrusions of a distinctly different approach to film – one derived more from current European, especially French, art cinema. In the *New Statesman*, after the film's release in September 1962, John Coleman commented, 'you can almost hear the clashing of new waves, English and French'.[33] The story had been divided into three sections: running at Borstal, a flashback to the robbery and arrest and finally the race itself (although the text's relatively free interior monologue intermingled these different moments considerably). In the film this breakdown of chronological sequence is achieved by the use of four separate flashback episodes (as well as numerous momentary images). More local elements which undermine any pretensions to documentary-style realism are the comic speeding-up of the film as Colin and Mike run away from the bakery, the deliberate reference to television advertising codes (including stars opening out on the screen) as the Smith family spend the compensation money on consumer goods, and intentionally ironic contrastive editing (Stacey's brutal arrest shown between shots of the massed Borstal boys singing 'Jerusalem').

The cumulative effect of these technical devices (along with Lassally's poetic, lyrical composition in the solitary running scenes, building on his canal bank scenes in *A Taste of Honey*) set the film apart from both the relatively uncomplicated realism of *Saturday Night and Sunday Morning* and Richardson's own *A Taste of Honey* where events followed a chronological sequence and few attempts were made to draw attention to the film's nature *as film*. In transforming the short story, Sillitoe and Richardson together converted it into a much more specified social analysis, a parable about conformity and consumerism. This latter element tended to pull the film's style away from cinematic naturalism towards ironic commentary on the excesses of the newer life-styles and their attendant mass cultural forms. It was this stance, rather than the presentation of ordinary regional working-class life which was to characterise the direction of British cinema in the mid and late 1960s.

The Schlesinger Films – from Documentary to Fantasy

By mid 1961 the success of Woodfall was such that northern social realism had become an attractive cinematic commodity. Joseph Janni, after his failure with *Saturday Night and Sunday Morning*, had much less difficulty in persuading Anglo-Amalgamated to put up £165,000 for *A Kind of Loving*.[34] A similar deal was arranged for *Billy Liar* (first published as a novel in 1959, but more successful as a West End play starring Albert Finney and directed by Lindsay Anderson). Waterhouse and Hall were contracted to script both their own play and Barstow's novel and the director for both films was John Schlesinger. Schlesinger's experience was predominantly in documentary both for the BBC (particularly in the arts programme *Monitor*) and with his 1961 thirty-minute film *Terminus*, about Waterloo station, made for British Transport Films.

A Kind of Loving was released in April 1962, having been shot in Lancashire in late 1961. The script simplified the novel's structure by dispensing entirely with Ingrid's father and omitting the whole high-culture theme (no Mr Van Huyten, nothing of Vic's passion for classical music and no hint that David is an English teacher). Rather the film followed closely

the stages of development in Vic and Ingrid's relationship, from romantic infatuation to sexual desire and fulfilment (accompanied by Vic's growing indifference), pregnancy, marriage, breakdown and the final, anti-climactic, reconciliation.

While the central narrative remained, the single perspective (of Vic's voice) did not; this would have been impossible given the overall project of 'objective' realist vision. There were no voice-overs and consequently almost the whole of Vic's 'special pleading' and direct revelation of inner feelings were abandoned; in only two scenes was something of this retained through Vic speaking his thoughts aloud half to a companion and half to himself. Equally the camera rarely identifies itself with Vic's vision; only in the café scene, where Vic's lack of interest in Ingrid's trivial gossip is indicated (and validated) by the camera following his eye around the other couples in the café (persuading the viewer also to lose the thread of Ingrid's chatter), is this carried through in any extended way. Ingrid, generally, appears as a character available for judgement independent of Vic's version of her (most explicitly through shots of her, at home or in the office, when Vic is not present).

Of all the New Wave films *A Kind of Loving* is most explicitly concerned with gender relations. Vic and Ingrid's relationship is seen as subject to two kinds of social determinations – those of class gradations and gender stereotypes. As in the Arthur/Doreen relationship, Vic and Ingrid are shown as originating from two different class fractions. Vic's traditional working-class roots are (unlike Arthur's) respectable rather than rough, epitomised by his father's status as a railwayman and member of a brass band and his sound common sense. Ingrid's mother, by contrast, represents the worst side of the new affluence, with her bigotry towards all manual workers (who are 'holding the country to ransom') and her cultural shallowness (addiction to the most banal television quiz programmes). The distance between the two life styles is shown when, after Vic has walked Ingrid back to her new semi-detached house (with a drive and a garage) 'out at Cross Green' ('it's lovely out there' says Vic on hearing where she lives), he is shown descending through allotments and cobbled streets to his

family's own terraced house (in a street with not a single car). With the absence of the novel's high-culture strand the value contrasts become simplified to an opposition between traditional working-class values and the new 'cultureless' life, epitomised, as John Hill has pointed out,[35] by the sequence in which Vic and Ingrid choose between attending a brass band concert (at which Vic's father is playing) and watching television. Ingrid's objections to the concert ('it's a bit old-fashioned') are supported by her mother and they don't attend.

Hill sees this sequence as crucial in the film's construction of gender positions, with the new world of affluence associated with women and the older working-class world representing male dominance. The film's 'solution' is then read as a reassertion of the 'normality and naturalness of the patriarchal family'.[36] This is persuasive but may underrate the degree to which the film takes up the novel's quite explicit attempt to investigate stereotypes in gender relations and to specify the deep penetration of socially constructed ways of seeing into apparently spontaneous personal feelings. This is nowhere more evident than in the scene on the park bench when Vic and Ingrid enter a heavy clinch for the first time. As kiss follows kiss and Ingrid declares 'I love you, I'm crazy about you', the camera slowly pans across a range of grafitti on the shelter wall behind them, lingering momentarily on the scrawled message 'I love you Adam'. Ingrid's feelings for Vic are shown as constructed by the culture of feminine romance she inhabits just as his feelings for her are shown by the contradictory discourses of male predatory sexuality and family patriarchy.

The film then registers three conflicts simultaneously – those of class divisions, gender and generation. The removal of Ingrid from her mother's house (to less comfortable conditions) is both an assertion of the husband's rights over the mother's and a rejection of the shallowness of the new affluence. Ingrid's mother, however, cannot be taken as the sole defining image of woman in the film. The key figures in persuading Vic to try again are his sister and mother, both of whom forcibly point out his shoddy treatment of Ingrid. The mother is particularly sharp: 'have you ever thought what it

means to a women to lose a baby?' The film, more clearly than the novel, offers clear evidence to support Ingrid's view that 'It's rotten being a girl sometimes'.

The closing shots do not suggest a clear resolution. As Vic and Ingrid revisit the park and head again for the bench and shelter, they haven't yet found a place to live; the perspective of the shot (over the industrial city) and the soundtrack (railway trucks being shunted) however, return their future firmly back to the film's northern setting. A considerable amount of the film is shot with this downward angle perspective; both the park and Vic's street are steeply sloped and from both, the city, and in particular the railway, form the continual backdrop. Schlesinger's film, perhaps more than any other of the New Wave films, offers a systematic inventory of the characteristic settings of northern working-class life: inside and outside the factory, on the buses, in the cinema, at the football match, through the patches of waste ground and past the railway yards. After the final row with Mrs Rothwell Vic walks the night streets (unlike the novel where he stays the night in the house and leaves in the morning) and finally sleeps on a bench at the railway station. This constitutes already a kind of symbolic return to his roots, since his father (a miner in the novel) is a railwayman himself. This change of occupation is highly functional for the film since it allows the traditional working-class way of life to be seen repeatedly intertwined with the whole urban setting.

The film clearly registered the effect of Schlesinger's work in television documentary; one critic regarded it as 'well upholstered with documentary techniques and in a documentary way very competent, with unobtrusive and selfconscious North country backgrounds'.[37] The opening sequence set the prevailing style and tone. A group of shouting children run from terraced streets, across waste land, followed by the camera which then halts and pans up to give a full shot of a church and then a wedding group, as they come out and pause on the steps for the photographs. As the credits roll, the camera picks out the components of the scene: the drivers waiting, the small crowd watching, and the members of the family. Vic's family are set visibly in a solid community and environmental setting, treated in a faintly comic, but not

disrespectful way – in fact in terms of the established rhetoric of the 'personal' television documentary.[38]

The contrast between this and the opening sequence of *Billy Liar* (released August 1963) indicates the difference between the two films in their approach to the iconography of the northern urban environment. In *Billy Liar* the credits roll over a soundtrack of the radio request show *Housewives' Choice*, with Godfrey Winn presenting; the camera pans and cuts fast across a range of women listeners (thrown into confusion or hysterics as their requests are played) in semis, high-rise flats and finally a terraced house, where the occupant is enjoying her seventieth birthday – the camera then pans to show the rest of the street being demolished. The film's persistently ironical style and its targets (both 'progress' and ordinary urban life) are indicated in the sequence. The idea of a distinctive traditional northern identity is treated as illusory or anachronistic, while the new glossy consumerism is presented as merely absurd through Danny Boon's fake sincerity, the mass standardisation of the new supermarket he is opening and Shadrack's modernisation of the undertaking business (plastic coffins and radio control of the funeral fleet).

Between traditional northern life and new consumerism lies the subtopian existence of Billy's family in their semi-detached house, with the father's small business and Billy's dreary clerical job. Billy's fantasies are a way of escaping and transcending all these aspects; the actual transcendence, however, is not Billy's but the film's. Billy's desire to be a scriptwriter is unfulfilled within the narrative, but is the basis of the film's escape from the realist conventions of the New Wave. While in the stage play the fantasies remained verbal, the film offers them as fully realised images and sequences which, themselves, are frequently cinematic in origin. Billy's momentary machine-gunning of his parents, Shadrack and Barbara are linked to longer sequences of him as the military leader of Ambrosia: addressing the crowd in the football stadium, in a 'Pathe News' sequence ('The Rape of Ambrosia') visiting the battlefield (actually walking the moors) and, as in the closing shots of the film, leading his victorious army. Other recognisably cinematic sequences are Billy as the lonely prisoner writing his memoirs and Barbara transformed into a

sex kitten. Overall it is this space offered by Billy's fantasies which allows the film to use the stock of cliché-ridden, conventional cinema images (those against which the 'realism' of the New Wave films were defining themsleves) as a creative resource.

Billy Liar had then a very ambivalent relationship to the earlier New Wave films. It had 'plenty of realistic locations, provincial settings, working-class domesticity, inside views of pub, dance-hall and pub, it all sounds like the mixture as before'.[39] It wasn't, however, because of both its persistently ironical view and its emphasis on the desirability and possibility of complete escape, not just in Billy's fantasy, but through the figure of Liz and the presence of London. In earlier New Wave films escape was hardly an option – the material of casual conversation about London between the two girls in *The Loneliness of the Long-Distance Runner* and of Vic's vague aspirations to travel and see the world before he gets 'caught' by Ingrid. *Billy Liar* (as novel, play and film) recalled an earlier 1950s mode in Billy's echoing of Jim Dixon's desire in *Lucky Jim* to get to London as the place of opportunity, (in Wain's *Hurry on Down*, the hero does indeed end up in London as a successful comic scriptwriter). Billy, unlike Jim and Charles, loses his nerve and remains locked in his fantasies, but the authenticity of the option is guaranteed by Liz who goes on her own. This was a change from Waterhouse's novel, where Liz refuses to go to London with Billy, heading instead on her own for Doncaster;[40] the idea of London is then recognised as a fantasy. In the film (through the figure of Julie Christie) Liz is presented as a qualitatively different figure from Billy's two competing fiancées: and indeed from every other character; London is then a genuine option as an escape from both northern provinciality and the routine drabness of ordinary life and it was this option which British cinema tended to follow through the rest of the 1960s.[41]

'This Sporting Life' – 'A Bleak Northern Affair'

Six months before *Billy Liar* effectively undermined so many 'New Wave' conventions Lindsay Anderson had made his rather belated entry into feature films with *This Sporting Life*.

Independent Artists (who relied on Rank for distribution) had bought the film rights to Storey's novel and asked Reisz to direct. Reisz, however, revived a Free Cinema relationship by acting as producer with Anderson as director. Anderson, through lack of opportunity as much as personal inclination, had made no films since 1957, working instead largely in the theatre at the centre of the 'Vital Theatre' movement, directing seven plays at the Royal Court. In his return to film-making with such a clearly nominated 'realistic' subject as *This Sporting Life*, the influence of the very active theatrical debate about naturalism and its limitations is very evident.

The film noticeably avoids the regular use of those general townscapes which characterised earlier 'New Wave' films. Instead the camera remains much closer to the immediate human figures, not so much to emphasise dialogue as to stress gesture, pose and movement (of face and body). Richard Harris's playing of the hero (renamed Frank, to avoid identification with Arthur Seaton) is marked by a tendency to expression through barely suppressed physical violence (both on and off the rugby pitch) and a series of distinctive gestures and poses, most notably the tightly folded arms, almost hugging himself in, adopted at moments of intense feeling: envy watching the rugby heroes feted at the dance-hall, embarrassment and enjoyment while singing (as a celebrity) in a pub, and despair, looking down on the industrial landscape after being finally rejected by Mrs Hammond. The culmination of this stylistic emphasis is in the penultimate scene where, after Mrs Hammond's death, Frank breaks into the empty house, wanders round the rooms and finally, in a 'stagy', melodramatic but absolutely appropriate gesture, holds his head and sinks to a despairing crouch on to the floor.

This powerfully climactic response to Mrs Hammond's death is in considerable contrast to the novel's radical under-statement, where nothing at all is relayed of Arthur's reaction. This reflects how far the film is based essentially on the first half of the novel: the series of flashbacks motivated by Arthur's enforced dental treatment, particularly the anaesthetic, and subsequent disorientation at Weaver's Christmas Eve party. Much of the novel's second half is simply omitted, with no

reference to Arthur's parents or the family lives of other players, and with Mrs Hammond's death brought forward to a few days after Frank has left her rather than the few years of the novel. The central device of the film then becomes the flashback, based (in a script by Storey himself) on the novel's four separate remembered episodes from Arthur's past, but treated much more fluidly with considerably intercutting between different stages and aspects of Frank's life. Towards the end of the film, as the whole of the action becomes set 'in the present', the emphasis falls on establishing parallels between life on and off the rugby pitch, with frames of Frank lying face down in the mud alternating with him face down on the bed in the sordid lodging house.

This greater concentration on the central relationship with Mrs Hammond and a cinematic style which, in the context of presumed 'working-class realism' might seem to employ 'too much art',[42] did not prevent a clear social analysis being offered. The fundamental relations of domination and subordination between directors and players are quite clearly defined throughout – as in Weaver's self-congratulatory comment after Frank's signing-on, 'You're the property of the City now'. The simultaneous temporary prosperity and fundamental insecurity of the players' position is registered particularly through the visual obtrusiveness of Frank's new large white car. Both its speed (in the exaggeratedly fast first sight of it racing through the streets) and colour (in a film much of which is shot at night or in the dullness of late winter afternoons) mark it as a deliberate statement of personal success. Its simple presence in front of Mrs Hammond's terraced house causes gossiping neighbours to gather: 'it's like riding around in your own front room' Frank calls out in an attempt to arouse envy. Like the fur coat which Frank forces Mrs Hammond to accept, the car suggests a life style completely at odds with her deadly routine of primitive domestic labour.

If Harris's playing of Frank embodies the film's visual style, then Rachel Roberts's Mrs Hammond determines its mood – joyless and committed to the refusal of pleasure. The film was, commented Anderson, 'a bleak Northern affair, of powerful, inarticulate emotions frustrated or deformed by puritanism

and inhibition. The background rough and hard: no room here for charm or sentimental proletarianism.'[43] It offered neither the documentary satisfactions of a fully realised northern working-class life nor the possibility of identification with a generation hero (or heroine). Frank Machin, unlike Arthur Seaton, Colin Smith, Jo or even Billy Liar, could not stand as a representative of youth rebelling against a failed parent culture. Like *The Loneliness of the Long-Distance Runner* and *Billy Liar*, *This Sporting Life* sought to build and go beyond the 'naturalistic look' of the earlier 'New Wave' films, but unlike them not in ways which prefigured that media-orientated, London-based expansive exuberance which characterised so much British popular culture of the mid 1960s. In terms of feature films Anderson's career was again interrupted as he largely by-passed that moment and re-emerged with *If* (1968), a film heralding its dissolution into the destructive, anarchic and liberating phase of 1968 and after.

British Cinema in the 1960s

By 1963 both British production companies and their financial backers had removed their support from northern working-class subjects. The landscape which was to replace the industrial North was sketched in *Live Now – Pay Later* (October 1962) and *Nothing But the Best* (February 1964), both ostensibly satirical (but often equally celebratory) accounts of the excesses of the new 'affluence' and 'classlessness'. After 1962 Woodfall itself had deliberately turned away from contemporary working-class life with Tony Richardson's *Tom Jones* (June 1963). The high budget (it was the first Woodfall film in colour) caused Bryanston to be replaced by United Artists as the main source of finance and the emphasis on sensuality and sexuality, together with a further development of the mix of techniques used in *The Loneliness of the Long-Distance Runner*, pushed Woodfall well into the mid 1960s – a move confirmed subsequently by Dick Lester's *The Knack* (June 1965) in which Rita Tushingham (like Julie Christie in Schlesinger's *Darling*, also 1965) came in from the provinces to 'swinging' London. By the mid 1960s the Free Cinema project of moving the British cinema out of a London, middle-class-based perspec-

tive seemed to have run into the ground (although it was now a different London and a different middle class from that of the first post-war decade). Only towards the end of the decade was something of that project revived in the work of Ken Loach, with *Poor Cow* (December 1967) and particularly *Kes* (shot in 1968), made jointly with Tony Garnett. *Kes*, based on Barry Hines's novel set in a Yorkshire mining village, returned to an uncomplicated and unapologetic realism, reflecting an apprenticeship outside the commercial cinema, in the BBC *Wednesday Play* unit. By the mid 1960s it was in television (particularly television drama) rather than cinema that traces of the Free Cinema and 'New Wave' projects survived and were positively advanced and transformed – within a medium whose institutions and technical possibilities were still in an early and volatile stage of development.

6. Television: Art, Reality and Entertainment

The Expansion of Television 1946–63

THE BBC resumed television transmissions in June 1946 to a handful of viewers in the London area; by March 1947 there were under 15,000 licensed sets. This rose slowly to 760,000 in 1951 and then with increasing speed to 4.5 million in 1955. 1953 was the watershed year. Between March 1953 and 1954 over 1 million new licences were issued and the figures continued to grow at a comparable rate, reaching 8 million in 1958 and 12 million by 1963. The mid 1950s (rather than the late 1940s) were the key years, for a number of reasons. The amount of income available for expenditure on consumer durables grew while there was a relative fall in the price of sets; by the early 1950s it was also possible to rent or buy by hire purchase. Equally important was the rate of growth of the national network. Transmissions for the Birmingham area began only in 1949, for the North in 1951 and for the main centres of Scotland and Wales in 1952. By 1953 the BBC could reach 85 per cent of the population.[1] The Coronation in June 1953 was the first major event to be presented through this network; an estimated 20 million people watched on the 2.5 million sets available.

The expansion of television occurred at three levels: the range of the network, the number of sets and the hours of transmission. In 1954 the BBC was broadcasting 6 hours per day, compared to a total, by 1963, of 16 hours (aggregating both channels' output). Commercial television rode the tide of this expansion rather than being a prime cause of it. The immediate origins of the service lay in the return of a Conservative government in 1951 which reversed Labour's

plans to maintain the BBC monopoly. A combination of pressure from business interests (prospective contractors and advertisers), the appeal of free-market ideologies and the opposition of the Labour Party were sufficient to override doubts within sectors of the Conservative Party as to the likely effects of a service financed by advertising. The residual effect of these reservations was, however, the creation of a general overseeing body (the Independent Television Authority – ITA) with terms of reference remarkably similar to those of the BBC.

Initially the ITA could do little to promote particular kinds of programmes or control general standards as the first companies to be launched faced almost immediate financial crises. The capital outlay for a new television service was considerable and a system of finance by advertising required large regular audiences which necessarily originally did not exist. In September 1955 when the service was launched, only 3 per cent of all British households could receive ITV; the service was limited to the London region and even there the majority of sets were not designed for two-channel reception. Further regions gradually began transmission, the Midlands in February 1956 and the North-West in May 1956. Sets were converted and new sets bought. By the end of 1956, 53 per cent of all television homes were receiving ITV and within two years this had risen to 76 per cent.[2]

It was not until 1958 that the companies began to show a profit. During the first two years there was a desperate struggle to maximise audiences as quickly and cheaply as possible. While the ITA held the line on its quota (around 14 per cent) of non-British material, the companies launched numerous series of copies of American-style game shows and quizzes. Sir Robert Fraser, then Director-General of ITA, has commented that 'the serious content suffered in the struggle to find an audience to let us carry on. So if you look at the *TV Times* for 1957, what you see is a popular entertainment service, what we would now regard as a narrow service.'[3] However, once economic viability (and, very quickly, large profits) was achieved then the ITA began to exert a genuine influence on the programme schedules and from early 1958 pursued a policy of increasing the amount of current affairs, schools, education,

religious, drama and regional programming, to create 'a more rounded and comprehensive service'.[4]

By 1958 television was present in the majority of homes, irrespective of social class, and it was rapidly becoming accepted as a domestic necessity. As audience figures for television outstripped those for radio and as cinema audiences continued their decline, television became the dominant cultural form for both popular drama and non-fictional representations of contemporary social life.

Television forms: technical constraints

Between 1958 and 1963 the current condition of working-class culture was commented on, and reflected in, a wide range of television programming from political discussions and party political broadcasts through advertising to general current affairs. A particularly prominent example was Christopher Mayhew's BBC series *What is Class?* in the late summer of 1958, which included a powerful interview with Dennis Potter, then 20 years old, reflecting on the gap between his two identities as miner's son and Oxford undergraduate. This broad role of television as a producer and reproducer of the terms of the debate about working-class culture is beyond the concerns of this chapter. The particular focus here is rather with those television forms which attempted a direct experiential representation of contemporary working-class life. The main forms involved are single plays, documentaries, drama series and drama serials. However, before considering these in detail it is necessary to specify some of the general determinations operating on all television production in the period up to 1963; determinations which take the form of a closely linked set of technical, economic and ideological constraints.

In the mid 1950s British television was predominantly a live medium. There were three kinds of material available for broadcasting: live studio material, outside broadcasts and recorded film. In the early 1950s there was no way of recording television on to videotape; a number of systems had been devised to record television signals on to film, although there were considerable problems of synchronisation and retention

of quality. By 1953 the BBC had succeeded in devising effective solutions to these problems, in time for the successful recording of the Coronation for both archival and export purposes. Initially this was regarded as simply a means of retaining live broadcasts for further showing, although it soon became clear that pre-recording of some programmes could have economic advantages (for example in allowing studio capacity to be more fully used in the daytime). Nevertheless such pre-recordings were by no means the norm, even by the end of the decade.

The technical problems of devising an effective method of videotape recording were severe and only began to be solved effectively by the development of the Ampex system, first demonstrated in the USA in 1956; tape, rather than film, recording was required in America in order to allow programmes to be screened twice on the same day to cope with time-shifts across the Continent. At this stage each machine cost $75,000[5] and it was not until 1960 that the system was in regular use in British television. Even this did not lead immediately to the introduction of fully flexible editing facilities. Here particularly economic and technical constraints went hand-in-hand. Editing magnetic tape was not easy – it was still, literally, a scissors and paste job – and it was not until 1963 that the advance into electronic editing, by transferring material on to a single final mastertape, was made. The disadvantages of the earlier method were not merely technical; each tape, in the early 1960s, cost £100 (and a cut tape was not reusable), at a time when the whole budget of a quality TV drama might be under £5000.

Television companies were naturally wary of anything which increased production costs, even where it improved the quality of the programmes. In 1962 Howard Thomas, then Managing Director of ABC Television, put both sides of the argument:

> key scenes or 'flashbacks' could be pre-recorded and fed into the final recording. Recording also provided breathing time between acts and also time for an artiste to change clothes or to be 'aged' with make-up. Re-takes were also possible, although this was regarded as a last resort in television, because it could lead to the time-consuming

system of numerous 'takes' which is common practice in the film industry.[6]

Generally there was still pressure to continue live production (with inserts) or to record as economically as possible – in sequence without editing – in order to minimise costs.

In 1956 Arthur Swinson advised prospective television writers to adapt to the nature of television as a live medium, specifically the constraints of time ('if John Smith has to change his costume the script must be constructed so as to give him enough time') and of space ('it is no use a writer asking for twenty-three sets, because he will never get them').[7] Writing on the same subject in 1963 he noted a major change in that, 'between 1950 and 1959 every play or documentary I wrote went out live. Since then every programme has been recorded either on film or tape.'[8] He was, however, very precise in noting the actual degrees of freedom this gave, and confirmed Thomas's suggestion of fundamental economic constraints: 'programme companies have no great desire to increase the amount of tape editing, even to improve the quality, and there are good economic reasons for their attitude.'[9] If editing were allowed then re-takes and editing time would add considerably to costs. Swinson himself was clear that writers should make no assumptions at all about such facilities. For the 'next two or three years' at least, the writer must 'construct his programmes as if they are to be broadcast live from beginning to end'.[10]

The 'live' nature of television was, in any case, not necessarily felt to be a limitation. There was a widespread doctrine that it was a positive distinguishing feature of the medium. It is not surprising to find this in the early days of post-war television, when a virtue had to be made of necessity and television was defining itself against cinema. It is, however, striking how strongly the view persisted well into the 1960s. There were three arguments here, all broadly aesthetic in emphasis. The first had an apparent technical base and referred to picture quality. In 1958 one television producer claimed that:

a 'live' television picture has more life than any present

known means of recording it. It is not that the audience is aware that a play is being performed *now*, but that celluloid covered with emulsion cannot emulate the vitality of a direct electrical picture.[11]

A second argument held that the viewer received a qualitatively different kind of experience from the *knowledge* of watching live programmes. In 1962 Howard Thomas maintained that, 'for the viewer there is the sense of "it's happening now at this moment" and there is always the hope that the unexpected might happen'.[12] As a general point relating to live outside broadcasts this may be accepted; in the mid 1950s it was also frequently used to assert television drama's similarities with theatre rather than cinema. However, by the early 1960s this argument could hardly be sustained since the audience could, generally, have no way of knowing whether they were watching a live or a pre-recorded production.

The third argument concerned the internal dynamics of the dramatic performance and was not so much in support of live television as of continuous performance whether live or recorded. In early 1964 Don Taylor, producer of the David Mercer trilogy *The Generations*, argued for the aesthetic advantages of current television practice:

> continuous performance ... seems to me to be television's key advantage over film. ... The discontinuous film performance, even by the cleverest film actor, always suffers by comparison with a TV performance that really clicks. This seems too obvious to need amplification. In the emotion of a performance growing from scene to scene, new things are discovered about a part in the act of playing it.[13]

Taylor gave an example of a fifteen-minute scene centring on one character – 'a kind of passionate interior monologue' – in Mercer's *A Climate of Fear* which required continuous performance for the actress's 'emotional growth' into the scene. He claimed equally that the lack of physical movement would have 'bored the (stage) audience to tears' and argued that Mercer's plays were the kind of drama which was

'specifically of television, unperformable in any other medium'.[14]

Single-Play Drama

In the 1950s particularly attempts to define a specific genre of television drama were closely linked to an assessment of what could be achieved in the live studio. In 1952 Jan Bussell had advised writers that:

> Scenes between twos and threes are what television wants: quiet intimate stuff which the camera can get right into. Five people on the set for any length of time is a producer's headache, meaning constant re-grouping and cutting from shot to shot in order to show viewers what the character looks like in close-up.[15]

In 1956 Arthur Swinson indicated the usual settings for such small group encounters: 'Within each set the action is usually pegged to a room, an office, a shop ... until it moves on to the next scene and is pegged there.'[16] The similarities between this kind of drama and theatre naturalism are evident. Swinson went on to argue for these techniques to be applied to the portrayal of everyday British life: 'television drama ... should draw its subjects from the contemporary life of the nation and even snatch its plots from the daily newspapers.'[17] After 1956 developments within the theatre helped to provide writers and examples for such new directions within television drama. Two other influences were mentioned by Swinson as positive indicators for the future of television drama in Britain, the arrival of ITV and the example of contemporary American television, particularly Paddy Chayefsky's play *Marty*.

Chayefsky's achievements were repeatedly referred to in the debates of the late 1950s concerning the proper scope of television drama. *Marty*, produced on American television in 1953, was the story of an 'ordinary man', a New York butcher, who defies the collective opinion of friends and family in sticking to the unattractive girl he loves. Chayefsky's impact in Britain was, however, as much due to the publication of

a collection of his television scripts (with accompanying theoretical notes) as to the play itself. According to Alan Plater, Chayefsky 'observed that the greatest single asset of television was its simplicity and directness; the ability to watch a face in close-up ... television drama should be the drama of the ordinary man or woman.'[18] Ted Willis was one of the first British writers to recognise Chayefsky's achievement. Willis's *Woman in a Dressing Gown* presented by Associated Rediffusion in their Television Playhouse series (July 1956) applied Chayefsky's principles in the portrayal of contemporary British social reality. In 1958 Willis developed Chayefsky's thinking into some detailed principles on the nature of television drama:

> realism is the only road.... Superficial movement is not important, even dangerous: the chase from set to set can destroy mood and tension. The finest television is that which is concentrated in time and space and character, which takes one or at the most two characters and makes their nature known.[19]

In the same number of *Encore* Michael Elliott gave support on technical grounds to this emphasis on the intimate presentation of a small number of people:

> Drama is concerned with people, and people are most expressive through their faces. But to see the expression on a face clearly a television camera has to be much nearer than a film camera, and therefore excludes more. Whereas a film director works mainly in medium shot, a television producer should work mainly in medium close-up.[20]

The development of this aesthetic coincided, by 1959, with progress in all the three areas noted as growth points by Swinson in 1956. There were signs of a move towards more contemporary material, partly fed by the post-1956 theatrical revolution. *Look Back in Anger* (in extract form) had been shown by the BBC in October 1956 and as Willis and Alun Owen exemplified there was a growing interchange between stage and television playwrights. Secondly the arrival of ITV

had expanded the demand for television drama. All four major companies initiated drama policies, the two most prominent being ABC and Associated Rediffusion. From 1958 to 1964 Associated Rediffusion regularly took full-page advertisements in *Encore*, asking new playwrights to come forward with scripts. In 1958–9 these advertisements contained specific advice, that 'in a television play dialogue is far more important. Film writers try to make television too visual.'[21] By the autumn of 1959 the company were pointing out that they had now achieved 100 live productions in their *Television Playhouse* series.

ABC's rival series was *Armchair Theatre* and here Swinson's third growth point – transatlantic influence – was crucial with the hiring of Sidney Newman from Canada's CBC to head this already established series. Under Newman *Armchair Theatre*, between 1958 and 1962, presented a variety of dramatic material. Initially Newman relied heavily on productions of American and Canadian plays and although by 1960 the emphasis had changed towards British playwrights a survey of its productions for 1959–60 shows that less than a quarter of the output was depicting the life of 'ordinary people' in Britain. Despite this much of the series' reputation then and subsequently was related to this aspect of its work. Early in 1962 Newman claimed that 'the recognition of the working class as a respectable subject for serious drama was brought about by television',[22] while in 1966 John Russell Taylor nominated the period October 1959–March 1961 (from Alun Owen's *No Trams to Lime Street* to the end of *Armchair Theatre's* run as a weekly series) as the golden age of television drama, through plays which 'revivified a weary naturalistic convention of play-writing by using it in a new way to look at fresh subject-matter: life as it is really lived today by working and lower middle-class people in, and particularly outside, London.'[23] Newman's initial brief had been: 'to continue the development of a programme having its roots in the North and Midlands but conceived as family entertainment for a Sunday night viewing circle in homes throughout the British Isles.'[24] In the early days the productions were rehearsed in London and then transmitted live from Manchester; by 1961, with pre-recording, production had moved to ABC's London Studios, but took place predominantly under 'live' conditions:

Recordings are therefore treated as far as possible like a continuous live performance... sequences presenting special difficulties are pre-recorded ... then inserted into the main performance. Unscheduled editing, however, is done only in cases of dire necessity, since it is both difficult and expensive to cut electronic tape.[25]

Pre-recording gave time for the worst possibilities of live performance to be avoided (such as an actor dying during the Second Act), although mistakes might be left in, such as that in which a lift was shot going down rather than up in Alun Owen's *The Rose Affair*. It was within these constraints that Owen's early television plays were written and produced in the 'golden age' period of *Armchair Theatre*.

Owen's first performed work was a radio play, *Two Sons* (originally composed by performing and recording the dialogue), broadcast in early 1958. His first stage plays *The Rough and Ready Lot* and *Progress to the Park* were produced in 1959 and he was then commissioned to write a play for *Armchair Theatre*. Owen subsequently had three new plays performed in Armchair Theatre within a year: *No Trams to Lime Street* (18 October 1959), *After the Funeral* (3 April 1960) and *Lena, Oh My Lena* (25 September 1960). These plays resulted in Owen being given the Award of 'T.V. Playwright of 1959–60'; they also established for him a press reputation as the leading television exponent of northern realist working-class drama. This was clearly illustrated by the reception of his subsequent part-fantasy play, *The Rose Affair* (8 October 1961). Numerous references were made to his having broken away from an established formula of 'writing about north country working men and women with a realism that jerked the viewer with the shock of recognition' (*Daily Sketch*), 'working-class realism' (*Daily Worker*), and giving 'realistic pictures of North of England life' (*Glasgow Herald*).[26]

In *No Trams to Lime Street* three young sailors return to Liverpool after four years absence, each with a particular mission to fulfil. In his Introduction Owen commented on the dramatic value of Liverpool's 'multi racial population' – 'a Celtic town set down in Lancashire'.[27] One sailor is Irish Catholic, a second Welsh and the third English Protestant.

The action moves from the ship to the streets of Livepool, a pub, a flat and back to the ship again as each sailor reflects on his inconclusive adventures. *After the Funeral* addressed more specifically the double identity of those who (like Owen himself) have split allegiances to Liverpool and Wales. Two brothers return to North Wales for their mother's funeral, and to visit their grandfather who is now left to live alone. The phoney Welshness of the younger brother (a Professor of Welsh studies) is set against the direct honesty of the elder brother, a seaman about to settle down in Liverpool; the play contrasts the attempts of the younger brother to persuade the grandfather to live with him (to enhance his own status as authentically Welsh) as against the elder brother's genuine concern for the grandfather's welfare. Virtually all the action takes place inside the house of the grandfather who chooses the elder son, Liverpool and authenticity against a fantasy of Welsh cultural identity.

While both these plays established Owen's reputation as an authentically regional dramatist, neither of them could legitimately be taken as an example of 'working-class realism'. This label could only be properly applied to *Lena, Oh My Lena*, set in the yard of two factories situated 'on the East Lancs road ... between St Helens and Salford' (p. 109). The camera directions in the script stress how the play develops by cutting between scenes at the loading-bays of the two factories, one a grocery warehouse employing men and the other a bottle-washing factory where women work. The dialogue is set amongst the work of loading and stacking and the tea breaks and lunch breaks between. The play effectively begins with the appearance of Tom, an English Literature student, 'from a lower-middle-class family which he has romanticised into the working class' (p. 107). Tom wants to take a holiday job at the warehouse, rather than pea-picking with the other students, so that he can 'work with "people" for a change' (p. 125). He is, however, rather surprised at the 'people' he sees; 'Funny looking lot of women aren't they?' he comments on seeing the women at the bottle factory to which Ted, the foreman sharply responds: 'No they're not. They're just ordinary women, getting a bit extra to build up the old man's wages' (p. 119).

Tom is quickly attracted by Lena, one of the women at the bottle-factory, who becomes part of his romantic fantasies about connecting with 'people': 'Lena ... Lena ... Lena ... You're lovely and real, beautiful and real' (p. 140). For Lena, however, Tom is only 'a bit of fun' – a way of making Glyn, her lorry-driver boy friend, jealous. Tom's failure to understand the unwritten rules of Lena's flirtation with him is part of a general difficulty in understanding the habits, norms and even language of manual work and the people who have to do it. The play ends with Tom's humiliation by Lena's rejection of him and Glyn easily knocking him over. Tom leaves to go back to the other students, admitting they are his 'sort' after all.

Modes of speech are central to the play's placing of characters' identity. Owen advises that Tom 'has a slight Liverpool accent but when he is nervous or angry it becomes the schoolmaster's voice full of Southern vowels' (p. 107); a typical example of a direct equation between class and regional affiliations. Dialogue tends to be more fragmented and monosyllabic than in Owen's earlier plays; Tom's attempts at conversation or lyricism are rejected by Lena: 'I think you gab a bit too much' (p. 141). Overall in these television plays Owen states that he had tried to discipline the voluble, Dylan Thomas-like, aspects of his style and it was the constraints of this discipline that made him want to move out of this naturalistic mode:

> It was not that I had lost sympathy with inarticulate characters, but amid a plethora of plays (including my own) about characters whose conversation was practically confined to saying "yeah ... well ... like" and kicking their heels I felt a desperate need for eloquence.[28]

Owen's remarks suggest the restrictions inherent in the Armchair Theatre production method of handling the lives and experiences of ordinary people, emphasising dialogue, small-group interaction and the consequent limitations of setting. *Lena, Oh My Lena* represented, or at least so Owen felt, the most that could be achieved within that method.

During this Armchair Theatre period BBC dramatic output

was very considerable in quantity as they attempted simultaneously to develop in the areas of series and serials, classic plays and novel adaptations as well as new single plays. The very quantity and range of output, however, without the same degree of organisation of material into specific drama series as was common on ITV, failed to create a distinctive identity for single-play offerings. This was certainly true in the area of 'regional realism' where no single playwright emerged with as clear an identity as Alun Owen, although the label was applied vigorously and pejoratively by the *Spectator* TV critic to a first play by a new writer in December 1961:

> David Mercer's *Where the Difference Begins* ... was the spawn of *Look Back in Anger*, about the dilemma of working-class sons who have gone up in the world; [it has] lines like 'When I leave this house, it'll be in a wooden box' and 'Working chaps'll never be better so long as fellows like thee go over t'other side', cannot some script editor see that this just will not do? Social consciousness is a vast, magnificent unending source of drama, but that is no excuse for bad plays.[29]

Mercer himself has acknowledged that *Look Back in Anger* was one of the influences behind the play. More immediately he records that 'after I'd seen *A Taste of Honey* I thought, well, if that's a good play, I'm bloody sure I can do better.'[30] In 1959 he wrote a stage play which despite being optioned by Oscar Lewenstein did not get produced: 'I believe he thought that the whole Northern working-class thing was beginning to work itself out.'[31] Mercer's agent was then contacted by Don Taylor who looked at the play, then called *A Death in the Family* (and having a likely running time of three hours). Taylor advised Mercer on revisions and cuts to reduce the length by half and the revised play *Where the Difference Begins* was broadcast on 15 December 1961.

The play is set almost exclusively in the house of a 60-year-old Yorkshire railwayman. Apart from two short telecine clips (one of railway yards, the opening sequence) the style is fourth-wall naturalism with the general environmental setting created largely by reference rather than visual image. Marga-

ret, the middle-class daughter-in-law of Wilf, the railwayman, looks out of the window on to 'One goods-yard, a row of tarted up slums and about half a million chimneys.'[32] The play bears striking structural resemblances to *After the Funeral*. As their mother lies dying, Wilf's two sons return to undergo self and mutual examinations of their achievements. As against Owen's play with its central issue of Welshness (with class undertones), Mercer's play focuses more explicitly on class, and on politics.

The 'difference' of the title has a number of resonances. Most generally it is the same difference as Ted Willis referred to in the 'Vital Theatre' debate – that between 1930s deprivation and 1950s affluence – and, like Wesker, Mercer makes a qualitative critique of the change. All the characters share the same perception of the current condition of the working class: material prosperity and political/spiritual apathy. Edgar, the eldest son, a scientist (and 'solid conservative') uses the situation to justify his own comfortable, uncritical, position: 'Look at your working classes now. Haven't they got it all? But they're not exactly a testament to the highest achievements of the human race, are they?' (p. 77). Wilf sees the difference as a loss of moral strength:

> Their sons and daughters come up in their cars to take them for a drive on a Sunday afternoon. But it's not t'same. Now we've gotten t' telly.... Socialism had some guts in it in them days. But.if its altered, so has't working classes. (p. 30)

Richard, the 'shagged-out political idealist', provides the most bitter and sardonic account as part of the 'social realist' fairy story he tells to his unborn child:

> Dad's getting on in years and doesn't quite get the hang of the changes ... He gets subsidised teeth, free glasses for reading and a gold watch for devoted service. The day comes when Mam says well there's no getting away from it we're better off now than we've been for many a long year.... And practically all there is left to do is shout where

do we go from here? . . . when we all have everything to live with and nothing to live *for*? (p. 67)

The new generation affluent working class form the play's central reference point but are conspicuous by their absence. The truth of their situation is presented through the lack of a true successor to Wilf's personal integrity and political will among his sons. The social mobility and affluence of Edgar stand for the general material improvement while Richard's lack of political direction reflects the political vacuum on the left which full employment and consumerism seemed to bring. From Wilf's point of view Edgar's self-satisfaction and Richard's aimless (if principled) drifting place them together as beyond connection with him and as traitors to their class of origin. In reply to Edgar's denigration of working-class achievements he states: 'They'll never be no different so long as fellers like thee goes over to t'other side!' (p. 77).

The play is then not so much an examination of contemporary working-class life as an enquiry into the consequences of what is taken as an unproblematic description. The problem left is that of the middle-class intellectual seeking meaning and direction; personified in the play by Richard (whose one positive political direction is charted by CND) and, as powerfully, by Margaret who, under the pressure of Richard and Gillian's example, recognises the lack of fulfilment in her role as a typical middle-class wife and mother. These characters point forward to the problems explored in the further two plays of the trilogy.

Thematically and stylistically the play was in fact a point of departure rather than an indication of areas of continuing interest. Don Taylor commented: 'In attitude it is basically simple and in style basically realistic. It is very much a beginning, a point from which to continue.'[33] Mercer himself has described the whole trilogy as:

extremely clumsy, because it hovers uneasily between theatre conventions and visual conventions with an awful lot of *words*. But there was the awareness that television drama could be developed in all kinds of directions – I was

beginning to get through to that in *The Birth of a Private Man*.[34]

The move away from working-class life went hand-in-hand with the use of a wider range of television techniques. The second play, *A Climate of Fear* (22 February 1962), is set predominantly in London and centres on Frieda (a character developed from Margaret), her children Colin and Frances and the claims and demands on them made by the current CND campaign of civil disobedience. The interlinking of private and public issues is here foregrounded by the cutting-in of genuine newsreel clips. The third play, *The Birth of a Private Man* (8 March 1963), opens with a funeral in Yorkshire and moves the subsequent action to London, Warsaw and the Berlin Wall. With a larger cast, more scene changes and one scene set in a Warsaw film studio showing Second World War footage, Mercer had moved a considerable distance from the first play of the trilogy in both style and theme.

Even before the broadcast of the third play Mercer had already attempted to break up the received wisdom of television drama with *A Suitable Case for Treatment* (21 October 1962). Here the theme of personal breakdown treated tragically in *The Birth of a Private Man* is both more fully and comically present in the character of Morgan. The play features dream sequences and fantasy as well as 'realistic' scenes of Morgan's antics. Taylor notes that 'Mercer threw away some of his words and substituted pictures, particularly pictures used for associative rather than descriptive reasons.'[35] According to Mercer, 'It broke every rule in the television drama book'. The 'book' in fact, it was clear by early 1963, had to be rewritten.

An early attempt by the BBC to 'rewrite the book' was the formation of the Langham Group in 1959. They saw television as:

a magical paint-box giving immediate results, not just a recording machine, but a new self-contained medium.... Directors could then begin work entirely within the medium. They could learn how to score their sound and pre-record

it, so that they would then be free to concentrate on making the pictures the prime centre of interest.[36]

Assessments of the achievements of the Group (disbanded in 1963) vary considerably. Most general accounts of television drama's progress as a form pay lip-service to their achievements, although in 1964 Don Taylor was highly critical of the emphasis on pictures rather than words. Nevertheless Taylor was also interested in developing the range of 'pictorial devices' at the director's disposal, noting three of potential value: 'the use of obsessive close-up, the use of unrelated film and the divorcing of the picture from the sound',[37] all of which had already been employed by Taylor in his productions of Mercer's plays.

Much of Taylor's position was shared by Troy Kennedy Martin. In an article in *Encore* in 1964 Martin agreed with Taylor's assessment of the Langham Group ('an art set-up ... propitiated on the altar of prestige')[38] and shared his emphasis on a wider range of pictorial techniques. He went, however, much further on the break needed with the theatre performance model. He argued that 'Naturalism ... is the wrong form for drama in the medium' and that 'all drama which owes its form or substance to theatre plays is OUT'.[39]

The essence of his definition of naturalism was telling a story through means of dialogue, making studio time equivalent to real time, retaining the theatre legacy of 'photographing faces talking and faces reacting' and emphasis on close-ups. Against this Martin advocated freeing the camera from following dialogue, telling the story by direct narration, freeing the dramatic structure from real time and exploiting the 'objectivity' of the camera. The result would be 'a new drama one hundred per cent a director's medium' which would 'cut across the myth of the live transmission producing spontaneity'.

Martin's essay provoked a number of replies in the next issue of *Encore* including one from Tony Garnett (then primarily an actor) suggesting that 'most, if not all, of the traditional differences between film (i.e. cinema) and television drama production are not essential differences, but accidental, historical or imaginary.'[40] When Garnett moved into the production

side of TV drama on the *Wednesday Play* series – first as story-editor in 1964–5 and from 1966 as producer – it was towards the erosion of these differences that much of his work tended.

The *Wednesday Play* slot on BBC1 (from October 1964) was a product of the reshaping of BBC drama which Sydney Newman inaugurated after his appointment at the beginning of 1963. Its programme over a six-year span (until being replaced by *Play for Today*) contained a wide range of material but, crucially, it provided, particularly through the production of James MacTaggart and Tony Garnett, space for plays which attempted the direct representation of contemporary working-class life. Writing in 1966 Troy Kennedy Martin asserted that its success 'was due not least to the fact that for the first time in television drama a play series could be recorded on the principle that the real editing would follow in the cutting room'.[41] It was in fact not just editing but equally outside filming facilities that made all the difference. Originally used only for news and current affairs, 16mm filming had been introduced into actuality documentaries at the end of the 1950s and was now introduced into drama production. This proved much less expensive than the use of 35mm feature film stock which required, under union agreements, more extensive crewing.

Garnett linked this transformation directly to the nature of the material being dramatised:

> We were interested in social forces and the fabric of people's lives and the kind of conflicts that go on particularly at places of work, where people spend quite a lot of their lives. It seemed to be driving towards actually going out there ourselves.[42]

Garnett connected this to the break with a dramatic form centring on conversation – a shift from this 'idealist philosophy' to an emphasis on 'material existence'.

Garnett's first production for *The Wednesday Play* was Jeremy Sandford's *Cathy Come Home* (16 November 1966), directed by Ken Loach. Garnett and Loach went on to produce a series of plays by Jim Allen, *The Lump* (February 1967), *The Big Flame* (February 1969) and *The Rank and File* (May 1971),

which constituted by far the most advanced televisual state-
ments of the political and social conditions of the industrial
working class made in that period. *Cathy* was different in its
focusing on a specific social problem – homelessness. It was
shot almost exclusively on film and, crucially, had a somewhat
oblique relationship to the tradition of the television play (as
practised classically by *Armchair Theatre*); it represented rather
a rendezvous between that tradition and the genre of 'drama-
tized documentary', a form with a very long and distinguished
broadcasting history. In fact documentary as a whole (whether
dramatised or actuality) had already provided an alternative
to and, in many ways, more effective space than, single-play
drama for televising contemporary working-class life in the
period 1958–63.

Television Documentary

The term 'documentary' has frequently referred to a consider-
able range of television forms. Paul Rotha's *Television in the
Making* (1956) indicated two ends of a spectrum with the
inclusion of separate articles on 'The Story Documentary' and
'Documentary Journalism'; in *Writing for Television Today*
(1963)[43] Arthur Swinson confirmed the persistence of this
division with chapters on both 'The Drama Documentary'
and 'The Actuality Documentary'. Swinson defined 'drama
documentary' in terms of four characteristics: it was played
by actors, live in the studio, it attempted to reproduce real
locations in the studio and it used true stories. The 'actuality
documentary' was predominantly filmed, showing the real
people concerned and the actual locations, and edited together
to produce a coherent programme. Between these two extremes
there were intermediate forms. The drama documentary might
mix actors and 'ordinary people' (with scripted parts) or
shoot some scenes on the actual location, while the actuality
documentary might film reconstructions rather than the actual
event. Such a diversity of practice, not surprisingly, caused
considerable disagreement concerning the proper scope of
documentary.

In 1954, reviewing a television programme on the 1930s
documentary film movement, William Salter remarked that,

by comparison, television documentary was 'too much infected with fiction', with an over-dependence on 'reconstructions televised in the studio'.[44] For those working within television, however, the story documentary was an achievement to be valued, 'one of the few art forms pioneered by television',[45] claimed Caryl Doncaster in 1956. The form owed much to radio, particularly the work of the BBC Features Department, but with the much greater technical complexity of television there were even more pressing reasons than with radio for scripted studio reconstruction in the presentation of 'actuality'.

In many production aspects the story documentary was identical to the television play; one major difference, however, lay in the expectations which the writer had to fulfil: 'what plot he uses must only exist to give shape and cohesion. He can never make use of *deus ex machina*, the happy ending, the numerous other theatrical devices which untie the knots.'[46] The writing had also to be based on thorough research and carefully scrutinised for inaccuracies of fact. During the early 1950s story documentary was used predominantly to present the operation of complex social service institutions in immediate human terms. These included the courts, children in care, after-care of prisoners, legal aid, the police and the medical profession.

In 1955 Colin Morris joined the relatively small group at the BBC who worked in this field. Morris's work made a relative change of emphasis towards focusing on the problems of those caught up in, or needing, welfare institutions rather than the workings of the institutions themselves. He moved towards a single-story form in programmes such as *The Unloved* (June 1955), dealing with a home for delinquent children, *Women Alone* (August 1956) on unmarried mothers, and others on alcoholism and prostitution. William Salter was among those unimpressed by Morris's work. *A Woman Alone*, he commented, was 'neither a documentary in the genuine sense nor a work of fiction'. The problem was that the audience, knowing that the leading part was being acted, became diverted from the documentary content by being 'forced to make some judgement about her performance as an actress'.[47] This issue of the improper mixing of real and fictional modes was to remain a long-standing one in television production

and criticism. It is important to note, however, that whereas *Cathy Come Home* in 1966 was attacked for being a play that illegitimately used documentary conventions, Salter's complaint was the opposite – that documentaries were being made ineffective because of their too obviously scripted and dramatised modes. By implication he clearly preferred documentary to adhere to an 'actuality' format.

In the early 1950s television's main contribution to actuality documentary about contemporary British society was the series *Special Enquiry* which began in October 1952 and ran monthly every autumn and winter until 1957. Each programme had a 'personality anchor-man', and a report (usually filmed) from a second, on-the-spot reporter. The subjects, according to Norman Swallow the general producer, were always 'social problems ... issues on which the British record ... is not as perfect as it might be'. The first programme focused on Glasgow slums and later subjects included unemployment, smoke pollution and the colour bar. Swallow saw the central element as 'simple unscripted statements by ordinary people ... the simple human drama played by the real people in the real environment.'[48] Such an effect was, however, necessarily produced by careful editing and sometimes by reconstructions, not merely by pointing the camera.

In 1955 the *Special Enquiry* team was joined by Denis Mitchell, seconded from radio in Manchester. As a talks producer Mitchell's main innovation had been to use the newly developed portable tape recorder to record people talking in their own environment: homes, pubs, chapels. During the early 1950s this had developed into a regular feature – *People Talking* – where the material was edited and shaped into programmes on particular subjects such as 'The English Sunday', 'Unusual Beliefs' and 'Night in the City'. The emphasis here was not on social problems but on the presentation of the thoughts, feelings and, above all, the actual speech of ordinary people.

Mitchell's first programme for *Special Enquiry* was to be on the 'problem' of teenagers. Immediately he sought to change the production routines established, telling Swallow that he wanted to work: 'by making a radio programme first, and then building a film around part of that radio programme. But

having said, "No, you can't do it like that", he then proceeded to show me how to do it.'[49] Mitchell shot separate silent film (which made the equipment more portable) and counterpointed it to his already edited sound tapes. He quickly established a distinctive style, and a foothold for himself in television documentary. A number of his films were made from the base of BBC's North Region in Manchester, using the 'think-tape' method, as it became known. *A Soho Story* (1959), by contrast, used a format more like the story documentary centring on the life and experiences of Mac the Busker, using synchronised sound with Mac talking straight to camera.

In two films, however, Mitchell pushed his 'think-tape' technique further by focusing not on any particular group of people but on the general 'feel' of the contemporary northern urban environment. According to Mitchell his general interest at that time was: 'Going some place, maybe a back street ... and sort of saying, well, this is the essence of it, this is what it smells like.'[50] Both *Night in the City* (June 1957) and *Morning in the Streets* (March 1959) were shot in a number of northern cities (including Salford and Liverpool). Of the two *Morning in the Streets* had a more unified mood. In *The Listener* K. W. Gransden saw it as:

> a most interesting experiment in the combining of two techniques. We started with the visual images, shot in several cities in the North of England and put together as a composite portrait, in the poetic-realistic style which the 'thirties taught us to find significant: steep cobbled streets looking foreign and deserted in the deep early morning.... Then the voices started, sudden and unexpected: tramps and middle-aged women ... reminiscing and philosophizing on tape: a brilliant sound-radio script in the latest and purest style superimposed on to the pictures.[51]

Philip Purser's assessment saw also a more specific social critique:

> It took a hard look at the precarious good times of the late fifties and weighted them against the backlog of two world

wars, depression and unemployment. On balance as an old tramp volunteered, it was still a bit of a lousy life.[52]

Morning in the Streets (which won international television awards) confirmed Mitchell's reputation; he now finally moved from Manchester to London and began to work on material of international significance. His mode of 'personal documentary' did not however easily fit any existing format or department (*Morning in the Streets* was classified under 'Talks'[53]). *Special Enquiry* itself was discontinued in 1957 – and during the late 1950s the closest parallel to Mitchell's work within broadcasting was to be found not on television but in the Radio Ballads of Charles Parker and Ewan MacColl.

While the Radio Ballads (broadcast between 1958 and 1963) are an unique and distinctive form, their structure represented a combination of specific radio techniques available at that time. MacColl had been involved in radio for over 20 years; the origins of Theatre Workshop lie in a meeting between MacColl and Joan Littlewood while they were both performing in a dramatised documentary in Manchester in 1934. During the 1930s BBC Regions had the opportunity to develop distinctive, if limited, areas of work; London, the national service, dealt with material of presumed universal and permanent significance, while the Regions, in a subordinate role, were to reflect 'the everyday life and variety of the areas it served'.[54]

In the Northern Region this included a specific commitment to presentation of working-class experience and speech, which could not however be easily achieved. Recording equipment was limited (disc, not tape, and difficult to transport) and the BBC insisted that everything had to be scripted in advance (since most talks and interviews went out live and therefore could not be controlled through editing). The result was that a producer would talk to contributors, take notes and then write a script which the contributors (or possibly actors) could present in the studio. One form which emerged from this was the story documentary in which a fictional character could be used as a focus for organising the documentary material. A frequent aspect of such drama-documentaries or features was the use of song as part of the dialogue or narration. Ewan

MacColl was involved in a number of such programmes, including *Coal* (1938), a presentation of the life of Durham miners – the series also included *Cotton*, *Wool* and *Steel*.

It would be possible to trace the many subsequent variants and developments of this in the work of the post-war Features Department. The period of achievement here is, roughly, the decade after 1945 until increasingly common use of the portable tape recorder undermined the need for a strongly constructed story documentary as the best way of representing actuality. Folk music continued to be used as one resource within Features programmes and, also, in the early Fifties, began to gain some foothold in its own right, as when in 1951–2 Ewan MacColl worked with Denis Mitchell on a series of programmes called *Ballads and Blues* each with a theme such as work, the sea or war and peace.

It was the case then that when in late 1957 Charles Parker began to research a programme for the BBC Midland Region on the death of an engine-driver he had a clear format in mind:

> We began ... field recordings as a convenient means of acquiring authentic background information on which to base a script; but almost immediately the calibre of the speech which we began to capture on the tape recorder forced us to reassess their function, and acknowledge that these field recordings cried out to be used as a direct element in the work.[55]

The final programme consisted of two main elements – edited field recordings and 'songs written in or derived from the traditional modes organically related to the field recordings'. In Parker's view this 'radio ballad' (seven were made in all) was a new art form and he stressed the considerable degree of selectivity involved in editing the field recordings – 'from 70 to 80 hours of material we cull – at the most – 25 minutes for direct use'.[56] The aim here was not so much to reflect the typical as to derive the exceptional:

> when the particular speaker, under the pressure of the

moment, relives in his or her own language, some deeply
felt experience; is brought, in fact to the point of creation
in speech, and by intonation, rhythm, imagery, or all
three together achieves a shattering degree of immediate
communication.[57]

This emphasis on intensity of communication suggests how
the edited speech complemented the songs. In *John Axon* and
those later ballads which focused on specific occupations the
link was made to a tradition of industrial or occupational folk
song and in a review of the first two ballads – *John Axon* and
Song of a Road (about motorway construction workers) – Bill
Holdsworth (a Union official, involved in the setting up
of Centre 42) paid particular attention to the music. He
congratulated MacColl for 'making a great contribution to
the fight against the mass pop-culture' by bringing alive 'the
personal dramas of our own day and age'.[58]
 The first two ballads were followed by *Singing the Fishing*
(East Coast herring fishing) and *The Big Hewer* (coal mining).
A pattern was established of programmes built round specific
occupational subcultures. The particular significance of this
in the late 1950s was in the emphasis on work as the primary
determinant both of lifestyle and ways of seeing the world – a
contradiction of the conventional wisdom concerning the
changes wrought by affluence.
 In three later ballads Parker and MacColl moved away
from this pattern, which raised problems often acute, of ap-
propriate musical style. *The Body Blow* dealt with polio victims,
while *On the Edge* considered adolescence and teenagers.
The final ballad – *The Fight Game* (the world of professional
boxing) – constituted a partial return to the original format
although crucially with an underlying irony indicating that
for the first time the human subjects were not receiving
unreserved approval. The Radio Ballads team was disbanded
at the end of 1963, ostensibly on financial grounds, although
Parker remained firmly of the opinion that it was objections
to the format and musical style that underlay the decision.
 In television, the years 1957–62, according to Norman
Swallow[59] were those of the 'personal documentary'; the

'essayists of television' who flourished then included John Schlesinger, Ken Russell and Denis Mitchell. Mitchell defined the aims of such work as:

> to show people as they truly are, expressing themselves in their own words, and doing the things they normally do. They are real people living in a real world. But what the producer has also done ... is to give a harmony to the people in his films by means of his own vision of them and of the world they live in.[60]

Commenting on this passage Swallow points out the logical contradiction between reproducing the 'real' and harmonising the film through the producer's own personal vision. In practice the work of these 'personal' documentarists tended to present itself along a continuum between these two poles – with Russell's work increasingly blatantly 'personal' and Schlesinger's apparently most 'real'.

After *Morning in the Streets* Mitchell himself produced two series of films on non-British subjects – an African trilogy in 1960, and three films in 1961 on American society. The third of the African documentaries was *Between Two Worlds* and was about the contrast between Masai tribesmen and one of them who had left to become a student teacher. Both title and theme were echoed in a film made by Dennis Potter under Mitchell's supervision, *Between Two Rivers* (3 June 1960). The film dealt with the mining area of the Forest of Dean where Potter had spent much of his childhood. Potter employed a number of Mitchell's methods, but diverged in his use of an explicitly committed commentary which criticised the impact of consumerism on the Forest mining community. Overall the film had three phases presented in a manner which was, 'individual and personal, less concerned with the district as an objective reality than with its impacts upon the narrator.'[61] The 'traditional' community was presented first, then Potter's experience at Oxford (leading to 'violent reaction' against 'the Forest's narrowness, conservatism, and lack of cultural horizons') and finally a return to the Forest which reassessed the value of the 'old valley culture' in relation to the new 'acquisitive' society. Typical of the film's method was the

contrast between shots of involved, excited spectators at a rugby match with the same faces 'totally impassive' watching the game on television.[62] The film 'antagonised the BBC higher echelon'[63] and had two effects – it began Mitchell's disillusion with the BBC and caused Potter to leave and become leader-writer for the *Daily Herald*. By 1963 Mitchell too had left the BBC.

After his departure Mitchell, with Norman Swallow, set up an independent company to make films for Granada on subjects dealing with contemporary life in the North. The films were to be shot and edited on video-tape, a new development made possible by improvements to the editing precision of tape. Using video-tape had a number of advantages. Tapes could be wiped and re-used, rushes could be seen immediately, less light was needed than for film cameras and sound was automatically synchronised. The major disadvantage was the lack of mobility; the cameras were too large to be hand-held and had to be connected to a control vehicle (for recording); Swallow noted – 'Work of the verité kind is impossible. Everything has to be planned beforehand'.[64]

The company's first film to be made was *The Entertainers* produced by Mitchell with John McGrath as director. To cope with the immobility of equipment, a house in Manchester was converted into a theatrical boarding house; the real life subjects (local singers, strippers and music-hall entertainers) arrived each day to play themselves in their own rooms. The result was a more constructed and fictional piece than Mitchell's earlier films, with elements of the story documentary format; the sound-track was neither 'wild-track' nor scripted but improvised by 'real people'. A second film, *A Wedding on Saturday*, was made by Swallow, his first 'personal documentary'. The intention was 'to suggest the changes, economically, and socially, and in personal attitudes, that had occurred in a working-class area of Britain in the previous thirty-odd years.'[65] The film was set in the mining villages of South Yorkshire, centring on a real wedding when 'people are less likely than usual to conceal their deepest feelings'.[66] Swallow's account of his production procedures clearly indicates the balance between objective and personal elements in the typical 'personal documentary'. Three months of living amongst the

subjects (both for research and to establish community trust) led to an initial list of 26 sequences to be shot. As shooting went on the programme shape changed, sequences were dropped, conversations edited and a final programme emerged out of the nature of the material as shot, controlled and shaped by the director's choices. *A Wedding on Saturday* was also a film which in its subject matter – northern working-class life and its changes handled realistically and experientially – typified a central concern of the period.

In 1961, commenting on the likely audience for Mitchell's documentaries, Philip Purser wrote: 'He reckons that the truth should be recognisable to anyone; unfortunately the masses prefer *Dixon of Dock Green*.'[67] *Dixon*'s roots in fact lay in (as well as the Ealing classic *The Blue Lamp*)[68] the television story documentary, and police stories generally had proved a staple of that genre. In the early 1950s Robert Barr had devised a series called *Pilgrim Street* (about a London police station) and in 1960 he was responsible for another police drama-documentary series *Scotland Yard*. A few months previously Colin Morris had turned his attentions to the police with a programme called *Who Me?* dealing with interrogation methods (how one CID sergeant used subtle pressure and half-truths to induce confessions). Hilary Corke in *The Listener* was unimpressed by both the police methods and Morris's own ethics, particularly querying the representativeness of this sergeant and the kind of claims being made for truth by such programmes which 'far from providing us with a platinum standard for dramatized documentary, cannot even distinguish between the two halves of their subject and serves us up one in the guise of the other.'[69] In reply Elwyn Jones, for the BBC drama documentary department, argued that the *Radio Times* had pointed out that the officer was 'a most unusual CID sergeant';[70] the police themselves were clearly not too disturbed by the picture of themselves given since the Lancashire County force co-operated further with Colin Morris on a drama-documentary series about their work *Jacks and Knaves* (broadcast in the last two months of 1961). This time *The Listener*'s critic was full of praise possibly because unlike *Who Me?* (which was discussed under the Documentary reviews heading) *Jacks and Knaves* was treated under Drama – as was its successor

programme which began on 2 January 1962 – under the title of *Z Cars*.

'Z CARS'

Z Cars was the result of a conjuncture of particular technical possibilities, institutional developments and the projects of a number of key individuals which occurred within the BBC in the early 1960s. Elwyn Jones and Robert Barr were the executive producers. Jones, then assistant head of BBC drama, was instrumental in securing the initial co-operation of the Lancashire County Police for *Z Cars*. Barr, as well as having a production role, wrote one of the scripts for the original 13-part series. The two main scriptwriters, initially, were Allan Prior and Troy Kennedy Martin. Prior was already very experienced in writing for radio and television; in 1960 he had scripted a television drama-documentary series called *Man at the Door* dealing with such occupations as bailiff, debt-collector and education welfare officer. Prior, born in Newcastle, had lived in Lancashire until 1957 and was perceived as bringing first-hand local knowledge to the programme.

Alongside these three figures (predominantly emphasising the drama-documentary element of the programme's origins) were Martin and John McGrath, the original director. Martin had entered television work in 1959–60 with two plays about National Service in Cyprus and had subsequently studied with the experimental Langham drama group. McGrath had joined the BBC at the end of the 1950s after having become disillusioned with the theatre upon seeing his play *Why the Chicken?* (about 'a clash ... between working class consciousness and living and feeling ... and Oxford consciousness'[71]) being rearranged by commercial theatre operations to make it acceptable for the West End (which it never reached). McGrath did general script-editing, took the directors' course and worked mainly in features and documentaries.

It was McGrath and Martin between them who provided the impetus to transform the existing drama-documentary format (as in *Jacks and Knaves*) into *Z Cars*. McGrath recalls the series as originating in joint thinking by Martin and himself:

to use a Highway Patrol format, but to use the cops as a key or way of getting into a whole society.... And it was very cleverly worked out ... the two kinds of communities these cops were going to work in. The first was called New Town, which was roughly based on Kirkby. The other was Seaport, which was based on the sort of Crosby-Waterloo waterfront. The series was going to be a kind of documentary about people's lives in these areas, and the cops were incidental – they were the means of finding out about people's lives.[72]

The question of precisely *what* 'kind' of series *Z Cars* was to be was contested from the beginning. According to Barr, in early 1962, there was 'a constant war between me, who wants it to be a documentary, and Troy, who wants to write fiction'. The full situation was even more complex. Within the documentary intention there were differences between the idea of focusing on the reality of police work and McGrath's project of 'finding out about people's lives'. Equally within the fictional intention different directions were possible – towards a strong story-line emphasising the 'cops and robbers' element or towards the kind of writing that Martin favoured – 'I wanted to break down the dominance of the story line and put in its place character and dialogue'.[73] The first series embodied one particular configuration of these elements. The programme was announced as 'a weekly series of thirteen dramatised documentaries about the work of a County Police Force'.[74] In line with current practice for story documentaries there was no cast list printed and the first programme was welcomed in *The Times* as a 'formal innovation ... the first serialization of a dramatised documentary'.[75]

The original *Z Cars* was broadcast live – a fifty-minute production at 8.25 p.m. on Tuesdays. Despite its self-presentation as a realistic picture of contemporary northern life it was broadcast from London. Even film inserts were shot predominantly in London; of the first 63 programmes only 6 included film shot in the North. The number of film and videotape inserts was unusually high for a live production, but despite this live transmission was retained well into 1963. Elwyn Jones explained that:

to begin with there were not enough studios available, and then they believed there was something they got out of a live production which was not in a recorded programme.[76]

The 'live' production was part of a considerable degree of autonomy which the original *Z Cars* had. Allan Prior stated that he had 'never had the same feeling of freedom, in language or in subject – never felt I could carry a situation or scene *as far* as I do in *Z Cars*.'[77] *Z Cars* also escaped many of the restrictions imposed on live drama in the period, mainly because, defined as documentary in intention, it could ignore assumptions about the well-made television play. Film inserts were a regular feature. A study of episode 26, 'A Place of Safety' (broadcast in summer 1962), indicates that in nearly three days filming eight separate film sequences were shot (although producing less than four minutes of the actual programme). In addition four scenes were shot on videotape on the morning of the transmission for insertion during the broadcast. In the studio itself the director usually had six cameras at his disposal and up to fifteen sets. In episode 26 there were 83 scenes (a change of scene on average every 36 seconds) and 254 camera shots on the script.[78] The contrast between this and the sixteen scenes used in Mercer's *Where the Difference Begins* (broadcast less than a month before the first *Z Cars*) indicates a very different kind of televisual construction from that of contemporary single-play drama. An effect of mobility and pace in *Z Cars* was also achieved by studio scenes of the 'Z Car, suitably soiled (standing) on wooden rollers for easy manoeuvring in front of back projection screens that produce the 60 m.p.h. illusion.' In Peter Lewis's opinion the overall result was 'the equivalent of a fast-moving feature film in fifty minutes flat with no retakes'.[79] McGrath, however, has also emphasised the differences between cinema and television which influenced his technique:

film concentrates on carrying a whole load of information. . . . Television is incapable of that. It's small. It cannot have a sensual relationship with the audience – what it conveys is a line of information, an accretion of information which can build to an emotional or dramatic point. And what I was

trying to do with *Z Cars* was to use the cameras in such a way that you never did anything, never moved a camera, unless it was to file a new piece of information.[80]

McGrath's other major influence was in the casting – relatively unknown actors maintaining a strong identification with the characters:

> They were sent to Lancashire to do some preliminary filming, went out in the crime cars, went to the policemen's homes and got to know them. 'Before we begun rehearsals', says McGrath, 'I spent a clear week with them discussing the complete social background of every character – age, parentage, why they were in the police force, what they wanted out of it.[81]

Field research and authenticity also characterised the script-writing. In summer of 1961 Martin went on a preliminary research trip to Bootle, Crosby and Kirkby, returning in the autumn with Allan Prior to put together the first scripts. Martin's reaction to the northern environment was mixed:

> I hated the appalling lack of taste everywhere. But I loved those police officers, those warm, huge men with their boots and tremendous solidity. They had a tradition, one that is vanishing from Britain as the South, and America, takes over. It is a man's country all right, with fights in the pubs and husbands hitting wives. There's a hard brand of humour. The women have a self-contained independence. Of course, all this is in the mainstream of developments, in the novel and the theatre. It's *Room at the Top* and *Saturday Night and Sunday Morning* country, but television hadn't caught up with it.[82]

Martin's comments suggest the particular cultural moments reflected in the early *Z Cars* – older notions of the North as harder and bleaker than the South, together with the impact of post-war change (the New Town) and the consequent strain on notions of community. This general research into 'the North – its way of life and its idioms of speech'[83] (as

John Hopkins put it, another non-northerner who joined the scriptwriting team in spring 1962) was essential, particularly for those who, unlike Prior, knew little of the Lancashire urban environment. A second aspect of script research was into the detail of police work. The scriptwriters went out in Crime Cars, propped up bars with the CID, visited Police Headquarters, Fingerprint Libraries and Information Rooms; they also enlisted the help of former and serving Lancashire policemen. Of the first twelve scripts three were based on actual incidents and the others on typical situations drawn from the crime car work of the Liverpool area.

Equally important were the writers' assumptions about the kind of 'story' they should write. Martin was attempting to 'hold a mirror up to English life as it is at the moment' as well as 'to break down the dominance of the story line and put in its place character and dialogue'.[84] His early scripts, particularly, often had more than one story-line within an episode, with the emphasis falling on the social relationships underlying the specific stories. In the first episode, *Four of a Kind*, one policeman was shown quarrelling with his wife and blacking her eye; in later episodes it was the public who were presented unfavourably. In *Friday Night* the same policeman dealt with a dying young motor-cyclist, with an inquisitive unhelpful crowd and the drunken driver who caused the accident looking on. Prior's *The Whalers* showed a Norwegian whaling ship arrive in port, the crew with five months wages to spend, and presented the police handling the problems caused by their search for drink and women. In Hopkins's *Affray* a policeman is seen 'choking to death in his own blood' after a pub brawl. Of the real incident which inspired this, Hopkins noted that 'the town was still vibrating with the after-effects of the incident – the tension between police and public'.[85] In a general impression of *Z Cars* in early 1962, Peter Lewis perceived 'a stream of unstated protest – against the ugliness of life in New Town, against materialistic apathy. . . . What emerges is a kind of dry-eyed lament for life as it is messily lived in Britain in affluent 1962.'[86]

The first episode of *Z Cars* caused immediate adverse police reaction – predominantly related to how policemen were shown behaving off-duty. A senior officer objected that 'officers

were shown eating disgustingly'. The chairman of the Police Federation objected to one officer being shown as a wife-beater and another as 'gambling madly on horses'. *Z Cars* was, he said, 'nowhere near the class of *Dixon of Dock Green*'.[87] As the series grew in popularity, giving a generally sympathetic version of police problems, these complaints faded. By July 1963 Francis Hope regarded *Z Cars* as 'notorious for the fact that policemen liked it better the nearer they are to actually walking the beat'.[88] John Hopkins reported the reaction of one real Z Car policeman to his episode *Affray*: 'that's what it was like – do them good to see it'.[89]

Apart from police complaints, there were two major areas of criticism. There was firstly the question of the programme's ethical position. Donald Soper in *Tribune* argued that '*Z Cars* destroys genuine respect for the law by blurring the real divisions between right and wrong'.[90] Inspector Barlow's aggressive interrogation methods and police assault on a man suspected of child murder were typical of those elements to which Soper objected. Secondly there was the general issue of violence; this came particularly to the fore with the publication of the Pilkington Report in June 1962. The policeman's death in *Affray*, a violent attack on a man serving a summons (he fell down several flights of stairs and fractured his skull) in *A Place of Safety*, and the stabbing of a man by his wife and son in *Incident Reported* were the kinds of scenes which allowed *Z Cars* to be caught up in general criticisms of the amount of violence shown on television.

Replies to such criticisms were typically made in terms of the programme's realism (rather than, for example, the artistic licence to infringe social norms). From the earliest programmes realism was acknowledged as its strength. *The Times* critic reported that the first episode was 'keenly observed, neatly acted and documentary in approach',[91] while in February 1962 a comparison with *Dixon of Dock Green* was used as a way of defining the realism of *Z Cars*. The moral points in *Dixon* tended 'to place P.C. Dixon and his doings just one degree further from reality than they can conveniently bear ... *Z Cars* on the other hand, is realistic to a fault.'[92] The policemen here, the article went on, were 'human'.

In *The Listener* (January 1962) Frederick Laws also empha-

sised the programme's reality as against *Dixon*. *Z Cars* police-men 'show signs of professional ambition, enjoy a rough house and can express frivolous opinions about their life and work ... while I admire the smoothness, variety and the timing of *Dixon of Dock Green*, it is sugary nonsense.'[93] Donald Soper's ethical objections were specifically answered by Derek Hill in *The Listener*, who again used *Dixon* for comparison, arguing that *Z Cars* 'has broken with the bland tradition of Ted Willis, the policemen's P.R.O., and shows both sides of the law as equally human.'[94] 'Realism' was also the grounds on which *Z Cars* was defended against the charge of gratuitous violence. Hill noted that 'the fights were the most convincing I have ever seen on television – a less realistic presentation would have been hypocritical', while Albert Casey argued that 'the toughness can be a kind of spiritual strength, a defence against an antagonistic environment which itself can be brutal or mean'. By contrast Casey asked, 'Do we really prefer the fantasies of *Dixon of Dock Green*?'.[95]

The persistent comparisons of *Z Cars* with *Dixon* reflected the dominant position which the latter had in defining the television image of the policeman. In the first quarter of 1961 *Dixon* was the second most popular programme in the whole of the BBC schedules; its viewing average of 13.85 million was only outstripped by the 15.25 million of the *Black and White Minstrel Show*. It is not surprising then that *Dixon* had its defenders, including not only the Police Federation but also the series orginator Ted Willis. By May 1962, when Hill's comments appeared in *The Listener*, Willis was becoming rather annoyed by the repeated attacks. In replying, however, he did not seek to defend *Dixon* by denigrating *Z Cars*. Rather he argued that both programmes were reflections of different aspects of police work. In *Z Cars* the emphasis was on patrol car work where 'the crews are a sort of police commando, picked for their toughness'. In *Dixon* the area was more that of 'social work' and the policemen were a different type (those suited to patrol a beat on foot): 'Go into any London police station ... and you will find a *Dixon*'. Willis emphasised further that '*every single story* used as a basis for a Dixon episode has either come from the police files or from a newspaper clipping' with an emphasis on 'the day-to-day routine of

a uniformed constable, without any murder, mayhem or violence'.[96]

This latter point was linked by Willis to issues of scheduling and entertainment value. *Dixon*'s transmission time (Saturdays at 6.30 p.m.) limited its scope; 70 per cent of the material used in *Z Cars* could not be used in *Dixon*. Nevertheless *Dixon*'s characters had 'kept going so long precisely because they appear to millions as real people whom they recognise and respect'. It was the long-running success of the series itself, however, which led to Willis's only concession to Hill's criticism. The success had caused a tendency 'to develop the domestic (soap-opera) side of the series ... the original sharpness is lost, the outline is softened and blurred. This is a hazard of the long running series.'[97] A year later Willis saw elements of this problem emerging in *Z Cars*, which had become 'inherently as sentimental as *Dixon*. The four main coppers in *Z Cars* all have hearts of gold. It no more deals with the truth than *Dixon*.'[98] Realism, Willis argued, was in any case a historically relative concept. *Dixon* itself had originally been regarded as 'the acme of realism ... but public taste has changed. And the critics have altered. What seemed real in 1955 seems old fashioned in 1963.'[99] Such claims are partly borne out by the comments of the *Spectator* television critic in July 1955:

> P.C. Dixon saunters amiably about his beat catching bicycle thieves, reuniting fallen daughters with forgiving fathers, worrying about his day off and dodging the sergeant. This is a vast improvement on the routine mechanics of *Fabian of the Yard* ... the true ring of authenticity comes quite often.[100]

Authenticity here was a question of the everyday, the ordinary (as in the signature tune, 'just an ordinary copper patrolling his beat around Dock Green'), as against the image of the police as super-sleuths in *Fabian*. From the beginning, however, there was also a sense that *Dixon* was perhaps too cosy. Also in July 1955 Philip Hope-Wallace saw *Dixon* as following a pattern by which the television policeman 'constantly appears as a family man',[101] and as the series

became a fixture on BBC in the late 1950s so the emphasis on a policeman's life as 'protective routine in which the constable is more concerned to be a good uncle than a formidable sleuth'[102] was matched by a very rigid narrative and presentational structure:

> At the beginning, Dixon appears in front of the police station, touches his forelock and announces the text for today. During the course of the story (whatever the plot) two things must happen; the audience's excitement must be relieved by a short break for risibility; and Dixon the Family Man must be worked into a sketch involving his daughter, son-in-law policeman and sundry extras in a tea-drinking ritual. Finally, Dixon appears in front of the police station, points the message preached in the show.[103]

This summary pinpoints those areas of weakness in the programme which comparisons with *Z Cars* were to stress, including characterisation, where Dixon himself was so free of 'personality or even idiosyncrasy, one feels that to catch him picking his nose would be like the revelation of some great truth'.[104] It was in comparison with this that the wife-beating, gambling and ill-mannered policemen of *Z Cars* seemed both so disturbing and 'realistic'.

The realism of *Z Cars* was then crucially relative. Dixon, on the beat, operating within a small-scale East London urban village (the nature of which was assumed rather than presented), living in the community, an unassuming good man, could be contrasted with young, active policemen highly mobile in crime cars (the very objects which symbolised the new age of affluence and dispersed, fractured communities) moving between different areas and problematically related to the inhabitants. Against the 'slowness, predictability and rigid structure of some traditional ceremony'[105] of *Dixon* was the intercutting of film, videotape recordings, cars against back-projections and McGrath's style of directing. Additionally the northern setting was some kind of guarantee of realism. In 1963 Elwyn Jones explained that the series was set in the North so as to resist 'the temptation of the glamour and well known association of the London metropolis'.[106] Allan Prior

regarded Lancashire speech as particularly valuable for a scriptwriter, allowing 'full freedom to go to the current English of the man in the factory or on the beat – in Lancashire, particularly, an English that is almost Elizabethan – and (thank God) still spoken.'[107] The overall aim at the beginning had precisely been as McGrath put it, 'to use a popular form and try to bang into it some reality'.[108]

Z Cars was originally planned as a 13-part series. However, initial audience figures of 9 million grew rapidly to 14 million. This persuaded the BBC to extend the series to 31 episodes and to launch a second series (after a six-week break) in September 1962. The consequences of this extension were that the initial team of writers was augmented to eight, while Martin, who had written six of the first thirteen scripts, wrote only two more in the first series. At this stage he began to express worries about the development of the series; there had already been a '30 per cent loss of his intentions in the series as it had emerged on the screen' and the extension led to a loss of continuity in the production team:

> You would need a far more closely knit team of writers and directors ... A series is a living thing, always twisting and turning. But if they insist on this sameness week after week then the characters tend to become caricatures of themselves. After a time you get hollowness and nothing.[109]

At the end of the first series both Martin and McGrath left *Z Cars*. McGrath commented:

> after the cops kept appearing week after week people began to fall in love with them, and they became stars. So the pressure was on to make them the subjects, rather than the device. And when the BBC finally decided that's what they were going to do, then Troy and I decided we'd had enough.[110]

Despite the loss of Martin and McGrath the second series proved even more popular than the first. Viewing figures for the first quarter of 1963 showed *Z Cars* as the most popular

BBC drama series with an average audience of 16.65 million, and a clear audience lead of nearly 3 million over *Dixon*.

The key figures were now Prior and Hopkins. In mid 1963 Hopkins estimated that he and Prior had written over two-thirds of all *Z Cars* episodes between them. McGrath later commented that 'the series was very lucky, in that it got John Hopkins, who actually managed to write about policemen in a way that was interesting – but we didn't want to write about policemen'.[111] Hopkins's own view of *Z Cars* was that 'the basic conflict at the heart of the programme' was 'the conflict between the police and public'.[112] The programme had in fact developed by emphasising one aspect of the mix of initial intentions; the predicament of the police was now central, rather than the problems of the whole community which McGrath had stressed. At a public meeting in Lancashire 'the main criticism voiced from the audience was that the programme portrayed a police force in occupied territory – that there was lack of relationship with the public.'[113] With the policemen as the only regular characters the tendency was that, as Albert Casey had predicted, 'the critical distance ... between the creators and their policemen heroes will diminish'.[114] Arthur Swinson also noted the more general problems involved from the beginning in attempting to fulfil general documentary intentions through a police series:

> The *Z Cars* series has been a great triumph for documentary writers, ... but it is in some ways a pity that it has come by fusing the documentary with the crime story, of which violence and suspense are natural ingredients.[115]

Initially, at least, the fears implied here of a shift towards a more simple 'cops-and-robbers' mode were not justified. The period 1963–5 was the classic period of *Z Cars* production, when those programmes were made which educationalists through the 1960s frequently used and referred to as examples of the possible positive virtues of popular drama. During this period it was recognised as 'very far in advance of anything in its field',[116] 'in a class by itself',[117] 'the finest chunk of drama I have seen in any long-running television series', and 'way

out ahead of any possible rival'.[118] In *Encore* John Garforth used *Z Cars* as pivotal evidence in criticising Wesker for cultural snobbery:

> there is a flattering assumption that because we are watching a Wesker play instead of sitting at home watching *Z Cars* we are superior beings. But that popular equals bad equation is a conditioned reflex of the intellectual and needs to be thought about.[119]

Garforth could be quite confident of the connotations of positive value that the mention of *Z Cars* would carry. Nevertheless the worries that Martin had voiced about the series format were beginning to surface. In July 1963 Francis Hope indicated the drawbacks of such over-familiarity with the characters:

> Barlow is so unpleasant, Lynch so cocky, Smith so gruff, Blackett so fatherly (all of them sensible everyday qualities) that one could switch on week after week merely for the pleasure of joining the gang and sinking into the familiar geography of Newtown and Seaport. To rest on this would reduce it to a more abrasive *Coronation Street* run on a formula of cosy uncosiness.[120]

A year earlier, predicting this problem, Peter Lewis had defined it as Sharples' Disease:

> People like what they know, they like their expectations to be fulfilled, they get cross and feel let down if characters don't behave predictably; life doesn't perform to a formula, and the more you insist on a formula in fiction, the less you reflect life.[121]

Lewis's comment is revealing as to the situation of television in 1962, in its assumptions that a non-formulaic representation of 'life' was the thing to aim for, in its indication that *Dixon* was being replaced by *Coronation Street* as the yardstick against which to measure *Z Cars* and, above all, in its knowledge that the popularity of *Coronation Street* was already so extensive that

it could be invoked merely by the mention of one character's surname.

'Coronation Street'

In November 1954 William Salter, in the *New Statesman*, wrote optimistically of the possibilities for genuine regional programming under the forthcoming ITV arrangements, particularly with regard to 'a centre like Manchester, with its strong sense of identity and with its hinterland of Lancashire'.[122] Before 1960 Salter's hopes were only partly fulfilled. The northern franchise had been divided between ABC (weekends) and Granada (weekdays) and of all the initial commercial companies Granada had the most difficult launch. With other contractors having larger areas at their disposal and cutting rates to attract advertising, Granada's initial income was particularly poor. It was at this point (June 1956) that Granada concluded a four-year agreement with Associated-Rediffusion which ensured complete weekday networking between London and the North, with Granada supplying 15 per cent of programmes and Associated-Rediffusion 85 per cent. Associated-Rediffusion would finance Granada's programme production and would receive, in return, a high proportion (up to 90 per cent) of Granada's advertising revenue.[123]

This agreement had a number of results. It provided security for Granada, even though it meant much smaller profits for 1957–60 than otherwise would have been the case. To Granada's advantage, it guaranteed exposure for their programmes in the London area, allowing them to develop a range and style of programming with this in mind. In the late 1950s the company established a reputation for leading the field in current affairs programmes, as well as for having a left-wing slant. Sidney Bernstein (head of the company – the family were the leading shareholders) was known to be sympathetic to Labour and *Under Fire* (in which leading figures, usually MPs, were quizzed by a studio audience) was, in 1958, the subject of an official complaint from Lord Hailsham, the Conservative Party chairman.

Granada's reputation for innovative programme-making

was thus established without any major concern for serving a regional audience. By 1958 this issue was increasingly preoccupying the ITA, posing particular problems for the contractors in the Midlands and the North (less so for London where it was not easy to distinguish between the 'national' and the 'regional'). After July 1960, when Granada chose not to extend its agreement, the company began to consider how best to develop both in terms of gaining better return on its capital and in terms of responding to ITA general policy. The production of *Coronation Street* (initially for screening on Granada only) was one result of this consideration.

The situation of Granada in 1960 was a necessary but hardly sufficient condition for the launching of a continuous serial drama about life in a northern working-class street. The continuous serial format was, however, clearly one which would automatically have come under consideration given the range of continuous serial programmes in British broadcasting in the 1950s. The format had originated in American radio 'soap operas' of the 1930s, although in Britain it did not become firmly established until the 1950s. *Mrs Dale's Diary* began its 21-year run in January 1948, centring on a London suburban doctor's wife. Both *The Dales* (as it later became) and *The Archers* were broadcast five days a week through the 1950s. *The Archers*, fully launched in January 1951, was intended to combine farming advice, information about the countryside and the fictional life of 'typical country people'. By 1955 its audience was nearly 20 million.[124]

In the early days of ITV there were two attempts to emulate this daily episode form: *Sixpenny Corner* (based around the Nortons and their neighbourhood of small artisan businessmen), and *One Family* (the Armstrongs who lived in a rambling old vicarage). However, the daily fifteen-minute episode caused much more complex production problems on television than on radio. By the end of 1956 both had disappeared from the schedules. The most successful continuous serial on ITV in the 1950s was ATV's *Emergency Ward 10*, a twice-weekly half-hour serial begun in 1957. This combined a mild drama-documentary element (how hospitals work) with a central core of fictional characters (doctors and nurses).

Before ITV's launch the BBC had already sought to

transplant its own family serial format to television, most notably with *The Grove Family* (first shown on 9 April 1954). This was at first only fifteen minutes per week (extended to thirty minutes in September 1955) and ran continuously until June 1957. The Groves were variously described as an 'average suburban family', a 'peculiar exercise in suburban narcissism' and 'aggressively lower middle-class'.[125] They were, one critic suggested, representatives of 'the class that from this week onwards for the rest of our lives, we must all try to belong to'.[126] It was not therefore surprising that the fourth episode saw Grandma acquiring a television set for her birthday. As John Braine observed later in the decade (1958), there was generally a rather paradoxical situation facing the television writer: 'if he is to faithfully present contemporary life, won't he have to commit artistic incest and show his characters most of the time glued to, and in most of their waking hours talking about, the telly.'[127] A bizarre example of such 'artistic incest' had in fact already occurred two years earlier in *The Appleyards* (a BBC children's serial, which ran in intermittent series). In a May 1956 episode 'Mum' and 'Dad' bought their first television set, and 'as the programme finished, and those taking part in it were being listed, there was a pause before the last two, Mum and Dad – and, surprisingly, we heard the familiar, sweet, chirpy, signature tune of *The Grove Family* ... and Mum said to Dad: "This is the Groves ... you'll like them dear: they're just like us".'[128] Whether incest, narcissism or self-parody this neatly illustrates the degree to which these BBC family series attempted to project on to the 'family audience' a mirror-image of themselves. It was against the terms of this image that *Coronation Street* defined itself. Derek Granger, one of the first producers, contrasted it with 'the feebleness of attitude which tries to achieve an archetypal type of popularity by trying to create stock figures in a stock formula – Mr and Mrs Everyman from a sweetly, antiseptic, dehydrated no-class land.' In *Coronation Street* the setting was rather 'a street full of characters all stamped with a strongly-flavoured, doughty and impudent scepticism of the Lancastrian North'.[129]

As compared with *The Grove Family*, *Coronation Street* replaced southern suburbia with northern terraced housing, the lower

middle class with the working class, and the family with the street. The idea of the street as the central focus was indispensable to any notion of traditional working-class community. In 1951 Theatre Workshop's *Landscape with Chimneys* had sketched the basic elements of 'street life' as a dramatic performances; the publicity poster referred to 'ordinary people' who were 'rich in the raw material out of which drama is made ... the street is a world in miniature and by recording a year of its life, its tragedy, its hopes, its humour, its flashes of gaiety, Theatre Workshop offers you a play full of truth and simple humanity.'[130] Granger's summary of *Coronation Street* in 1961 suggests a similar dramatic intention: 'a street of terraced houses, a pub, a Mission Hall, a raincoat factory, a chip shop, a school, a dance hall, a cinema and a corner shop – there is enough in such a microcosm to tell (within certain limiting terms) pretty well the story of the world.'[131] It is a measure of the difference between 1951 and 1961 (as well as between live theatre and television) that the play ran only briefly to small audiences in makeshift halls while the television serial commanded an audience soon rising to over 20 million.

A more likely direct stimulus to the thinking behind *Coronation Street* was *The Uses of Literacy*. Richard Dyer[132] has noted how four key elements ('common sense, the absence of work and politics, the stress on women and the strength of women and the perspective of nostalgia') in Hoggart's picture of 'traditional' working-class life are reproduced continually in the television serial. Hoggart too began by invoking the 'miles of smoking and huddled working-class houses' within which 'there is a fine range of distinctions in prestige from street to street' and again 'inside the single streets there are elaborate differences of status'.[133] As Reyner Banham noted in 1962, it was a clear case of 'Coronation Street, Hoggartsborough'.[134] Within television Mitchell's *Morning in the Streets* had given this landscape a contemporary visual identity, while the Associated-Rediffusion series *Our Street* (early 1960) had investigated everyday life in an anonymous street in Camberwell. Derek Hill noted the attempt to present street life as organised round the pub (*The Prince Albert*) and commented critically: 'it looks as if it was the brain-child of someone who

had seen a couple of Free Cinema productions but never stopped to think about them'. He felt that 'the only thread running through the programmes is the demolition of the street and the break-up of the community'.[135]

Coronation Street, by contrast, suggested the retention of community precisely through the physical stability of the street itself. The street was intended to be typical Salford terraced housing and, as in *Z Cars*, authenticity was to be guaranteed by the first-hand knowledge of the writing and production team: Harry Kershaw, the executive producer, son of a Manchester cotton warehouseman; Peter Eckersley, writer and producer born in Leigh; and Tony Warren, the serial originator. Warren's original programme proposal referred to:

A fascinating freemasonry, a volume of unwritten rules. These are the driving forces behind life in a working-class street in the North of England. The purpose of *Florizel Street* ... is to examine a community of this nature, and in so doing to entertain.[136]

Maintaining the balance was essential. If the characters were to be entertaining they were not to be figures of fun. Warren was clear that 'I am *not* having a joke at the expense of the people in the North. What I have aimed at is a true picture of life there and the people's basic friendliness and essential humour.'[137]

The first episode was broadcast on Friday 9 December 1960 at 7 p.m. (only twelve were definitely planned). At this stage the Friday episodes were transmitted live with the Monday episode being performed immediately after and tele-recorded. Even after the introduction of VTR the two programmes per week (which became installed in their 'traditional' Monday and Wednesday 7.30 p.m. slots during 1961) were still normally recorded as a continuous performance until 1974.[138] As compared to *Z Cars*, production constraints were considerable. Film inserts were rarely used, and even by the late 1970s usually only five different sets were available for each pair of episodes. The very first episode contained five sets (three living rooms, the corner shop and the pub) and nine scenes. *Coronation Street*'s continuous production requirements were

also much greater than those of *Z Cars* and scriptwriters worked within firm guidelines set down by the story-line writers and monitored by a script editor. Writers were rather lower in hierarchy of production than in *Z Cars* – in 1963 they were paid only £125 per script as opposed to £400 for a *Z Cars* script.[139] This also reflected *Coronation Street*'s position as a low-budget production; a key attraction of the continuous serial, for programme planners, is its cost. Sets can be continually reused, firm production routines laid down and (once established) stable audience figures can be predicted. Within the scripts the major difference between *Z Cars* and *Coronation Street* was that in the latter, dialogue (rather than action, gesture or townscape) provided the central focus for the camera. This was both cause and product of the central means at the script writers' disposal for furthering their story-lines: conversation, frequently casual exchanges, and street, shop or pub gossip.

The first episode was not entirely typical of what was to follow – nevertheless its structure and content indicates the basic elements of the *Coronation Street* fictional world. Within a clear frame of the opening rooftop shot (leading down to the street and corner shop) and reverse closing shot (back up to the roofs) there are nine interior scenes, introducing three story lines. The first involves the taking-over of the shop by a newcomer (an effective device to introduce viewers to street life via information given to the new shopkeeper). As the Tanner family is mentioned and the married daughter appears in the shop, the second story line is introduced by a cut to the Tanners' house and a row between Elsie Tanner and her son (just out of prison). Elsie compares her family to the Barlows who are 'not rowing all the time'. There is then a cut to the Barlows who, although clearly much more respectable, *are* rowing about whether college-boy Ken should take a girl to tea at the hotel where his mother works in the kitchen. As the episode progresses these three story lines are all developed, together with the establishment of, in Hoggart's terms, 'elaborate differences of status within the street'. Ena Sharples's appearance in the corner-shop is unconnected to any narrative strand, but her language, opinions and information then and subsequently constituted a major way in which the general

social world of Coronation Street was established and maintained.[140]

The first episode was rather more clear-cut in the presentation of certain issues in class terms (the ex-prisoner seeking a job, the scholarship boy ashamed of his family) than much of what was to follow. However, the implicit claims to realism were maintained. First there were the general characteristics of the continuous serial form: the mirroring of real life by being set in real time (the characters 'day-to-day life has continued in our absence'[141]), and by being open-ended (logically the continuous serial can never end, unless its world does – the hospital closes or the street is demolished). The 'interweaving of stories'[142] as in the first episode, is the narrative corollary of this; as one narrative strand ends, another begins and one is always in mid story. The use of pub, corner shop or other common meeting place is here invaluable in allowing disparate stories plausibly to follow each other; a typical device is for the camera to follow one character leaving the pub and in the same shot pick up another (and hence another narrative possibility) entering.

Secondly the characters were ordinary – not doctors, nurses, or policemen (and certainly not wealthy or beautiful). Granada advertised *Coronation Street* in 1961 as 'life in an ordinary street in an ordinary town'.[143] Thirdly, however, the street was extraordinarily ordinary; its working-class world was distinguished by its exceptional self-sufficiency and localised frame of reference. In 1961 Derek Granger commented:

> this is possibly the first full working class saga of the admass age. There have been working class situation comedies ... and other series like *Dixon of Dock Green* which make large use of working class characters but which remain heavily authoritarian and 'Establishment' in attitude.... The kind of 'Establishment' figures who have largely been the mainstay of most of the serials – e.g. the avuncular probation and welfare officers, the kindly P.C.'s and zealous detective inspectors, worldly solicitors and knowing private eyes and the omniscient Q.C.'s – seldom if ever show their faces down *Coronation Street*.[144]

Granger here indicated how for *Z Cars* and *Coronation Street* between them broke up the unity between authority and community posited by the very title of *Dixon of Dock Green*. While *Z Cars* showed next generation Dixons mobile, isolated and problematically related to a dissolving community, *Coronation Street* created a segment of 'Dock Green' in all its specificity, *from the inside*, disconnected from any explicit social authority.

Fourthly, reality was guaranteed by the northern setting, through the idea of northerners as more down-to-earth than effete, insincere southerners, and the sense of anthropological observation of a hitherto unknown tribe (in 1961 *TV Times* published a glossary of northern terms, e.g. 'mithered' and 'nowty' likely to be unfamiliar to many, particularly southern viewers).[145]

Such 'realism' was, however, always offered within the framework of popular entertainment. Granger noted that in *Coronation Street*, 'things are warmer, funnier, more readily fanciful and amusing ... than they are in reality'. This was a progressive trait within the programme: 'Characters conceived originally in much more natural terms have taken wing and now seem to exist as if our feet had just left the ground in a form of comic suspension.'[146] Sharples's disease caused characters both to assume caricatured and exaggerated form and to be unavailable for sustained development.

The relative insulation of life in Coronation Street indicated a second major way in which the series pulled away from contemporary realism. It invoked, so W. J. Weatherby thought, memories of the Blitz and the 1930s but with one crucial difference: 'It is like getting the camaraderie of hard times without the hard times, the camaraderie of the Depression with the comparative affluence of today.' This was 'life not as it is lived, but in a curious way how many of us might like to live it'.[147] Derek Hill suggested the chief appeal was 'its almost nostalgic sense of group interdependence ... at a time when community feeling is rapidly disappearing'. Watching *Coronation Street* itself filled the gap created by a 'dwindling sense of togetherness'.[148] This, if true, was the other side of Braine's 'artistic incest'; television itself (through *Coronation Street*) was filling the gap which it had itself created

(as a prime mover in the creation of the home-centred society). Whatever the reasons *Coronation Street* rapidly became 'the most popular British TV programme ever'.[149] By March 1961 it was widely networked and by mid 1961 was claiming audiences of over 20 million. It was this massive popularity (rather than as with *Z Cars* an immediate public controversy) which eventually led the programme to come under 'serious' scrutiny by television critics.

Unlike *Z Cars*, *Coronation Street* had few serious pretensions. This allowed three kinds of response from critics – patronisingly dismissive, harshly negative and celebratory. Peter Forster took the first of these positions, 'there is much to be said for the series in terms of other values than simple enjoyment' but basically it was 'a good, brisk soap-opera ... not a work of dramatic art'. Its popularity was easily explained by the appeal of its 'working-class locale' as against the 'middle-class gentility' of *The Dales* and the 'country air' of *The Archers*: 'It should surprise nobody that television, now the most popular medium with the masses, has made a hit with a working-class formula.'[150]

The second position was adopted by Clancy Sigal in January 1962. *Coronation Street* was 'a lie from start to finish if it is supposed to represent any recognizable aspect of life'. It was out of date, it omitted 'the passion and joy and complexity of life', it avoided class-tensions between shop-keepers and residents and it depicted working-class people 'as entirely and without qualification circumscribed and defined by the life of their simple-minded dialogue'. Sigal's list went on: *Coronation Street* de-fused real tensions and 'solved' problems by 'the lie and gloss of togetherness'. Instead of enhancing 'our fantasies creatively', it channelled 'them into harmlessness. *Coronation Street* gently rapes you.'[151]

There were two possible answers to this. Firstly the relevance of realism as a criterion could be denied; the programme, Derek Granger argued, was intended as entertainment, not art or documentary. Secondly Sigal's knowledge of the reality to which the programme referred could be challenged. John Killeen retorted that:

If he had lived, as I have, for nearly 30 years in a back-to-

back house with an outside shared lavatory, a bath in the
scullery and no garden, in a district which teems with
neighbourliness, characters and dialect, his evaluation of
Coronation Street might be less external.

Sigal was ignorant of the 'the still extensive enclaves of
northern proletarian life' of which '*Coronation Street* does
give a reasonably convincing idea'.[152] Killeen concluded by
suggesting there were lessons for town planners in the relation-
ship between architectural environment and social interdepen-
dence which *Coronation Street* exhibited.[153]

The third, positive, position was taken up by Derek Hill in
the *Spectator* (only two weeks before Sigal's outburst which
was implicitly a response to Hill). Hill noted the programme's
dependence on nostalgia, its larger-than-life quality and lack
of genuine villainy as crucial elements in its appeal and
achievement. It was a programme 'entirely free from patron-
age' which, Hill concluded, 'is consistently wittier, healthier
and quite simply better than any of television's supposedly
respectable series'.[154] Hill's views were not widely shared by
television critics of the period. The judgement of Hall and
Whannel in *The Popular Arts* (1964) was more typical; people
in *Coronation Street* 'are rooted in life and recognizable' but
'lead cosier and less complicated lives than people in real life'.
The result was 'a playing-through of experience at that speed
which is calculated not to disturb'.[155] In the late 1960s and
early 1970s to such criticisms were added the absence of
explicit politics and of industrial work-situations (criticisms
also levelled at such community studies as *Family and Kinship
in East London* as well as *The Uses of Literacy*).

The terms of the critical debate over *Coronation Street* have
more recently been changed by a collection of essays published
in 1981.[156] From these, two particular reasons for making a
positive assessment of *Coronation Street* emerge. Firstly there is
a re-emphasis on *Coronation Street*'s devices (particularly comic)
of artifice – deliberate caricature, comic patter and vulgar
'seaside postcard' jokes. As Weatherby noted in 1962 *Coronation
Street* did have 'a little of the gusto and down-to-earth humour
of the old music-hall'.[157] *Coronation Street*'s relation to northern
working-class life was then not so much the reproduction

of its routine experiences as of its characteristic forms of entertainment. Secondly, and more significantly, attention has been drawn to how *Coronation Street* addresses issues of gender and sexual politics. Terry Lovell notes that, 'the normal order of things in *Coronation Street* is precisely that of broken marriages, temporary liaisons, availability for "lasting" romantic love which in fact never lasts'.

The central characters are 'strong independent women, typically middle-aged ... with experience and a degree of financial independence ... who work outside the home as well as in it'. The attraction for female viewers is precisely the pleasure of observing a world in which such women operate. This, while not a reversal of patriarchal ideology, is 'an important extension of the range of imagery which is offered to women within popular forms'.[158] This centrality of women characters had been recognised very early. In December 1961 Derek Hill called Ena 'the second best-known lady in the land' while crash barriers and mounted police had to be used to allow Elsie Tanner (Pat Phoenix) to open a shop in Leeds. Even Sigal allowed one of the few 'claims to distinction' of the programme to be the 'vivid acting of the actresses who play the young and old termagants, Elsie Tanner and Ena Sharples'.[159]

It has been argued that this tendency is an inherent feature of the continuous serial, both because it aims at a predominantly female audience and because of the need to keep romantic possibilities continually open. The centrality of Meg Richardson to *Crossroads* over a fifteen-year period supports such a thesis. Equally, however, *The Archers* has no dominant pattern of this kind; it is also a more family-centred series than *Coronation Street*, with a greater stability of characters. Clearly there are differences in the production constraints of radio and television. The need to present 'reality' in sound only allows many children to be born, grow up and emerge as adult characters without any need to give them any particular physical embodiment. Equally the convention that allows a change of actor or actress (for the same character) on radio but not television has faced *Coronation Street* with a much greater turnover of characters than *The Archers*.

Whatever the causes, the effect that Lovell notes was

inherent from the beginning. Those very elements – the centring on the domestic, the 'trivial', the mixture of romance and 'down-to-earth' realism in sexual relations – which previously provoked criticism now appear part of the serial's value and strength. Lovell argues that the programme offers 'its women viewers certain "structures of feeling" which are prevalent in our society, and which are only partially recognised in the normative patriarchal order'.[160] In returning this suggestion to the period of the programme's origin it can be noted that the predominant 'structure of feeling' of representations of working-class life between 1957 and 1964 was not of this kind. Many of the major texts – *Weekend in Dinlock, Saturday Night and Sunday Morning, A Kind of Loving, This Sporting Life, Z Cars* – privilege a male-dominated world and perspective in which women are secondary. It may not be merely a reflection of formal differences that it is not these texts but rather *Coronation Street* alone which retains an active cultural presence 25 years later.

7. Oasis in the Desert: Education and the Media

By the end of the 1950s the rapid expansion of the television audience (particularly for ITV) had provided a new stimulus to that debate about popular cultural standards which had been continuous in Britain since the mid nineteenth century. Increasingly this debate came to be structured in terms of a modern morality play, with the cultural health of Everyman (the 'ordinary' person or, more usually, the schoolchild) being protected by the good angel (the education system) and corrupted by the bad angel (the commercial mass media). This was at least how it looked from the point of view of many teachers and educationalists, as is apparent from a resolution passed at the National Union of Teachers (NUT) Conference in the spring of 1960:

> Conference believes that a determined effort must be made to counteract the debasement of standards which results from the misuse of press, radio, cinema and television; the deliberate exploitation of violence and sex; and the calculated appeal to self-interest.
>
> It calls especially upon those who use and control the media of mass communication, and upon parents, to support the efforts of teachers in an attempt to prevent the conflict which too often arises between the values inculcated in the classroom and those encountered by young people in the world outside.[1]

The resolution had the effect of creating a Special Conference, held at Church House, Westminster, in October 1960,

with the title of *Popular Culture and Personal Responsibility*; a conference which Raymond Williams later called 'the most remarkable event of its kind ever held in this country'.[2] Particularly remarkable was the range of people it brought together in a common cause. Among the speakers were Arnold Wesker, Karel Reisz and Colin Morris. A paper by Richard Hoggart ('The quality of cultural life in mass society') was circulated to delegates in advance, while the first substantive verbal contribution was a talk from Williams ('The growth of communications in modern society').[3] Williams was, however, preceded by an opening speech from 'Rab' Butler, then Home Secretary (and 'father' of the 1944 Education Act) and among the delegates were sixteen MPs as well as an extensive list of representatives from educational, youth welfare, religious and media organisations. It was, however, Hoggart and Williams who were in effect asked to define the general terms within which the conference was to operate and this reflected the key position which these two figures already held in the cultural debates of the period, deriving predominantly from their major texts of the late 1950s, *The Uses of Literacy* (1957) and *Culture and Society* (1958).

Hoggart and Williams – the view from adult education

The Uses of Literacy has now assumed such a mythic existence that two general points need to be made about it immediately. It has virtually nothing to say about television and it does not so much contrast the depression of the 1930s and the 'neon and plastic of the 1950s'[4] as reflect a particularly mixed and transitional cultural moment of the late 1940s and early 1950s. The book was in fact finished in 1955, having been begun in 1952 and incorporating material which Hoggart had been working on since 1946. It was initially conceived as 'a series of critical essays on popular literature' which Hoggart 'soon began to feel that I wanted to relate ... to the day-to-day experience of people'.[5] This double intention is referred to in the Preface where Hoggart links it to the 'two kinds of writing ... found in the following pages': that dealing with the description of characteristic working-class relationships and

attitudes, and 'the more specific literary analysis of popular publications'.[6]

Much subsequent criticism of the book has focused on how these two kinds of writing become totally identified with what is apparently offered as the analysis of two distinct historical moments, the 'older order' of Part One and the 'new' of Part Two (implicitly post-war, with full employment and the beginnings of affluence). Hoggart's personal experience of pre-war working-class life seems then to be replaced by a distanced and nostalgic judgement of post-war working-class life. Hoggart's mode of writing undoubtedly helps to form this view of the book. He is not systematically historical in making clear when particular scenes or key transitions occurred and despite his own repeated statements that there are very considerable forms of persistence and that changes take place over a long period of time, the book's two-part structure (everyday shared experience followed by a life-style apparently dominated by mass art) seems almost inevitably to lead to a simple binary model of oppositions and deteriorating standards.

Hoggart himself was quite clear that he was basing his account of working-class life on 'personal experience'; such experience was, however, not only childhood memory, it was also 'an almost continuous if somewhat different kind of contact since then'.[7] This was not simply observation but also a matter of Hoggart's own experience – from the late 1940s to the mid 1950s he was a tutor in the Adult Education Department of the University of Hull. In *The Uses of Literacy* Hoggart almost deliberately refuses to use this experience *in itself* as a reference point. He repeatedly states that he is not dealing with the 'purposive, the political, the pious, and the self-improving minorities in the working-classes' (the 'earnest minority' as this group gets described throughout the book). Rather he is considering 'the majority who take their lives much as they find them'.[8] However, part of this 'minority' are acknowledged in the Conclusion where Hoggart notes the existence of a group involved in the Workers' Educational Association and university extra-mural work and much of the book's analysis of popular literary forms has its roots in his teaching. As early as 1951 he noted that he was comparing

Faulkner's *Sanctuary* with Chase's *No Orchids for Miss Blandish* in his classes.[9]

Within *The Uses of Literacy* the three terms of the post-war cultural debate appeared in a particular guise (working-class 'lived' culture, mass-produced commercial publications and educational standards) and in a particular relation determined by Hoggart's specific biography. The adult education experience was crucial in inflecting the concern with educational standards towards a position which was neither university nor school orientated but rather addressed itself directly towards general cultural standards within the whole adult population. If the book's content is explicitly comparative between working-class 'lived' culture and mass art products then it is the adult education position which provides the perspective from which the comparison is made and in a sense for which Hoggart is writing. For who else is the 'intelligent layman'[10] to whom the book is addressed if not a member of that 'earnest minority' who, according to Hoggart, are 'in the habit of buying copies of Pelicans, and help to make possible the one-hundred-thousand issues of ten titles by one author which Penguin Books produce' (p. 261). By 1958 *The Uses of Literacy* itself was available in Pelican paperback and has remained in print ever since.

According to Hoggart the relationship of the newer mass art to the 'older order' was not simply a matter of replacing old attitudes with new. The models he suggests are rather those of resistance, ignorance and, most frequently, adaptation: 'Some of the more debilitating invitations have been successful only because they have been able to appeal to established attitudes which were not wholly admirable' (p. 15). Even attitudes which were admirable could be adapted. A belief in tolerance and freedom could become a willingness to accept anything without objection. An adherence to a principle of equality could become a refusal to accept any differentiations of quality. A desire for progress could easily be transmuted into the 'shiny barbarism' of a belief in the virtue of incessant change and the glorification of youth. The complexity of Hoggart's book lies in its detailed attempts to describe and judge the operation of this adaptive process.

These models of change become somewhat simplified when attempts at an overall summary are made. In the Conclusion Hoggart argues that there is a 'possible interplay between material improvement and cultural loss', that at present 'the older, more narrow but also more genuine class culture is being eroded in favour of the mass opinion, the mass recreational product and the generalized emotional response' and that 'the old forms of class culture are in danger of being replaced by a poorer kind of classless ... culture' (p. 280). Behind these formulations lay the assumption, not often made explicit, that cultural domination was replacing direct economic class power: 'this subjection promises to be stronger than the old because the chains of cultural subordination are both easier to wear and harder to strike away than those of economic subordination' (p. 201).

Between the book's completion and its time of publication (February 1957), a new situation had developed. By mid 1957 commercial television was in its most blatantly 'popular' phase, Suez, Hungary and 'Anger' had caused realignments in the personnel and perspectives of radical groupings and Braine's *Room at the Top* seemed to provide further evidence of 'the interplay between material improvement and cultural loss' to confirm Hoggart's judgement. By 1958 Hoggart was himself taking up the challenge to continue his thinking more precisely in relation to this new climate. In an essay published in 1958 he reaffirmed that 'we are moving towards a cultural classlessness' and now argued that 'in some respects television would be the best instance of the emerging classless culture'.[11] In September 1960 Hoggart, now a Professor of English at Birmingham, was named as the only academic among the thirteen members of the 1960 Committee on Broadcasting – the Pilkington Committee.

Since the early 1960s Williams's *Culture and Society* has been repeatedly invoked as a complementary twin to *The Uses of Literacy* in the foundation of the literary dimension of the field of cultural studies. A typical recent (1984) formulation of this, states that:

it is no accident that the two most influential books of social

theory to emerge from the 1950s – *The Uses of Literacy* and *Culture and Society* – were both produced by critics working in university English departments.[12]

In fact it would have been a remarkable accident if this had been so, for *Culture and Society* as much as *The Uses of Literacy* emerged out of a complex personal and intellectual context within which adult education work was again the crucial factor, alongside, in Williams's case, the memories of the failures and disappointments of the immediate post-war period.

In November 1945 Williams had returned to Cambridge to complete the final year of an English degree interrupted by four years' military service. Almost immediately he became involved in the planning of a journal which would 'approximately unite radical left politics with Leavisite literary criticism'.[13] The journal *Politics and Letters* endured only briefly from 1947–8; in Williams's subsequent thinking both the experience of this failure (connected with the more general failure of the Attlee government) and a sense of the validity of the original project are very important. Williams has subsequently commented:

> the failure to fund the working-class movement when the channels of education and popular culture were there in the forties became a key factor in the very quick disintegration of Labour's position in the fifties. I don't think you can understand the projects of the New Left in the late fifties unless you realize that people like Edward Thompson and myself, for all our differences, were positing the re-creation of that kind of union. (p. 74)

In connection with this Williams has further recalled that 'increasingly what for me became the decisive world was adult education. Virtually every WEA tutor was a Socialist of one colour or another. ... If there was a group to which *Politics and Letters* referred, it was adult education tutors and their students' (p. 69).

In October 1946 Williams began what was to become a 14-year span as an adult education tutor for the Oxford University

Tutorial Classes Committee, based in East Sussex. After 1948, when Williams entered a period of political 'withdrawal', it was almost only in terms of the adult education work that his cultural and political thinking was developed. His work was of a mixed kind (from Trades Council classes to commuter housewives; from public writing and speaking to conventional literature classes), but both the general support of Thomas Hodgkin, the Communist secretary of the committee and the 'practical autonomy' of being over 100 miles from Oxford allowed him to work on areas outside normal academic boundaries and to attempt (as one strand of his work) to 'develop a popular working-class education' (p. 80). Williams states that 'a lot of my subsequent work came out of that particular choice of jobs' (p. 67). Specifically *Culture and Society* began forming from an adult education class on the idea of culture in Eliot, Leavis, Clive Bell and Matthew Arnold in 1949. Part Two of *The Long Revolution* was based on topics which Williams 'had taught, or was going to teach, in adult classes' (p. 133), while *Communications* was based on 'methods and material I had been using in adult education classes'.[14] In considering these three books, as with *The Uses of Literacy*, the adult education class forms a crucial part of the sense of audience as well as of the content.

Although published in late 1958 *Culture and Society* had been begun in 1952 and finished in late 1956 (Williams 'was actually writing the conclusion during the weeks of Hungary and Suez'[15]). It is in the Conclusion particularly that Williams sets up a series of terms for thinking about the contemporary cultural situation. The contrast with Hoggart here is considerable. Williams defines working-class culture in a way that sees a necessary connection rather than an opposition between the everyday life experience and the political/industrial institutions of the class:

> Working-class culture ... is not proletarian art, or council houses, or a particular use of language; it is, rather, the basic collective idea, and the institutions, manners, habits of thought, and intentions which proceed from this.[16]

This perspective enabled Williams to reject outright a

number of positions which, already strong, were to become even stronger over the next few years. He rejected the idea that the majority of the population could be defined as an amorphous 'mass', that 'mass-communications' were necessarily bad simply because they were impersonal and required 'passive' reception ('the situation', he commented 'is that of almost any reader') and that the working class were becoming 'bourgeois' simply because they were acquiring a certain range of possessions. He further suggested much greater optimism than Hoggart not merely in the working class retaining its cultural identity but further in the possibility of extending its 'basic, collective idea' across the whole society.[17]

In a conversation with Williams, in August 1959, Hoggart observed that 'I felt from your book that you were surer, sooner than I was, of your relationship to your working-class background'.[18] This sureness, which formed a crucial point of reference when all ways forward seemed blocked, manifested itself in the fact that in the Conclusion to *Culture and Society*, Williams's positive concepts were based (unconsciously) on his 'Welsh experience':

> When I concluded it with a discussion of cooperative community and solidarity, what I was really writing about – as if they were more widely available – was Welsh social relations. I was drawing very heavily on my experience of Wales, and in one way correctly locating it as a certain characteristic of working-class institutions, but with not nearly enough regional shading and sense of historical distinctions and complications.[19]

Williams's assertion in *Culture and Society*, that 'the trade unions, the co-operative movement and the political party' were central elements of working-class culture (and not as Hoggart had implied alien elements created, perhaps, by the 'earnest minority') was directly verified by his experience of the Welsh border village in the 1920s and 1930s where there was no disconnection between the co-operative nature of day-to-day social relations and his father's membership of the union and the Labour Party. In the conversation with Hoggart,

however, it is clear that Williams was already recognising the ambitious nature of the claims:

> The most difficult bit of theory that I think both of us have been trying to get at, is what relation there is between kinds of community, that we call working-class, and the high working-class tradition, leading to democracy, solidarity in the unions, socialism.[20]

The parallel and more widely known formulation from Williams's work of this period is the attempt to define the relation between 'high' culture (Art) and culture as 'a whole way of life'. This formed a central aim of *The Long Revolution* but had already been clearly formulated in the 1958 essay, 'Culture is Ordinary':

> We use the word culture in these two senses: to mean a whole way of life – the common meanings; to mean the arts and learning – the special processes of discovery and creative effort. Some writers reserve the word for one or other of these senses; I insist on both, and on the significance of their conjunction.[21]

In the conclusion to the essay Williams suggested three means for putting this conceptual conjunction into practical effect: continuing educational expansion (including a rethinking of syllabus content); more public provision for the arts and adult education (not just for extending the existing 'tradition' but also for changing it); and a replacement of advertising as the 'keystone' of the 'mass culture' institutions.

By the end of the 1950s Williams's work, like Hoggart's, was clearly registering the increased intensity of the debate about the influence of the media in general and, in particular, its impact on class differences. In the concluding section of *The Long Revolution* (1961) Williams appeared less optimistic than in *Culture and Society* that a direct extension of existing working-class culture was possible. The sense of obstacles is greater; he related the effective substitution of 'consumer' for 'user' as a term of economic description to the 'visible moral

decline of the labour movement', to its development merely as 'an alternative power-group' rather than offering an alternative model of social organisation. He was also ambivalent about the value of the category of 'class' – 'we might get rid of most of this classification, and save ourselves much needless trouble, if we looked rigorously at what it is there to do'.[22]

Williams saw much of this 'classification' (whether asserting class difference or suggesting 'deproletarianization') as a form of diversion from looking at the real nature of the new society emerging in 'the new housing-estates, the new suburbs and the new towns'.[23] Here consciousness formed at work interacted unpredictably with that formed in the new communities – and again with the influence of the 'new communication systems'. Williams's account of this influence was recognisably similar to that of Hoggart: 'most of our cultural institutions are in the hands of speculators, interested not in the health and growth of the society, but in the quick profits that can be made by exploiting inexperience'.[24] It was this formulation which at the beginning of the 1960s recognisably allied Williams and Hoggart in opposition to commercial mass culture and also made them clear candidates for the agenda-setting function which they performed for the NUT Special Conference of October 1960.

Popular Culture and Personal Responsibility

The full transcript of the three-day conference runs to nearly 200,000 words and it is not easy to summarise the whole range of positions presented. Nevertheless certain basic assumptions were shared by most participants, particularly that British society was generally affluent and that young people were the particular beneficiaries of this. If there were cultural problems they were not caused by poverty or material deprivation; as the Home Secretary put it: 'We are facing, in fact, a situation that prosperity itself brings with it its own evils, which are no less renowned than those brought by poverty and want'.[25]

Working from this premise the dominant model of the conference was that of teachers as a beleaguered and isolated group struggling against the dominant materialist ethic of British post-war consumer society. According to the president

of the NUT, 'much that is being presented to the public by the modern media of mass communication shows evidence of a deteriorating standard of values. A good deal of what is being offered today is shoddy, often vulgar and sometimes vicious' (p. 2).

The implications of this for the position of the schools were spelled out by Jack Longland, Director of Education for Derbyshire and a frequent radio broadcaster:

> the school seems to sit there in the middle of an adult and workaday environment like an oasis in a wide desert. It will try, if it is a good school, to promote traditions of belief, values and disciplines, only to find that these stand in complete and bewildering contrast with the beliefs, values and disciplines of the adult world outside its gates ... the whole clanging and ubiquitous machinery of mass communications in newspaper, film, advertisement and much of broadcasting chants the message of wealth without earning it, success without deserving it, pie in the sky some day soon. The mirage of miraculous affluence flickers in front of our young customers' eyes, the reward not of work but of the lucky flutter on the pools or of Ernie's blind fingers rummaging among the Premium Bonds. (p. 25)

In his closing address to the conference Sir Ronald Gould, the general secretary of the NUT, quoted approvingly the 'oasis in a desert' concept and suggested that:

> the election cry 'You've never had it so good' and the counter-cry 'You'd have had it better if you voted for us' are based upon materialistic values which run counter to what I have enunciated as what should be done in school. (pp. 336–7)

There were some attempts, particularly with regard to film, to suggest positive uses of material from the new media within the classroom. Nevertheless the dominant problem was seen as how best teachers could train pupils to resist the enticements of the mass media and persuade them to adopt those values upheld by education: 'truth, honesty, tolerance, a sense of

duty, courtesy to others and ... kindness to others ... and liberty under the law' (p. 336).

At a few sessions representatives from the media were present to defend themselves. One advertising motivation researcher claimed that they were merely satisfying needs which were already present: 'Men do not just want something with four wheels and a metal body which will take them from Chelsea to the City to work. If that was what they wanted they would all buy bubble cars, but they buy something which expresses the sort of person they want to be' (p. 212).

Cecil King, chairman of the Mirror Newspaper Group, deliberately took up a more provocative stance in offering a series of eminently quotable observations. 'It is', he suggested, 'only the people who conduct newspapers and similar organisations who have any idea quite how indifferent, quite how stupid, quite how uninterested in education of any kind the great bulk of the British public are' (p. 253). In defence of giving the public 'what they want' he commented that 'In the commercial world it does not matter whether you are selling a newspaper or a breakfast food, if you chase away customers you will be out of business' (p. 286).

King's forthright views placed Norman Collins, deputy chairman of ATV, in some difficulties. ITV had of course to please both advertisers and the ITA; Collins cleverly moved to the offensive, deploring the general level of public taste and blaming it substantially on the failure of the education system:

> All they write for are pictures of film stars, television stars, or asking why there are not more jazz programmes, ... I hold the teachers very largely responsible, if that is the attitude of people in their teens and twenties. If we provided simply that it would be deplorable. (p. 251)

Although the positions of such media representatives and educationalists were opposed they tended to share a similar view of the people who were on the receiving end of media messages. In comparison with *The Uses of Literacy* it is striking how far the attitudes and whole being of these people were simply inferred from a reading of the content of the messages.

To a large measure this was due to the conference's whole perspective; the focus on 'children and young people' produced a model whereby these supposedly unformed minds and empty consciousnesses were fought over by two contending philosophies. In much of the debate the third term of reference (what Hoggart called 'the wider life' which people live and 'the attitudes they bring to their entertainments'[26]) was simply not present. Even where it did appear it did so in partial and contradictory forms. One strand of thought here, among a few optimists, held that the innate resistance of 'commonsense' to media influence was greater than often supposed. Stanley Reed, who had taught in East London for eighteen years, commended:

> the sterling commonsense of fourteen to fifteen year old girls ... They seem to me to be terribly sensible young ladies and to be able to admit to me very cheerfully and happily that they do indulge in a great deal of romantic day-dreaming about stars of film and television. ... But their basic commonsense enables them to detach themselves from this and to settle down quite happily with the pimply boy from next door and become good wives and mothers.[27]

This view was in fact only a more patronising version of that already put forward in *The Uses of Literacy*[28] and its assumptions as to women's proper sphere went almost wholly unchallenged through the whole conference. The only voice against was that of Dora Russell who, in reply to some comments by Roy Shaw on women's magazines, observed that:

> the main point about them is that they are not women's magazines in that sense but men's magazines, because first of all they are for the advertising firms who want to sell their products, among which cosmetics are not the least, and secondly they do present an image of women which is the kind of woman that men want to have, and unfortunately this kind of woman is expected to remain at home and take no interest in outside affairs.[29]

Dora Russell's comment was totally ignored (as indeed was

her plea for the issues of the conference to be related to the concerns of CND) – it constituted a perspective which simply could not be made sense of within the frame of reference of the vast majority of the participants.

A different strand of optimism saw some virtue in those newer forms of youth subcultural activity which involved participation. Skiffle was fleetingly offered as one example and the general position was formulated by Peter Kuenstler who argued that it was wrong 'to assume that anything young people may produce or be tempted to produce for themselves must have no standards ... because it does not fit in to the pre-conceived pattern of cultural activity that we have now' (p. 317). This was echoed by Paddy Whannel: it was important to 'discriminate between good and bad in the popular medium' (p. 317).

In almost every case, however, references to the actual cultural situation of the majority of the population were lacking in specificity and in the recognition of significant determining factors other than the media or the school. In the concluding debate Dr Tropp from the London School of Economics remarked on the 'growing sense of unreality' he had felt:

> The discussion has been held solely on the level of culture, as if culture were something autonomous, existing on its own. The last time discussions of this kind were held was in the 1870s, among the German philosophers, and Marx and Engels soon put a stop to that. We live in a capitalist commercial society which subsists on profit-making. ... We also have a grossly uneducated society, which throws boys and girls . . . out into the world at the age of fifteen, having been taught in classes by teachers inadequately prepared for their task. ... Given all this, I think that it is strange rather that popular culture is so good rather than that it is so bad. (p. 320)

Tropp's amazement ('Either I am alone and wrong, or you are all wrong') suggested that he had not followed the debates within English Studies since the 1920s and also that he had not taken note of the continuing influence of that other key

text from around 1870 – Arnold's *Culture and Anarchy*. His comments also were totally ignored.

There were few voices which did not speak within the existing terms of reference. Some, like those of Russell and Tropp, could be ignored; others demanded explicit rebuttal. Wesker struck a major note of dissent early on, claiming that it was education itself, as much as the media, which was responsible for fostering attitudes which uncritically accepted social success and material gain as personal goals. This was immediately and repeatedly repudiated through the conference. A Mr Stevenson from the ITA (also introducing himself as an anthropologist) suggested that there were an 'enormous variety of cultural standards existing in the country' (p. 47) and it was by no means clear which kinds of values should be preserved; he was heavily criticised for implying that the responsibility for choice of values might be evaded.

A significant effect of the conference was then to refocus the cultural debate already begun by *The Uses of Literacy* and *Culture and Society*. The issues now seemed to be those of the schools' relation to the mass media (particularly television) as a matter of immediate educational practice. This could (and did) seem a significant advance – a move to a more immediate engagement with the specifics of popular and mass culture and a direct challenging of their creation of the kind of life-style so eloquently sketched by Jack Longland. The loss, however, was also great; it involved the effective suspension of the other half of Hoggart's project, the need for 'a firmer knowledge of the imaginative reality of "ordinary" people's lives, of the complex interaction of family, neighbourhood and workplace relationships'.[30] As, in the early 1960s, media products came under closer and more sensitive scrutiny, even Hoggart found it difficult to maintain this necessary other side of that project.

Popular Culture and Popular Arts in the Early 1960s

Hoggart himself did not speak at the conference, partly because he was engaged elsewhere on the second and third days' proceedings as a defence witness in the 'Trial of Lady Chatterley' at the Old Bailey (Williams was also a witness,

giving his evidence at the beginning of the following week).[31]
His leading role in both public events meant that by the
beginning of 1961 when the Pilkington Committee began its
work, his reputation as the pre-eminent liberal cultural analyst
was at its height.

The committee eventually published its report in June 1962
and its analysis and conclusions reflected that sector of opinion
which the NUT Conference had helped to consolidate. Even
after twenty years the severity of its criticisms of ITV still
provoke sharp hostile comment,[32] and the contemporary
reception (particularly in those national papers whose owners
had shares in commercial television companies) was even
harsher. In broad terms, the committee was favourably
impressed by the BBC's record and evidence, but signally
unimpressed by ITV's view that television had little social
effect and that it was merely giving the public what it wanted.
In the committee's view: 'Television does not, and cannot
merely reflect the moral standards. It must affect them either
by changing them or reforming them'; broadcasters should
then 'respect the public's right to choose from the widest
possible range of subject matter and so to enlarge worthwhile
experience. ... This might be called "giving a lead".'[33] In the
Daily Mirror it was called 'Pilkington tells the public to go to
hell', while the *Daily Telegraph* summed up the message as
'whatever is popular is bad'. In the *Daily Sketch* readers were
warned 'If they think you're enjoying youself too much – well
they'll soon put a stop to that', and in the *Sunday Pictorial*
Woodrow Wyatt asserted that the committee represented a
'tiny handful of pretentious prigs' who objected to ITV
because it offered 'simple pleasures' and was 'produced by
ordinary men and women who like the same things as you
do'.[34]

The Pilkington Report and its reception are indications of
the intensification of the cultural debate in the period following
the NUT conference. In 1966 Williams argued that this period
saw the coming together of two 'phases' in the analysis of
culture and communications; the *Scrutiny* phase (concerned
particularly with critical work on the content of popular
culture) and the 'New Left' phase (which extended its concerns
to institutions). Despite differences, Williams argued, 'there

is important common ground, and their combined influence has had an evident public effect'.[35] Williams also noted, however, tensions between the arguments for a minority culture and those for a democratic culture as preferred alternatives. In retrospect these 'tensions' seem often quite severe, particularly when the older *Scrutiny* position became reinforced by the dominant conceptual model of the NUT conference. G. H. Bantock's essay, 'The social and intellectual background' in *The Modern Age*, the final volume of the Pelican Guide to English Literature published in 1961, provided an exemplary instance of this.

In the General Introduction to the whole series Boris Ford quoted with approval L. H. Myers's view that a 'deep-seated spiritual vulgarity ... lies at the heart of our civilization'.[36] Bantock applied this maxim with vigour in the section of his essay devoted to 'Problems of popular culture'. He first invoked a familiar *Scrutiny* formula to explain current debates about cultural standards: 'our current educational dilemmas merely serve to highlight our inability to find an adequate substitute for the old culture of the people – expressed in folk song and dance, rustic craft and natural lore – which industrialism has destroyed.' From this established position Bantock went on to claim that 'there is a good deal of evidence to show that the cinema and television foster a kind of escapist day-dreaming which is likely to be emotionally exhausting and crippling to apprehensions of the real world.' The all-embracing character of this judgement was matched by a failure to cite any 'evidence' at all; the model of media effects which underlay it was then presented in the same paragraph: 'night after night a selection of programmes of inane triviality sterilize the emotions and standardize the outlook and attitudes of millions of people.'[37] The direct correlation between media content and the minds of the audience was made clear by the strong verbs 'sterilize' and 'standardize'. There was then no need to give any detailed first-hand consideration to the whole life-experience of the 'millions of people' – everything could be inferred through textual analysis. The second central plank of the argument was historical comparison; the oppositions pre-industrial/post-industrial, active/passive and folk/mass showed by contrast how bad the contemporary situation really

was. The 'organic community' concept was still crucial to the argument, despite Bantock's mild disclaimer early in the essay that 'the "organic community" of rural England may not have existed quite as its more naive exponents believe; in re-animating the past it is easy to omit the stresses that are inseparable from the human condition.'[38] The addition of unavoidable aspects of the 'human condition' to the model of the 'organic community' did not yield any ground at all to Williams's criticisms (in *Culture and Society*) of Leavis's use of the term: 'it is foolish and dangerous to exclude from the so-called organic society the penury, the petty tyranny, the disease and mortality, the ignorance and frustrated intelligence which were also among its ingredients.'[39] Precisely the point of Williams's list was to note those elements which were *historical* (a particular society's material backwardness, deter-mined by its political and economic structure), and hence separable from the 'human condition' as a universal and inevitable situation.

Only at one point did Bantock's arguments concede any-thing to the more complicated formulations of the New Left position. He gave the pre-mass-media, working-class urban culture some (rather grudging) credit for achieving a mild degree of authenticity: 'Certainly there appears to be a decline in vitality from the days when the music hall, even if it fostered its own sentimentalities, involved its patrons in the performance in a way which contrasts favourably with the apathy of the modern audience for entertainment.'[40] Here, simply by the use of 'apathy', Bantock was able to tie his argument into the widespread sense of the decline of the working class as a class-for-itself in the face of the enticements of affluence.

Bantock's assertions were at one extreme of a spectrum of positions on the issue of the quality of popular culture available in the early 1960s. The agenda-setting function of the NUT Conference in this area is confirmed by the number of books of the period which declared their direct derivation from the conference. Two among these stand out as of particular importance and, in each case, their relation to the dominant conceptual model of the conference was rather different. *Discrimination and Popular Culture* (1964), edited by Denys

Thompson, was broadly in agreement with the conference position, while *The Popular Arts* (1964), by Stuart Hall and Paddy Whannel, tried to build on some of the minority arguments put there.

In the Foreword to *Discrimination and Popular Culture*, Thompson noted that the book was a 'direct outcome' of the conference. The identity of Thompson (as editor) also related the book to that long tradition of educational work on popular and mass culture which could be traced back to the 1930s. Thompson had co-authored *Culture and Environment* with Leavis in 1933, had been involved in *Scrutiny*, had founded and edited *English in Schools* in 1939, which became *The Use of English* in 1949, and was involved in the founding of the National Association of Teachers of English in the early 1960s. Contributors to *Discrimination and Popular Culture* included Frank Whitehead (who had represented *The Use of English* at the NUT Conference) and David Holbrook, whose books on teaching English were at the centre of the 'creative English' thinking of the period. Two other key members of this group (Raymond O'Malley and Brian Jackson) were among those given editor's thanks in the Foreword.

The book consisted of seven essays on particular areas of 'popular culture', effectively defined as that produced by the mass media, co-ordinated by Thompson's introduction. It was this which made explicit the underlying assumptions which determined the book's construction. Thompson advanced two major models as ways of understanding the contemporary cultural situation: the first dealing with historical comparisons and the second with the mechanisms by which contemporary popular culture was produced and reproduced. Historically the situation of the 1960s was contrasted to the middle ages, the nineteenth century and the pre-war situation. In the latter case he noted the change of context since his own work in the 1930s:

> The need then was to produce more so that no one should go without; easier times were just around the corner. We have rounded the corner and – with some exceptions – no one need go without in a welfare state. But we are still incited to produce more, keep up with the neighbours at

home or abroad. Not yet is the worker allowed to enjoy the fruit of his labour in leisure. Most workers now have more than their grandfathers would have thought enough. The basic needs are fulfilled, but fresh ones are constantly being created by advertising.[41]

This perception of a change in the operation of the capitalist economy led to an echoing of Hoggart's comments on the difference between past and present modes of oppression: 'The nineteenth century maimed and enslaved the worker's body; perhaps in the twentieth it is his mind that is maintained in servile contentment' (p. 17). It was accepted that the problems of material provision had been solved and that the struggle for a basic standard of living – the struggle over work – was no longer central. It was from this assumption that the argument moved to its second preoccupation, why and how the media were central:

The importance of the mass media is that they fill much of people's leisure, and with shorter hours and less absorbing work, leisure is almost the whole of life. It is in leisure, not in work, that most people nowadays really live and find themselves. More and more what we do with our leisure decides the quality of our living. If this is correct, the mass media matter a great deal; they may well be altering the aims and character of the nation. (p. 21)

Thompson's argument now severed any links of determinacy between work and leisure and replaced a qualitative relationship with a quantitative one (if we spend more time in leisure than at work then leisure must be more important). Leisure's dominance by the mass media was an index, moreover, of the loss of general social interaction: ' "The selves we are are to a great extent the products of our social contexts." It may be that these social contacts are being replaced by the mass media' (p. 16). This formulation recalls not only Hoggart's position but also the transition from Bethnal Green to Greenleigh in *Family and Kinship in East London*, from the multi-faceted extended family to the isolated nuclear family. The argument here was that it was not so much media content as

the very act of passive reception (rather than social interaction) that constituted the central danger.

Both models led to a position in which the teacher's main function was oppositional; lessons should be given in 'discrimination' which should use 'the first-rate in art, literature, and music ... to provide children with standards ... against which the offerings of the mass media will appear cut down to size' (p. 20). Only in two essays were there suggestions that some quality might be found in mass media products themselves. The most extended debate here was in Albert Hunt's essay on film which compared different possibilities within the medium. The comparisons made were substantially to the disadvantage of contemporary British cinema; Hunt criticised *The Guns of Navarone*, *The Young Ones* and *The Angry Silence* in detail (as against the achievements of Renoir and Bunuel). Hunt also considered British 'New Wave' films – particularly *Saturday Night and Sunday Morning* – and was not very impressed. Reisz was seen as evading the reality of violence and giving in at certain points to 'the traditional conventions of British comedy'. [42] Crucially, however, Hunt argued that film was at least available to be judged as 'art'. The other essay which had some positive points to make was on Recorded Music where David Hughes (who had been a speaker at the 1960 conference) recognised the authenticity and spontaneity of jazz, but at the cost of relegating it to an almost anachronistic form: 'Jazz ... is true folk music'. The trouble with this was that then, by definition, any recording of it was seen as a loss in quality ('the technique of the recording studio is utterly removed from spontaneity'). Hughes extended his positive assessment to both skiffle and the folk revival because there 'new songs are still being made through the natural creative process which over the ages has turned our desires and feelings into songs'. [43] Taken together both Hunt and Hughes only reinforced Thompson's models; contemporary 'popular culture' could only have quality if it was defined in other terms – either as serious art (film) or as a continuation of pre-industrial/mass media forms, as folk culture (jazz/blues/folk).

By contrast, in *The Popular Arts* Hall and Whannel started from the somewhat different perspective that 'the struggle

between what is good and worthwhile and what is shoddy and debased is not a struggle *against* the modern forms of communication, but a conflict *within* these media.'[44] In a book written for 'the teacher' and 'the general reader' the authors defined a stance distinct from both the militant hostility of the NUT position and the 'opportunist' approach which, patronisingly, refused to make any evaluative distinctions. They identified rather with the teacher who 'is asked to be the guardian of a cultural tradition to which he does not always wholly belong' (p. 22).

The central method of the book was nevertheless clearly derived from the *Scrutiny* inheritance: 'In the end we are driven back to a qualitative definition based on critical judgements of individual pieces of work.' This affirmation was linked to a major dismissal of 'effects' research:

> the argument about research and effects is frequently a red herring so far as the teacher is concerned. No one has yet suggested that we conduct a research programme to prove scientifically that Shakespeare, Dickens and Lawrence have an effect on us before we approve the teaching of literature. (p. 35)

This sense of a secure position and an unanswerable case marks the book as very much of its period (no hint of any crisis in English studies here). The concern was with 'actual quality' rather than 'effects'. In the light of much of what was assumed as 'effects' (in the formulations of Bantock for example) this decision was hardly surprising. It did, however, continue the effective suspension of that crucial first half of Hoggart's project (the consideration of who, in the adjective 'popular', are the 'people'). The only exception to this in *The Popular Arts* were some fairly general comments on the emergence of a specific teenage culture and market as a preface to a discussion of pop films and music.

The book's title recognised this narrowing by referring to 'arts' rather than 'culture'. This choice of noun was also crucial to the book's positive case – that there was a specific category of 'popular art' which could generate works of artistic quality. Hall and Whannel followed much of the accepted

thinking as to the nature of folk culture (part of communal ways of life or 'organic communities' and now gone), of minority art (a 'writer, poet or painter concerned with primacy of his own experience') and mass art (stereotyped, formulaic and tending to 'process' experience) (ch. 3). Crucially, however, they added a fourth term – separate from, though related to, the others. Popular art had evolved from folk art, but involved a much more separated area of entertainment and professional performance; it differed from mass art in that it used stylisation and convention for positive purposes and involved a closeness to the audience which was genuinely communicative rather than a matter of subjection or manipulation. Among examples of popular art (of the past) were music hall, Elizabethan drama and the rise of the novel (the latter two cases allowed an argument, in recognisably *Scrutiny* terms, that there was no necessary barrier between popular art and high art).

The major part of the book then consisted of showing how in particular areas of popular art good might be distinguished from bad. Areas considered included violence on television (*Z Cars* good, routine detective series bad), love in literature (*Lady Chatterley's Lover* good, teenage magazines bad) and in cinema (British 'New Wave' films good), 'real life' modes (Mitchell documentaries and the Radio Ballads good, *Coronation Street* and the *Daily Mirror* not so good) and the youth market (jazz and skiffle good, pop and Cliff Richard films bad). Overall through this diverse range of material it stood out that, within contemporary popular arts, quality was most frequently found in two areas – cinema and jazz. On the book's first page the authors declared these as their main areas of personal interest and this was extended to a general case: 'In considering the possibility of making popular art in the modern world and through the modern media, it is natural to turn to jazz and the cinema' (p. 72). They exemplified this with detailed studies of the blues (concentrating on Billie Holliday) and the Western (particularly the films of John Ford). They also argued that 'jazz seems an infinitely richer kind of music both aesthetically and emotionally' than pop (even though both were examples of 'entertainment' music). (p. 311)

The similarity between the place of jazz and cinema in *The Popular Arts* and in *Discrimination and Popular Culture* suggested the difficulty Hall and Whannel had in attempting to break with the NUT paradigm. Many of their examples of good contemporary popular art were either American or European and the question of the relation of such material to the people who constituted their British audience was hardly posed. Cinema had already, in any case, begun to collapse as a major popular form while the hope that jazz might emerge as a genuinely popular music in Britain (a hope implicitly present also in many Free Cinema and 'New Wave' film scores) was to prove unfounded. It is striking here that in both books last-minute and rather hurried observations on the Beatles were inserted in ways which suggest an inability to decide whether to assess them as merely another set of manufactured pop idols or as the signs of an indigenous authenticity (based on skiffle and blues roots) breaking through. Neither description, however, even at the early stage of 1964, could accommodate them with any degree of plausibility.

Two years previously Raymond Williams had also drawn on the NUT Conference for material in his book *Communications*. By 1962 Williams, like Hoggart, had moved from adult education to the teaching of undergraduates and post-graduates within the university. *Communications* itself does not bear the marks of this change, being largely based on historical and content analysis of the media, as developed in adult education classes. In the revised (1966) edition of the book, however, Williams reflected on the long-term implications of this transformation of role:

> University teaching is extraordinarily stimulating, but it is remarkable how much it excludes: both in the single sense of the syllabus ... and in the more complex sense, of the cultural atmosphere of a university, in which there are strong pressures to confine oneself to the traditional interest and habits of minority education, so that issues and institutions affecting majorities begin to fade.[45]

By 1966 Hoggart was Professor at Birmingham, Williams was at Cambridge, E. P. Thompson (also an adult education

tutor in the 1950s) was at Warwick and Stuart Hall (after teaching in a secondary school and editing *New Left Review* in its first 'popular' format) had moved to Birmingham as Hoggart's deputy at the post-graduate Centre for Contemporary Cultural Studies. In the face of the theoretical challenge of the next generation of the New Left both Williams and Hall were beginning systematic revisions of their earlier positions, while in response to the crude effects models of much media research and much commonsense assumption, there had been a retreat to the business of creating more sophisticated analyses of media content as the central plank of the new field of cultural studies. Crucially that sense of the immediate pressure to connect cultural analysis to the whole life experience and situation of working-class people, which the perspective from adult education had enforced, had been lost.

Afterword

THE Labour election victory of October 1964 removed any political need to continue the 'embourgeoisement' debate; even if the working class had disappeared, this was of no consequence if Labour could still win elections. By the mid 1960s the dominant Labour position was, rather, that its working-class past had been subsumed into a new alignment with a modernising technological society. Nowhere was this more evident than in the figure of Harold Wilson himself. When asked what class he belonged to, he replied 'Well someone who started at elementary school in Yorkshire and became an Oxford don – where do you put him in this class spectrum? I think these phrases are becoming more and more meaningless.'[1]

This sense of absorption of northern qualities into a new national (southern and London-based) style was present also in a film released three months before the Labour victory. *A Hard Day's Night* (1964), the Beatles' first feature film, was shot predominantly in a semi-documentary style (in black and white), with a script by Alun Owen. Part of its presentation of the 'real' experience of the Beatles as a massively successful beat group was their reception in London, where one particular scene shows George Harrison wandering by accident into the offices of a teenage fashion designer. Harrison is immediately seized on as the new trend-setter of the month, whose tastes and opinions need to be simultaneously pandered to and moulded. Owen's script, in intention mildly satirical, proved also prophetic as the Beatles (and a host of other northern groups) became promoted by, and absorbed into, a distinctively mid 1960s pop entertainment industry centred solidly in London.

This gradual smoothing out of a vital, but somewhat crude, northern style was a characteristic process across a range of

cultural products in the early and mid 1960s. In fiction the heroes of Braine, Barstow and Sillitoe were increasingly drawn towards the South and London, to middle-class women (journalists, actresses, social workers) and a more affluent world. Troy Kennedy Martin saw the development of *Z Cars* as a matter of 'the embourgeoisement of everyone involved, the characters within the series, the actors, the producers – who knows, perhaps even the viewers. There was a slow distancing of it from the people it was concerned to portray'.[2] According to Peter Lewis this transformation had already begun in 1962 – 'There was soon pressure to make them £1000-a-year men. One week Sergeant Watt got a shiny new raincoat. Another, Janey, the policeman's wife, got a snazzy new cooker to replace the old stove. All small things in themselves, but the accumulated effect has been to blur the sharp outlines with which the series began.'[3]

In *Billy Liar* this process was not so much a blurring as a clear change of emphasis, through the three versions, in the presentation of the character of Liz. In the first (novel) version she is known as 'Woodbine Lizzy' and even Billy is forced to admit to himself that she is always 'scruffy'.[4] The second (theatre) version suggests two alternative perceptions of her bohemianism; while Billy's mother sees her as 'scruffy' in 'that mucky skirt' (and Arthur 'wouldn't be seen stood standing talking to that scruffy-looking bird')[5], the stage directions (on Liz's first entrance) note that 'she is not as scruffy as we have been led to believe'.[6] By the third (film) version 'scruffiness' was no longer an issue. Alexander Walker has reported that, 'Schlesinger at first feared Christie might be "too gorgeous" for Liz the provincial swinger. "But when I look back on it," he said later, "her first entrance gives the precise feeling of liberation I was after".'[7]

Like Miranda in Fowles's *The Collector*, Schlesinger's Liz indicates a moment when the image of the attractive intelligent and (semi-) liberated young woman was allowed to emerge from the constraints imposed by the first decade and a half of post-war society. A defining element here was the rejection of the 'domestic' as a space for the creation of female identity; this involved a clear refusal of the perspective offered by those texts of the late 1950s and early 1960s which sought to recognise the

persistence (or bemoan the loss) of 'traditional working-class ways of life'. Such texts (from *Family and Kinship in East London* to *A Kind of Loving*) certainly, in their turn, sought to criticise the construction of the 'housewife', within affluence imagery, as the main agent of the new consumer society (and hence the primary target for advertising). However, neither traditional nor consumerist perspectives problematised the position of women as essentially wives, mothers and pivots of the family.[8] It was rather a case of two versions of the domestic role in contention: the Mum/children solidarity as the centre of the extended family and working-class community against the affluent housewife leading the domestic revolution into the home-centred society. What such a debate excluded was both the experience of women in paid employment (particularly that of the early 1940s) and the increasing experience of women moving into career jobs or higher education in the late 1950s and early 1960s. It was this latter experience that was particularly important for such refusals of the domestic as did appear in the mid 1960s. As British cinema in the 1960s and the novels of John Fowles (particularly *The Magus* and *The French Lieutenant's Woman*) show, such refusals were no guarantee against the continuing co-option of female figures within a world of male fantasy; nevertheless, as Juliet Mitchell implied in *Woman's Estate* (1971),[9] such a reaction should be viewed as a necessary pre-condition for the emergence of many aspects of the Women's Movement in Britain after 1968.

If many of the texts (written and visual) discussed in this book cannot escape the charge of virtual total unconsciousness concerning gender difference as a site of social construction, then they seem equally open to description as lacking in any political analysis. The issues here, however, are somewhat different. The cultural moment which forms, and is formed, by these texts is one which, as was argued in the opening chapter, is inseparable from its immediate political context. It was, however, a peculiarly 'non-political' political context; one in which, for the left (taking this to include the whole spectrum of those inside as well as outside the Labour Party), issues of political philosophy, organisation and programmes of action were frequently displaced into problems of primary social description (what kind of a society is Britain now?) or

of how to assess the increasing importance of the 'cultural' domain (whether defined in artistic, mass media or anthropological terms). The early New Left, and particularly the early *New Left Review*, constituted a clear attempt to by-pass both the Labour Party's loss of nerve and direction and the archaic dogmatism of the Communist Party by stressing the indissoluble links between the 'cultural' and the 'political' as spheres of analysis and action.

It can be argued (as E. P. Thompson did, of Williams's *The Long Revolution* in *New Left Review*) that this often resulted in too great a displacement of political questions into cultural questions. Such a view is undoubtedly reflected in the change of direction made by *New Left Review* in early 1962 under its new editorial board. However, that irruption of the political into the aesthetic sphere which occurred in the late 1960s (most obviously, although not exclusively, in theatre) can be viewed substantially as a further realisation of the original New Left project under a new set of political and social conditions. In this respect the failures and unsatisfactory solutions of the early 1960s in the particular area of drama (both in the theatre and television) left an open and unresolved situation which cleared the way for the forging of more explicit connections between political analysis and social representation than had been possible at the beginning of the decade. By contrast, in Britain, neither cinema nor (particularly) fiction produced work of comparable value in the late 1960s and early 1970s.

As has been illustrated, such differences between forms of cultural practice (in their handling of contemporary social concerns) have their own determinacy in terms of the available technical and institutional possibilities. This is most clearly the case with television where, in the early 1960s, it (as a producer of images) was involved in the attempt to construct descriptions of a new situation which television itself (as a general social force) was regarded as having caused. The unevenness of response, within different areas of television production, to this task was one effect of this peculiarly introverted moment.

The recognition of such determinacies and limitations, even if fully historically explicable, should not prevent the necessary

task of criticism and assessment, particularly in such areas as the idealisation of traditional working-class communities, the reproduction of fundamental patriarchal assumptions, the absence of a connected political analysis and the confusions over the relations between media content and audience. At the same time such assessment would need to judge the value of a cultural practice which is committed, in ways which cut across conventional divisions between the 'serious' and the 'popular', to the representation of contemporary social experience in terms which can offer denials and alternatives to dominant forms of generalised social description. In such an assessment the apportioning of praise or blame is ultimately less important than to learn and to judge what is possible and what is necessary for our own contemporary cultural practice.

Notes and References

1. THIS NEW ENGLAND

1. D. Childs, *Britain since 1945* (London: Ernest Benn, 1979) p. 127.
2. D. E. Butler and R. Rose, *The British General Election of 1959* (London: Macmillan, 1960) p. 197.
3. S. Hall, 'The supply of demand', in E. P. Thompson (ed.), *Out of Apathy* (London: Stevens, 1960) p. 95.
4. M. Abrams, R. Rose and M. Hinden, *Must Labour Lose?* (Harmondsworth: Penguin, 1960) p. 23.
5. Ibid., p. 100.
6. Ibid., p. 105.
7. R. Milne and H. Mackenzie, *Marginal Seat, 1955* (London: Hansard Society, 1958) p. 34.
8. *New Statesman*, 18 February 1950, p. 179.
9. H. G. Nicholas, *The British General Election of 1950* (London: Macmillan, 1951) pp. 213, 241.
10. *Spectator*, 27 January 1950.
11. *New Statesman*, 3 November 1951, p. 477.
12. D. E. Butler, *The British General Election of 1955* (London: Macmillan, 1955) p. 15.
13. *Economist*, 30 May 1953.
14. *Observer*, 31 May 1953, p. 6.
15. Butler, *British General Election of 1955*, p. 1.
16. L. Immirzi, A. Smith and T. Blackwell, *The Popular Press and Social Change 1945–65* (unpublished report for the Rowntree Trust, University of Birmingham) p. 5:24.
17. Butler, *British General Election of 1955*, p. 18.
18. Ibid., p. 83.
19. Immirzi *et al.*, *Popular Press and Social Change*, p. 5:10.
20. Milne and Mackenzie, *Marginal Seat*, p. 29.
21. Butler, *British General Election of 1955*, p. 162.
22. A. Sampson, *Macmillan* (Harmondsworth: Penguin, 1968) p. 159.
23. Butler and Rose, *British General Election of 1959*, p. 136 (facing).
24. Ibid., p. 24.
25. *Spectator*, 2 October 1959, p. 435.
26. G. Orwell, 'England Your England', in S. Orwell and I. Angus (eds), *The Collected Essays, Journalism and Letters and George Orwell*, vol. 2 (Harmondsworth: Penguin 1970) p. 97.

27. C. A. R. Crosland, 'The transition from capitalism', in R. Crossman (ed.), *New Fabian Essays* (London: Turnstile Press, 1952) p. 34.

28. R. Crossman, 'Towards a philosophy of socialism', in *New Fabian Essays*, p. 1.

29. Crosland, 'The transition from capitalism', p. 36.

30. A. Albu, 'The organisation of industry', in *New Fabian Essays*, p. 131.

31. Ibid., p. 131.

32. E. Durbin, *The Politics of Democratic Socialism* (London: Routledge, 1940) pp. 109ff.

33. Ibid., p. 119.

34. C. A. R. Crosland, *The future of Socialism* (London: Cape, 1956) p. 286.

35. Ibid., p. 285.

36. T. R. Fyvel, 'The stones of Harlow', *Encounter*, June 1956, p. 15.

37. C. Curran, 'The passing of the tribunes', *Encounter*, June 1956, p. 21.

38. C. Curran, 'The new estate in Great Britain', *Spectator*, 20 January 1956, p. 72.

39. C. Curran, 'The politics of the new estate', *Spectator*, 17 February 1956, p. 209.

40. W. Young, 'Return to Wigan Pier', *Encounter*, June 1956, p. 5.

41. *New Statesman*, 17 October 1959, p. 492.

42. M. Abrams, 'The home-centred society', *The Listener*, 26 November 1959.

43. *Economist*, 16 May 1959.

44. S. Hall, C. Critcher, T. Jefferson, J. Clarke and B. Roberts, *Policing the Crisis* (London: Macmillan, 1978) p. 235.

45. *Sun*, 15 September 1964.

46. The main source here is G. Sayers Bain, R. Bacon and J. Pimlott, 'The Labour Force', in A. H. Halsey (ed.), *Trends in British Society since 1900* (London: Macmillan, 1972).

47. J. Westergaard and H. Resler, *Class in a Capitalist Society* (Harmondsworth: Penguin, 1976) p. 76.

48. A. H. Halsey, J. Sheehan and J. Vaizey, 'Schools', in Halsey (ed.), *Trends in British Society*.

49. Curran, 'The passing of the tribunes', p. 21.

50. A. H. Halsey, 'Higher education', in Halsey (ed.), *Trends in British Society*.

51. J. R. Short, *Housing in Britain* (London: Methuen, 1982) Ch. 3.

52. R. Banham, 'Coronation Street, Hoggartsborough', *New Statesman*, 9 February 1962, p. 200.

53. A. Howkins and J. Lowerson, *Trends in Leisure 1919–1939* (Sports Council and Social Sciences Research Council, 1979).

54. M. Hall, 'The consumer sector 1950–60', in G. Worswick and P. Ady, *The British Economy in the 1950s* (London: Oxford University Press, 1962).

55. M. Young and P. Willmott, *The Symmetrical Family* (London: Routledge and Kegan Paul, 1973) p. 23.

56. F. Zweig, *The Worker in an Affluent Society* (London: Heinemann, 1961).

57. A. Marwick, *British Society since 1945* (Harmondsworth: Penguin, 1982) p. 121.

58. B. Wood, 'Urbanisation and local government', in Halsey (ed.), *Trends in British Society*, p. 280.

59. The expansion of television in this period is discussed in Chapter 6.

60. Hall, 'The supply of demand', p. 79.

2. SOCIAL SCIENCE AND SOCIAL EXPLORATION

1. D. V. Glass (ed.), *Social Mobility in Britain* (London: Routledge, 1954); J. Floud, A. H. Halsey and F. M. Martin, *Social Class and Educational Opportunity* (London: Heinemann, 1957).

2. R. A. Kent, *A History of British Empirical Sociology* (Aldershot: Gower, 1981) p. 37.

3. R. Frankenberg, *Communities in Britain* (Harmondsworth: Penguin, 1966) p. 9. (Subsequent page references are to this edition.)

4. N. Dennis, F. Henriques and C. Slaughter, *Coal is Our Life* (London: Eyre and Spottiswoode, 1956).

5. *Coal is Our Life* (second edn, London: Tavistock, 1969) p. 7. (Subsequent page references are to this edition.)

6. J. Klein, *Samples from English Cultures* (London: Routledge and Kegan Paul, 1965).

7. M. Stacey, *Tradition and Change: A Study of Banbury* (London: Oxford University Press, 1960).

8. Dennis, Henriques and Slaughter, *Coal is Our Life* (second edn) p. 168.

9. C. Critcher, 'Sociology, cultural studies and the post-war working class', in J. Clarke, C. Critcher and R. Johnson (eds), *Working Class Culture* (London: Hutchinson, 1979) p. 17.

10. M. Young and P. Willmott, *Family and Kinship in East London* (London: Routledge and Kegan Paul, 1957) pp. xvff.

11. J. Platt, *Social Research in Bethnal Green* (London: Macmillan, 1971) p. 138.

12. Ibid., p. 1. This is part of a policy statement of the Institute printed on the dust jackets of their books.

13. M. Young and P. Willmott, Review of *Social Research in Bethnal Green*, *New Society*, 28 October 1971, p. 841.

14. R. Titmuss, Foreword to Young and Willmott, *Family and Kinship in East London*, p. xi.

15. Ibid., p. 22.

16. Ibid., p. 30.

17. Young and Willmott, Review of *Social Research in Bethnal Green*, p. 841.

18. Young and Willmott, *Family and Kinship in East London*, p. 47. (Subsequent page references are to this title.)

19. P. Willmott, *The Evolution of a Community* (London: Routledge and Kegan Paul, 1963) p. 111.

20. M. Young and P. Willmott, 'Research Report No. 3: Institute of Community Studies, Bethnal Green', *Sociological Review*, IX (July 1961).

21. Critcher, 'Sociology, cultural studies and the post-war working class', p. 15.

22. B. Jackson and D. Marsden, *Education and the Working Class* (London: Routledge and Kegan Paul, 1962; revised edn, Harmondsworth: Penguin, 1966), revised edn, p. 18. (Subsequent page references are to both editions.)

23. R. Glass, 'Conflict in Cities', in A. de Reuck and J. Knight (eds), *Conflict in Society* (London: Churchill, 1966) p. 148.

24. R. Hoggart, *The Uses of Literacy* (London: Chatto and Windus, 1957) p. 11.

25. Ibid., pp. 17, 19.

26. This is discussed further in Chapter 7.

27. C. Sigal, *Weekend in Dinlock* (London: Secker and Warburg, 1960; Harmondsworth: Penguin, 1962). (Subsequent page references are to the Penguin edition.)

28. '*Weekend in Dinlock*: A discussion', *New Left Review*, May–June 1960, p. 42.

29. Sigal, *Weekend in Dinlock*, p. 81.

30. '*Weekend in Dinlock*: A discussion', pp. 42, 43.

31. D. Lessing, *In Pursuit of the English* (London: MacGibbon and Kee, 1960) p. 95. (Subsequent page references are to this title.)

32. M. Lassell, *Wellington Road* (London: Routledge and Kegan Paul, 1962; Harmondsworth: Penguin, 1966) Prefatory Note. (Subsequent references are to the Penguin edition.)

33. C. Curran, 'The new estate in Great Britain', *Spectator*, 20 January 1956, p. 74.

34. Lassell, *Wellington Road*, p. 73. (Subsequent page references are to this title.)

35. *New Statesman*, 16 February 1962, p. 234.

36. *Times Literary Supplement*, 17 August 1962, p. 627.

37. *New Statesman*, 4 June 1960, p. 832.

38. *The Listener*, 28 January 1960, p. 185; *Times Literary Supplement*, 22 January 1960, p. 45. The television 'fictionalised documentary' form is discussed in Chapter 6.

39. A. Wilson, 'Rescuing the workers', *Spectator*, 29 January 1960, p. 140.

40. *The Listener*, 15 March 1962, p. 482.

3. FICTION: COMMUNITIES AND CONNECTIONS

1. J. Lehmann, 'Foreword', *London Magazine*, December 1955, pp. 11, 13.

2. H. Laski, 'In praise of booksellers', *New Statesman*, 9 January 1943, p. 23.

3. C. Tolchard, 'Correspondence', *London Magazine*, January 1956, p. 73.

4. S. Laing, 'The production of literature', in A. Sinfield (ed.), *Society and Literature 1945–70* (London: Methuen, 1983) p. 123.

5. J. Taylor, 'Introduction: situating reading', in J. Taylor (ed.), *Notebooks/Memoirs/Archives* (London: Routledge and Kegan Paul, 1982) p. 27.

6. See R. Rabinovitz, *The Reaction Against Experiment in the English Novel 1950–60* (New York: Columbia University Press, 1967).

7. This is a documented in my (unpublished) Ph.D. thesis – *The Idea of a Post-War Britain* (University of Birmingham, 1973).

8. This phrase was used on the front cover of the early paperback editions.

9. G. Turner, *The North Country* (London: Eyre and Spottiswoode, 1967) p. 401. See also S. Laing, '*Room at the Top*: The morality of affluence', in C. Pawling (ed.), *Popular Fiction and Social Change* (London: Macmillan, 1984).

10. A. Walker, *Hollywood, England* (London: Michael Joseph, 1974) p. 80.

11. R. Hayman, *Playback* (London: Davis-Poynter, 1973) p. 8.

12. S. Barstow, *The Human Element and other stories* (London: Longman, 1969) p. 165.

13. R. Williams, *Politics and Letters* (London: New Left Books, 1979) p. 274.

14. Ibid., p. 272.

15. Laing, 'The production of literature', p. 128.

16. This is discussed further in Chapter 5.

17. A. Sillitoe, 'Introduction to the new edition', *Saturday Night and Sunday Morning* (London: W. H. Allen, 1958, new edition, 1970) p. 6.

18. J. Halperin, 'Interview with Alan Sillitoe', *Modern Fiction Studies*, vol. 25: 2: 1979, p. 176.

19. Ibid., p. 187.

20. A. Sillitoe, 'Both sides of the street', *Times Literary Supplement*, 8 July 1960, p. 435.

21. Sillitoe, *Saturday Night and Sunday Morning*, p. 206. (Subsequent page references are to this title).

22. N. Gray, *The Silent Majority* (London: Vision, 1973) p. 131.

23. Sillitoe, *Saturday Night and Sunday Morning*, p. 120.

24. Ibid., p. 156.

25. K. Allsop, *Scan* (London: Hodder and Stoughton, 1965) p. 60.

26. Sillitoe, *Saturday Night and Sunday Morning*, p. 129. (Subsequent page references are to this title).

27. D. Storey, *This Sporting Life* (London: Longmans, 1960) p. 14.

28. Ibid., p. 247.

29. D. Storey, 'Journey through a tunnel', *The Listener*, 1 August 1963, pp. 159–60.

30. Storey, *This Sporting Life*, p. 16. (Subsequent page references are to this title).

31. Storey, 'Journey through a tunnel', p. 161.

32. See A. Higson, 'Space, place, spectacle', *Screen*, vol. 25, No. 4–5, July–October, 1984.

33. Storey, 'Journey through a tunnel', p. 160.

34. The term is taken from R. Williams, *The Long Revolution* (London: Chatto and Windus, 1961) pp. 283–4.

35. S. Barstow, *A Kind of Loving* (London: Michael Joseph, 1960,

(Harmondsworth: Penguin, 1962). References are to the Penguin edition, p. 272.

36. According to David Lodge – 'The novel supremely among literary forms has satisfied our hunger for the meaningful ordering of experience *without* denying our empirical observation of its randomness and particularity', *The Novelist at the Crossroads* (London: Routledge and Kegan Paul, 1971) p. 4.

37. Barstow, *A Kind of Loving*, p. 7. (Subsequent page references are to this title.)

38. M. Pickering and K. Robins, 'The makings of a working-class writer: an interview with Sid Chaplin', in J. Hawthorn (ed.), *The British Working-Class Novel in the Twentieth Century* (London: Edward Arnold, 1984) p. 148.

39. This is argued in the chapter 'Realism and the contemporary novel' in *The Long Revolution*.

40. Williams, *Politics and Letters*, p. 272.

41. R. Williams, 'Working-class, proletarian, socialist: problems in some Welsh novels', in H. G. Klaus (ed.), *The Socialist Novel in Britain* (Brighton: Harvester, 1982) p. 121.

42. Williams, *Politics and Letters*, p. 285.

43. Ibid., p. 290.

44. J. Campbell, 'An interview with John Fowles', *Contemporary Literature*, 17, 4 (1976) p. 462.

45. J. Fowles, *The Collector* (London: Jonathan Cape, 1963) p. 230.

46. This is discussed in S. Laing, 'Making and breaking the novel tradition', in F. Gloversmith (ed.), *The Theory of Reading* (Brighton: Harvester, 1984).

47. *New Statesman*, 21 May 1960, p. 765.

48. *New Statesman*, 27 October 1961, p. 610.

49. *Spectator*, 20 October 1961, p. 551.

50. *Encounter*, December 1961, p. 76.

51. Storey, 'Journey through a tunnel', p. 161.

52. See Laing, 'Making and breaking the novel tradition'.

53. *Times Literary Supplement*, 5 August 1960, p. 493.

54. M. Richardson, *New Statesman*, 30 July 1960, p. 164.

55. I. Parry, *London Magazine*, December 1960, p. 63.

56. Campbell, 'An interview with John Fowles', p. 462.

4. IN THE THEATRE – THE LIMITS OF NATURALISM

1. T. Willis, letter to the *New Statesman*, 15 December 1945, p. 407.

2. T. Willis, 'Look back in wonder', *Encore*, No. 13 (March 1958) p. 13.

3. R. Williams, *Politics and Letters* (London: New Left Books, 1979) p. 74.

4. Willis, 'Look back in wonder', p. 13.

5. *New Statesman*, 21 August 1948, p. 154.

6. *Theatre World*, February 1949, p. 39.

7. *Theatre World*, February 1953, p. 35.

8. B. Kops, 'Committed to the world', *Encore*, No. 13 (March 1958) p. 12.

9. W. Young, letter in *Encore*, No. 17 (November 1958) p. 43.

10. Cited in J. Hill, 'Towards a Scottish people's theatre', *Theatre Quarterly*, 7, No. 27 (Autumn 1977) p. 63.

11. Ibid., p. 68.

12. *New Statesman*, 6 March 1948, p. 193.

13. H. Goorney, *The Theatre Workshop Story* (London: Eyre Methuen, 1981) p. 42.

14. Ibid., p. 42.

15. Ibid., p. 99.

16. T. Milne, 'Art in Angel Lane', *Encore*, No. 16 (September 1958) p. 13.

17. T. Willis, 'Discussion on vital theatre', *Encore*, No. 19 (March 1959) p. 21.

18. D. Watt, 'Class report', *Encore*, No. 10 (September 1957) pp. 60–2.

19. This is discussed further in Chapter 5 in relation to the subsequent film version.

20. L. Anderson, review of *A Taste of Honey*, in *Encore*, No. 15 (July 1958) p. 42.

21. *Spectator*, 6 June 1958, p. 729.

22. *Theatre World*, July 1958, p. 37.

23. *Spectator*, 20 February 1959, p. 257.

24. C. MacInnes, 'A taste of reality', *Encounter*, April 1959, p. 70.

25. *Theatre World*, March 1959, p. 8.

26. *Theatre World*, April 1959.

27. *New Statesman*, 21 February 1959, p. 254.

28. *New Statesman*, 28 February 1959, p. 283.

29. J. Mander, *The Writer and Commitment* (London: Secker and Warburg, 1961) p. 189.

.30. Cited in the *Spectator*, 10 February 1961, p. 185.

31. R. Brustein, 'The English stage', *New Statesman*, 6 August 1965, p. 193.

32. Scene description and introductory note to *Live Like Pigs*, J. Arden, *Three Plays* (Harmondsworth: Penguin, 1964) pp. 100, 101.

33. Ibid., p. 102.

34. K. Waterhouse and W. Hall, *Billy Liar* (London: Samuel French, 1960) Production Note, pp. 6, 7.

35. P. Hobsbaum, 'How provincial can you get?', *Encore*, No. 36 (March 1962) p. 27.

36. T. Willis, 'Discussion on vital theatre', p. 21.

37. R. Williams, 'Drama and the left', *Encore*, No. 19 (March 1959) p. 11 and 'New English drama', *The Twentieth Century*, CLXX, No. 1011 – reprinted in J. R. Brown (ed.), *Modern British Dramatists* (New Jersey: Prentice-Hall, 1968).

38. S. Hall, 'Beyond naturalism pure', *Encore*, No. 34 (September 1961) p. 13.

39. J. Whiting, 'At ease in a bright red tie', *Encore*, No. 21 (July 1959) p. 14.

40. C. Marowitz, 'A cynic's glossary', *Encore*, No. 31 (March 1961) p. 32.

41. P. Brook, 'Search for a hunger', *Encore*, No. 32 (May 1961) pp. 12, 14.

42. L. Anderson, 'Vital theatre?' *Encore*, No. 11 (November 1957) p. 44.

43. A. Hunt, 'Around us ... things are there', *Encore*, No. 34 (September 1961) p. 25.

44. Williams, *Politics and Letters*, pp. 203, 205, 223.

45. Ibid., p. 223.

46. C. Marowitz and S. Trussler (eds), *Theatre at Work* (London: Methuen, 1967) p. 67.

47. Goorney, *The Theatre Workshop Story*, p. 88.

48. Ibid., p. 99.

49. Willis, 'Discussion on vital theatre', p. 22.

50. Marowitz and Trussler (eds), *Theatre at Work*, p. 81.

51. A Wesker, *The Wesker Trilogy* (Harmondsworth: Penguin, 1979) p. 59.

52. Ibid., p. 68.

53. Ibid.

54. Ibid., p. 75.

55. *Theatre World*, August 1958, p. 9.

56. Wesker, *The Wesker Trilogy*, p. 92.

57. Ibid., p. 147.

58. Mander, *The Writer and Commitment*, pp. 196–7.

59. *New Statesman*, 11 July 1959, p. 48.

60. *Evening Standard*, 19 January 1960, cited in Mander, *The Writer and Commitment*, p. 196.

61. J. R. Taylor, *Anger and After*, second edn (London: Methuen, 1969) pp. 154–5.

62. M. Kaye, 'The new drama', *New Left Review*, No. 5 (September–October 1960) p. 64.

63. Wesker, *The Wesker Trilogy*, p. 164.

64. Taylor, *Anger and After*, p. 167.

65. A. Wesker, *Fears of Fragmentation* (London: Cape, 1970) p. 16.

66. Ibid., p. 11.

67. Marowitz and Trussler (eds), *Theatre at Work*, p. 86.

68. G. Reeves, 'The biggest Aunt Sally of them all', *Encore*, No. 41 (January 1963) p. 8.

69. Ibid., p. 14.

70. Ibid., p. 15.

71. Marowitz and Trussler (eds), *Theatre at Work*, p. 87.

72. Wesker, *Fears of Fragmentation*, p. 61.

73. Reeves, 'The biggest Aunt Sally of them all', p. 16.

74. J. Garforth, 'Arnold Wesker's mission', *Encore*, No. 43 (May–June 1963) pp. 41ff.

75. Goorney, *The Theatre Workshop Story*, p. 114.

76. Ibid., p. 116.

77. *Encore*, No. 43 (May–June 1963) p. 50.

78. J. McGrath, *A Good Night Out* (London: Eyre Methuen, 1981).

79. Goorney, *The Theatre Workshop Story*, p. 127.

80. Ibid., p. 133.

5. LIFE HERE TODAY – BRITISH NEW WAVE CINEMA

1. These and other statistics on British cinema are collated in the Appendix to J. Curran and V. Porter (eds), *British Cinema History* (London: Weidenfeld and Nicolson, 1983).

2. J. Spraos, *The Decline of the Cinema: an Economist's Report* (London: Allen and Unwin, 1962) p. 22.

3. T. Kelly, G. Norton and G. Perry, *A Competitive Cinema* (London: Institute of Economic Affairs, 1966) p. 16.

4. Ibid., p. 17.

5. C. Barr, *Ealing Studios* (London: Cameron and Tayleur/David and Charles, 1977) p. 84.

6. Cited in E. Sussex, *Lindsay Anderson* (London: Studio Vista, 1969) p. 32.

7. A. Walker, *Hollywood, England* (London: Michael Joseph, 1974) p. 37.

8. Ibid., p. 38.

9. Ibid.

10. Cited in A. Lovell and J. Hillier, *Studies in Documentary* (London: Secker and Warburg, 1972) p. 156.

11. L. Anderson, 'Get out and push!', in T. Maschler (ed.), *Declaration* (London: MacGibbon and Kee, 1957) p. 158.

12. *New Statesman*, 5 October 1957, p. 414.

13. For a detailed discussion of the film see S. Laing, '*Room at the Top*: The morality of affluence', in C. Pawling (ed.), *Popular Fiction and Social Change* (London: Macmillan, 1984).

14. *Spectator*, 30 January 1959, p. 144.

15. *New Statesman*, 31 January 1959, p. 144.

16. Walker, *Hollywood, England*, p. 110.

17. M. Balcon, *Michael Balcon Presents: A Lifetime of Films* (London: Hutchinson, 1969) p. 196.

18. Walker, *Hollywood, England*, p. 110.

19. J. Hill, 'Working-class realism and sexual reaction: Some theses on the British "New Wave"', in Curran and Porter (eds), *British Cinema History*, p. 305.

20. A. Sillitoe, 'What comes on Monday?', *New Left Review*, No. 4 (July–August 1960) p. 59.

21. Ibid.

22. Both cited in J. Richards and A. Aldgate, *Best of British: Cinema and Society 1930–70* (Oxford: Blackwell, 1983) pp. 134, 135.

23. For a different analysis of the significance of these shots see A. Higson, 'Space, place, spectacle', *Screen*, 25, No. 4–5 (July–October 1984).

24. *Spectator*, 4 November 1960, p. 689.

25. Richards and Aldgate, *Best of British*, pp. 137, 140.

26. R. Prince, 'Saturday Night and Sunday Morning', *New Left Review*, No. 6 (November–December 1960). p. 17.

27. A. Lovell, 'Film chronicle', *New Left Review*, No. 7 (January–February 1961) p. 53.

28. Walker, *Hollywood, England*, p. 121.

29. S. Delaney, *A Taste of Honey* (London: Methuen, 1959) p. 7.

30. Ibid., p. 26.

31. Ibid., p. 87.

32. Walker, *Hollywood, England*, p. 122.

33. *New Statesman*, 28 September 1962, p. 429.

34. Walker, *Hollywood, England*, p. 120.

35. Hill, 'Working-class realism', p. 308.

36. Ibid., p. 309.

37. Isabel Quigly in the *Spectator*, 12 April 1962, p. 512.

38. See Chapter 6 for a discussion of this form.

39. I. Quigly, *Spectator*, 16 August 1963.

40. The stage version had prefigured the film in this respect.

41. As Alexander Walker noted in the early 1970s: 'With Julie Christie, the British cinema caught the train south', *Hollywood, England*, p. 167.

42. J. Coleman, *New Statesman*, 15 February 1963, p. 246.

43. 'Sport, life and art', *Films and Filming* (February 1963), cited in Sussex, *Lindsay Anderson*, p. 45.

6. TELEVISION: ART, REALITY AND ENTERTAINMENT

1. B. Paulu, *British Broadcasting* (Minneapolis: University of Minnesota Press, 1956).

2. 'ITV Chronicle', *Contrast* (Autumn 1965) 4, 4, p. 102.

3. J. Bakewell and N. Garnham, *The New Priesthood* (London: Allen Lane, 1970) p. 284.

4. Ibid., p. 287.

5. *New Statesman*, 9 June 1956, p. 652.

6. H. Thomas, *The Truth About Television* (London: Weidenfeld and Nicolson, 1962) p. 173.

7. A. Swinson, 'Writing for television', in P. Rotha (ed.), *Television in the Making* (London: Focal Press, 1956) pp. 38–9.

8. A. Swinson, *Writing for Television Today* (London: Black, 1963) p. 14.

9. Ibid., p. 109.

10. Ibid.

11. M. Elliott, 'Television drama: the medium and the predicament', *Encore*, No. 13 (March 1958) p. 33.

12. Thomas, *The Truth About Television*, p. 172.

13. D. Taylor, 'The Gorboduc stage', *Contrast* (Spring 1964) 3, 3, p. 153.

14. Ibid., p. 206.

15. J. Bussell, *The Art of Television* (London: Faber, 1952) p. 103.

16. Swinson, 'Writing for television', p. 39.

17. Ibid., p. 42.

18. A. Hunt, 'Alan Plater', in G. W. Brandt (ed.), *British Television Drama* (Cambridge: Cambridge University Press, 1981) p. 143.

19. T. Willis, 'Look back in wonder', *Encore*, No. 13 (March 1958) p. 15.

20. Elliott, 'Television drama', pp. 33–4.

21. *Encore*, No. 23 (November 1959) pp. 46–7.

22. *Spectator*, 18 May 1962, p. 654.

23. J. R. Taylor, 'Drama '66', *Contrast*, 4, 5–6 (Winter 1965–Spring 1966) p. 133.

24. J. R. Taylor, *Anatomy of a Television Play* (London: Weidenfeld and Nicolson, 1962) p. 9.

25. Ibid., p. 12.

26. Ibid., pp. 42–7.

27. Alun Owen, 'Introduction', *Three Television Plays* (London: Cape, 1961) p. 7. (Subsequent page references are to this title.)

28. Taylor, *Anatomy of a Television Play*, p. 35.

29. *Spectator*, 22 December 1961, p. 930.

30. D. Mercer, 'Birth of a playwriting man', (interview with the editors and Francis Jarman), *Theatre Quarterly*, 3, 9 (January–March 1973) p. 46.

31. Ibid., p. 47.

32. D. Mercer, *The Generations* (London: Calder, 1964) p. 38. (Subsequent page references are to this title.)

33. D. Taylor, 'David Mercer and television drama', appendix to *The Generations*, p. 250.

34. Mercer, 'Birth of a playwriting man', p. 48.

35. Taylor, 'The Gorboduc stage', p. 206.

36. Cited in Taylor, 'Mercer and television drama', p. 242.

37. Ibid., p. 48.

38. T. Kennedy Martin, 'Nats go home', *Encore* No. 48 (March–April 1964) p. 21.

39. Ibid., p. 23.

40. 'Reaction', *Encore* No. 49 (May–June 1964) p. 45.

41. T. Kennedy Martin, 'Up the Junction and after', *Contrast* 4, 5–6 (Winter 1965–Spring 1966) p. 138.

42. T. Garnett, 'Television in Britain: description and dissent', *Theatre Quarterly*, 2, 6 (April–June 1972) p. 22.

43. Swinson's book may be usefully compared to his earlier *Writing for Television* (London: Black, 1955).

44. *New Statesman*, 4 December 1954, p. 738.

45. C. Doncaster, 'The story documentary', in Rotha (ed.), *Television in the Making*, p. 44.

46. Ibid., pp. 44–5.

47. *New Statesman*, 25 August 1956, p. 214.

48. N. Swallow, 'Documentary TV journalism' in Rotha (ed.), *Television in the Making*, p. 54. For a general discussion of actuality documentary in the early 1950s see P. Scannell, 'The social eye of television 1946–55', *Media, Culture and Society* (1979) 1.

49. Bakewell and Garnham, *The New Priesthood*, p. 184.

50. Ibid.

51. *The Listener*, 2 April 1959, p. 608.

52. P. Purser, 'Think-tape, a profile of Denis Mitchell', *Contrast*, 1 (1961–2) p. 108.

53. *BBC Handbook* (1960) p. 55.

54. P. Scannell and D. Cardiff 'Serving the nation: public service broadcasting before the war', in B. Waites, T. Bennett and G. Martin (eds), *Popular Culture: Past and Present* (London: Croom Helm, 1982).

55. C. Parker, 'The Radio Ballad', *New Society*, 14 November 1963, p. 25.

56. Ibid., p. 26.

57. Ibid.

58. B. Holdsworth, 'Songs of the people', *New Left Review*, No. 1 (January–February 1960) p. 48.

59. N. Swallow, *Factual Television* (London: Focal Press, 1966) p. 84.

60. Ibid., p. 178.

61. *The Listener*, 16 June 1960, p. 1068.

62. Ibid.

63. Purser, 'Think-tape, a profile of Denis Mitchell', p. 114.

64. Swallow, *Factual Television*, p. 205.

65. Ibid., p. 185.

66. Ibid., p. 186.

67. Purser, 'Think-tape, a profile of Denis Mitchell', p. 114.

68. See Chapter 5 for a discussion of this film.

69. *The Listener*, 15 October 1959, p. 700.

70. *The Listener*, 5 November 1959, p. 784.

71. J. McGrath, 'Better a bad night in Bootle', *Theatre Quarterly*, 5 No. 19 (1975) pp. 42–3.

72. Ibid., p. 43.

73. Both Barr and Kennedy Martin were reported in P. Lewis, '*Z Cars*', *Contrast*, 1 (1961–2) pp. 310–13.

74. Cited in *Screen Education*, No. 21 (September–October 1963) p. 18.

75. *The Times*, 6 January 1962, p. 4.

76. '*Z Cars* and their impact: a conference report', *Screen Education*, No. 21 (September–October 1963) p. 17.

77. 'Allan Prior and John Hopkins talking about the *Z Cars* series', *Screen Education*, No. 21 (September–October 1963) p. 13.

78. These details are drawn from the analysis in Chapter 3 of A. Hancock, *The Small Screen* (London: Heinemann Educational, 1965). See also M. Marland (ed.), *Z Cars: Four Television Scripts* (London: Longman, 1968).

79. Lewis, '*Z Cars*', p. 309.

80. McGrath, 'Better a bad night in Bootle', p. 43.

81. Lewis, '*Z Cars*', p. 309.

82. Ibid., p. 313.

83. 'Allan Prior and John Hopkins talking about the *Z Cars* series', p. 8.

84. Lewis, '*Z Cars*', p. 313.

85. 'Allan Prior and John Hopkins talking about the *Z Cars* series', p. 10.

86. Lewis, '*Z Cars*', p. 310.

87. Ibid., pp. 307–8.

88. *New Statesman*, 5 July 1963, p. 22.

89. 'Allan Prior and John Hopkins talking about the *Z Cars* series', p. 10.

90. Cited in *The Listener*, 3 May 1962, p. 787.

91. *The Times*, 3 January 1962, p. 11.

92. *The Times*, 24 February 1962, p. 4.

93. *The Listener*, 18 January 1962, p. 145.

94. *The Listener*, 3 May 1962, p. 787.

95. A. Casey, 'Blood without thunder', *Screen Education*, No. 16 (September–October 1962) p. 27.

96. *The Listener*, 17 May 1962, p. 859.

97. Ibid.

98. J. Green, 'A writer and his critics', *Contrast*, 3, 2 (Winter 1963) p. 134.

99. Ibid., p. 131.

100. *Spectator*, 29 July 1955, p. 170.

101. *The Listener*, 14 July 1955, p. 76.

102. *The Listener*, 14 June 1956, p. 827.

103. K. Coppard, 'Two television documentaries', *New Left Review*, No. 3 (May–June 1960) p. 53.

104. Ibid.

105. Ibid.

106. 'Z Cars and their impact: a conference report', p. 17.

107. 'Allan Prior and John Hopkins talking about the *Z Cars* series', p. 13.

108. McGrath, 'Better a bad night in Bootle', p. 43.

109. Lewis, '*Z Cars*', p. 315.

110. McGrath, 'Better a bad night in Bootle', p. 43.

111. Ibid.

112. 'Allan Prior and John Hopkins talking about the *Z Cars* series', p. 12.

113. 'Z Cars and their impact: a conference report', p. 20.

114. Casey, 'Blood without thunder', p. 27.

115. Swinson, *Writing for Television Today*, p. 129.

116. Casey, 'Blood without thunder', p. 25.

117. *New Statesman*, 29 June 1962, p. 950.

118. *Sunday Telegraph* and *The Guardian*, cited in *Screen Education*, No. 21 (September–October 1963) pp. 15–16.

119. J. Garforth, 'Arnold Wesker's mission', *Encore*, No. 43 (May–June 1963) p. 42.

120. *New Statesman*, 5 July 1963, p. 22.

121. Lewis, '*Z Cars*', p. 315.

122. *New Statesman*, 20 November 1954, p. 645.

123. B. Sendall, *Independent Television in Britain vol. 1, Origin and Foundation 1946–62* (London: Macmillan, 1982) pp. 193–201.

124. W. Smethurst (ed.), *The Archers – the first thirty years* (London: NEL, 1981) p. 42.

125. *Spectator*, 8 April 1955, p. 440; *The Listener*, 6 January 1955, p. 36; *New Statesman*, 18 September 1954, p. 323.

126. *The Listener*, 15 April 1954, p. 665.

127. *Spectator*, 18 April 1958, p. 485.

128. *New Statesman*, 12 May 1956, p. 517.

129. W. Weatherby, 'Granada's Camino Real', *Contrast*, 1 (1961–2) p. 285.

130. H. Goorney, *The Theatre Workshop Story* (London: Eyre Methuen, 1981) p. 74.

131. Weatherby, 'Granada's Camino Real', p. 285.

132. R. Dyer, 'Introduction', in R. Dyer (ed.), *Coronation Street* (London: BFI, 1981) p. 4.

133. R. Hoggart, *The Uses of Literacy* (London: Chatto and Windus, 1957) p. 21.

134. R. Banham, 'Coronation Street, Hoggartsborough', *New Statesman*, 9 February 1962, p. 200.

135. D. Hill, 'Phoney Street', *Screen Education*, No. 5 (September 1960) p. 38.

136. T. Warren, *I Was Ena Sharples' Father* (London: Duckworth, 1969) p. 58.

137. *T.V. Times*, 4–10 December 1960, cited in *Teaching Coronation Street* (London: BFI, 1983) p. 28.

138. R. Paterson, 'The production context of *Coronation Street*', in Dyer (ed.), *Coronation Street*.

139. P. Black, 'A fair price', *Contrast*, 3, 2 (Winter 1963) p. 85.

140. For a detailed description of the first episode see *Teaching Coronation Street*, pp. 28–32.

141. C. Geraghty, 'The continuous serial – a definition', in Dyer (ed.), *Coronation Street*, p. 10.

142. Ibid., p. 11.

143. *Spectator*, 24 March 1961, p. 405.

144. Weatherby, 'Granada's Camino Real', p. 284.

145. G. Turner, *The North Country* (London: Eyre and Spottiswoode, 1967) p. 406.

146. Weatherby, 'Granada's Camino Real', p. 285.

147. Ibid., p. 282.

148. *Spectator*, 29 December 1961, p. 948.

149. Advertisement in *New Statesman*, 14 September 1962, p. 337.

150. *Spectator*, 5 January 1962, p. 16.

151. *New Statesman*, 12 January 1962, p. 63.

152. *New Statesman*, 26 January 1962, p. 122.

153. Banham's article, 'Coronation Street, Hoggartsborough', (discussed in Chapter 1) was written in response to Killeen's letter.

154. *Spectator*, 29 December 1961, p. 948.

155. S. Hall and P. Whannel, *The Popular Arts* (London: Hutchinson, 1964) pp. 203–4.

156. Dyer (ed.), *Coronation Street*.

157. Weatherby, 'Granada's Camino Real', p. 289.

158. T. Lovell, 'Ideology and *Coronation Street*', in Dyer (ed.), *Coronation Street*, p. 52.

159. *New Statesman*, 12 January 1962, p. 63.

160. Lovell, 'Ideology and *Coronation Street*', p. 50.

7. OASIS IN THE DESERT: EDUCATION AND THE MEDIA

1. S. Hall and P. Whannel, *The Popular Arts* (London: Hutchinson, 1964) p. 23.

2. R. Williams, *Communications* (London: Chatto and Windus, 1966) p. 7.

3. A full transcript of the conference was later published under the title of *Popular Culture and Personal Responsibility* (National Union of Teachers: London, 1961).

4. C. Sparks, 'The abuses of literacy', *Working Papers in Cultural Studies* No. 6, p. 8.

5. R. Hoggart and R. Williams, 'Working class attitudes', *New Left Review*, No. 1 (January–February 1960) p. 26.

6. R. Hoggart, *The Uses of Literacy* (London: Chatto and Windus, 1957) p. 11.

7. Ibid., p. 20.

8. Ibid., p. 22.

9. R. Hoggart, 'English studies in extra-mural education', *Universities Quarterly*, 5, 3 (May 1951) – reprinted in *Speaking to Each Other, Volume Two* (London: Chatto and Windus, 1970) p. 221.

10. Hoggart, *The Uses of Literacy*, p. 11. (Subsequent page references are to this title.)

11. R. Hoggart, 'A sense of occasion', in N. Mackenzie (ed.), *Conviction* (London: MacGibbon and Kee, 1958) pp. 122–3.

12. M. Poole and J. Wyver, *Powerplays* (London: BFI, 1984) p. 12. This error does not prevent the book as a whole from providing an authoritative and indispensable account of Trevor Griffiths's television work.

13. R. Williams, *Politics and Letters* (London: New Left Books, 1979) p. 65. (Subsequent page references are to this title.)

14. Williams, *Communications*, p. 9.

15. Hoggart and Williams, 'Working class attitudes', p. 26.

16. R. Williams, *Culture and Society* (London: Chatto and Windus, 1958) p. 327.

17. Ibid., pp. 327–8.

18. Hoggart and Williams, 'Working class attitudes', p. 26.

19. Williams, *Politics and Letters*, p. 113.

20. Hoggart and Williams, 'Working class attitudes', p. 28.

21. R. Williams, 'Culture is ordinary', in Mackenzie (ed.), *Conviction*, p. 76.

22. R. Williams, *The Long Revolution* (London: Chatto and Windus, 1961) pp. 301, 317.

23. Ibid., p. 331.

24. Ibid., p. 338.

25. *Popular Culture and Personal Responsibility*, p. 3. (Subsequent page references are to this title.)

26. Hoggart, *The Uses of Literacy*, p. 11.

27. *Popular Culture and Personal Responsibility*, p. 35.

28. Hoggart, *The Uses of Literacy*, in the closing pages of Chapter 3.

29. *Popular Culture and Personal Responsibility*, p. 211. (Subsequent page references are to this title.)

30. Hoggart, 'A sense of occasion', p. 131.

31. A transcript of the trial is contained in C. H. Rolph (ed.), *The Trial of Lady Chatterley* (Harmondsworth: Penguin, 1961).

32. See, for example, B. Sendall, *Independent Television in Britain*, vol. 2. *Expansion and Change, 1958–68* (London: Macmillan, 1983) pp. 85–137.

33. Cited in *Contrast on Pilkington* (London: *Contrast*, no date – probably 1962), Part Two.

34. Ibid., Part Three.

35. Williams, *Communications*, p. 10.

36. B. Ford, 'General Introduction', in B. Ford (ed.), *The Modern Age* (Harmondsworth: Penguin, 1964) p. 7.

37. G. H. Bantock, 'The social and intellectual background', in Ford (ed.), *The Modern Age*, p. 38.

38. Ibid., p. 15.

39. Williams, *Culture and Society*, p. 260.

40. Bantock, 'The social and intellectual background', p. 39.

41. D. Thompson, 'Introduction', in D. Thompson (ed.), *Discrimination and Popular Culture* (Harmondsworth: Penguin, 1964) p. 14. (Subsequent page references are to this title.)

42. A. Hunt, 'The film', in Thompson (ed.), *Discrimination and Popular Culture*, p. 115.

43. D. Hughes, 'Recorded music', in Thompson (ed.), *Discrimination and Popular Culture*, pp. 156, 161, 172.

44. Hall and Whannel, *The Popular Arts*, p. 15. (Subsequent page references are to this title.)

45. Williams, *Communications*, pp. 9–10.

AFTERWORD

1. R. Rose (ed.), *Studies in British Politics* (London: Macmillan, 1966) p. 64.

2. T. Kennedy Martin, 'Four of a kind', in H. R. F. Keating (ed.), *Crimewriters* (London: BBC, 1978) p. 126.

3. P. Lewis, '*Z Cars*', *Contrast*, 1 (1961–2) p. 314.

4. K. Waterhouse, *Billy Liar* (Harmondsworth: Penguin, 1962) p. 143.

5. K. Waterhouse and W. Hall, *Billy Liar* (London: Samuel French, 1960) pp. 14, 24.

6. Ibid., p. 62.

7. A. Walker, *Hollywood, England* (London: Michael Joseph, 1974) p. 166.

8. *Coronation Street*, as indicated at the close of Chapter 7, was an exception to this in some respects.

9. J. Mitchell, *Woman's Estate* (Harmondsworth: Penguin, 1971).

Index